# Between
# Man and
# Woman Keys

# Between Man and Woman Keys

**stories**

Rosalind Brackenbury

2002 · JOHN DANIEL & COMPANY, SANTA BARBARA

"Between Man and Woman Keys" was first published in *Three Kinds of Kissing*, HarperCollins (UK), 1993. "At the Reef" was read on BBC Radio Scotland, 1995. "The Knowledge" was first published by *River City*, Memphis, Tennessee, as second prize winner in a short story contest, 1995. "Instead of the Revolution" was first published by *Stand Magazine*, as first prize winner in the International Short Story Contest, 1999.

Book design and typography: Studio E Books,
Santa Barbara, CA   www.studio-e-books.com

Cover art by Art Winstanley

Published by John Daniel & Company
A division of Daniel and Daniel, Publishers, Inc.
Post Office Box 21922
Santa Barbara, CA  93121
www.danielpublishing.com

LIBRARY OF CONGRESS CATALOGING-IN-PUBLICATION DATA
Brackenbury, Rosalind.
  Between man and woman keys : stories / by Rosalind Brackenbury.
    p. cm.
  ISBN 1-880284-52-9 (pbk. : alk. paper)
  1. Key West (Fla)—Fiction. 2. British—Florida—Fiction.
  3. Women—Florida—Fiction. 4. Women authors—Fiction. I. Title.
  PR6052.R24 B48 2002
    823'.914—dc21        2001006807

*for Allen, again*

# Contents

# Between
# Man and
# Woman Keys

# Between Man and Woman Keys

*"Brother don't let anybody tell you there isn't
plenty of water between Havana and Key West."*
—*Ernest Hemingway, 1937*

THAT WAS A fine Saturday afternoon. The town was full of tourists in light-colored clothes, white and pink and lilac, like baby clothes. There were a lot of pale legs around, and varicose veins and bellies; but there were some goodlookers too, most of them young. They went past and on like birds, only without the destinations and exactness of birds. They idled along looking at things. You could imagine doing that too for an hour or so, in a place where you had never been, but not for days at a time. They had a way of blindly crossing roads as if something on the other side—a color, a shape—had suddenly called them. A glitzy T-shirt, conch shells, a gaudy painting, a place where the food might be cheaper or the atmosphere more folksy, or what? They were in couples, mostly. Old couples, second-time-around couples, sugar-daddy couples, mostly. Old man/little girl, gay couples tight-bottomed with good haircuts, new couples with their arms around each other as if afraid to let go.

But the two who came down to the harbor that afternoon were something else. Murphy watched them come. He'd been out in the morning early that day, taken out a couple of fishermen from up north, who had fussed with their gear and caught nothing. It had been warm all day, a little humid and the sea calm. A nothing sort of day. If nobody wanted a charter in a while he'd go home and have a sleep. Catch up with Shelley, maybe make love and then have a sleep and wake for the evening and see what was what then. He was tired, with the stretched-eye feeling of getting up early. He rubbed his eyes,

raked through his beard and then saw that couple come wandering down the gangplank between the moored boats and the quay. A couple of young Hispanics, perhaps Cuban-American. A gay couple, he thought, on account of their walking so close together and their sharp-cut trousers and clean shirts. But not a gay couple, he thought, when the taller turned and looked him in the eye. Something there, some spite you never saw in a gay man. The shorter one didn't look at him but stared past straight out to sea. He wore glasses and his black hair gleamed in the sun. Neither of them could have been more than twenty.

"You a charter?" The tall one had his hand where his wallet might have been, checking everything—him, his boat, his money.

"Yeah. Wasn't thinking of going out again, though. Thinking of turning in."

"We make it worth it. We pay cash."

"What d'you wanna do? Go fishing?"

"Fishing. Yeah."

"Got your own gear?"

"No. We can rent it?"

"If you want. I've got what you'd need on board. How long do you plan on going for, an hour, two hours?"

The tall one looked at his watch. It was a good watch, Murphy saw, a flash one, not the throw-away kind. Between the watch and the fashionably turned-back shirt cuff, there was a narrow arm flecked with black hair, a boy's arm, the tendons showing. The young man looked from the watch to the boat, measuring distances. It seemed that they were already cut off from the Saturday afternoon Duval Street crowds, the three of them; it was odd, for Murphy it was less a thought or realization than a feeling, that something had come between him and the rest of his life. The tall one muttered to his friend in Spanish, and the other one shrugged. Murphy caught something about not waiting till tomorrow. He stood before them; and it was as if they had cast off already, the dark blue water separating them from land.

Shelley went up the steps with her arms full of a brown bag heavy with groceries from Fausto's. She'd bought wine and a bottle of oil,

and it weighed on her so she had to stamp heavily up the steps and kick her own front door open with her knee. It was warm out there and the wind had dropped and she felt sweat drip beneath her T-shirt. She put down the bags in a sagging armchair and flopped into the other herself, letting her brown knees and thighs flatten out, legs spread in shorts, feet in sandals sticking out straight in front of her. There was a slight nagging pain in her back, her period. But it was always at this time she wanted him even more. He said he'd come home early today, for a sleep. She thought of him, his broad brown body that was white only from the waist down to the tops of his thighs, the gray hair on his chest growing thick and silky, the width and strength of his back, and the place where his neck grew out of his spine and the skin grew rougher, and the crisp brush of his beard. There was the whole geography of a man; different each time, though you recognized landmarks. Every single body different, each time to learn afresh. With him, Murphy, it was the best ever. It was the secret, she thought, of middle age. He was in his mid-fifties, she eight years younger. They'd known each other three years. She said, you're the best ever, when he lay on his back sometimes looking at her from between his thick white eyebrows, the lips of his mouth drawn down in an ironic grin.

"Yeah, and who's talking, ma'am?"

"I am. I'm an expert. I told you so."

"Had more men than I've had chili dogs, have you?"

"Yup."

It was not that, but she liked to tease him, offer him the prize.

Now she sat in her slippery armchair in her clapboard house away from the sight of the ocean and felt her whole body loosen and grow moist, waiting for him. She'd hear the gate, and his heavy step creak up the porch steps, and then he'd be in.

"Okay, so we go?"

"Not so fast, pal."

"I pay, we got money."

"Money isn't everything."

"No? You are lucky, then. You have good business? Nobody has good business now, I think."

"No, business isn't terrific. But I'm a free man. I go out when I want to."

He thought, so this is the time I can't say no to? So what am I doing here, when I want to go home to sleep? But the season so far'd been bad, with more and more guys coming in with the notion of making a quick million bucks with their polished-up schooners, their natty little light cats; boats of all sorts queued and jostled here these days, as if Key West were some kind of goddamn magnet that pulled them all in. He'd raised his rates, thirty bucks an hour, and that was still moderate.

He looked at the young men not dressed for fishing. They danced with impatience, and tried to control it. They were stiff, like puppets, like someone was pulling the strings. Then Jürgen came down the gang, bending at the knees the way he did, in his long strides, a skinny man washed almost fleshless by years at sea.

"You goin' out again, man? Thought you'd be going home. Sat'day afternoon and all."

He winked, creasing up the side of his face. Murphy's moving in with Shelley Anderson just three years ago was still a subject, down here on the Keys.

"That'll keep your pecker up, Murph," was what they said, and he'd grin and acknowledge it. Neither of his two wives had been to him what Shelley Anderson was, in his unromantic middle age.

"You want to take them, then?"

"No dice, I'm bushed. I told you, I had to take that champagne cruise last night. Hey, man." He lowered both face and voice towards Murphy's ear—"I'm not too sure anybody should. Take a look at them."

"Just kids, wanting a fishing trip," said Murphy. "What else? Christ, Jürg, you been reading too much. Look, I can take care. I'll give 'em an hour or two. We're a bit short just now."

"So long as you know what you're doing."

"Look, I've been thirty years in this business, and if I don't do it, the fancy boats are going to take it on. It'll be all champagne cruises and the whole fucking carry-on. There'll be nothing left for us. Tell Shell I'll be back later, if you're passing? Thanks, man."

"So, what is it? Cash, plastic, check?" The taller one pulled out the

wallet that had been bothering him. Murphy saw hundred-dollar bills in a wad, done up with a rubber band as if there were so many they'd fly away. He blinked.

"Ain't no more'n thirty bucks an hour, pal." The young man handed notes over.

"We want for longer. For three hours. Four."

"You keen fishermen or what?"

Quick, in and out of his mind. Like a breath of wind, Jürgen's warning—But you couldn't afford to turn down trade on account of a little warning like that—and wanting to take your lover to bed on a Saturday afternoon.

"Okay, we'll cool it later. This one's mine." And he went to his boat, the little power-boat. *Mermaid III*, in the harbor, innocently empty, bobbing at anchor. With the air of people trying not to get their fingers dirty, the two dark young men stepped elegantly aboard.

It must've been a good hour, she thought, that she'd sat here like a fool, just doing nothing, just thinking about sex. She hadn't even unpacked the groceries. But it hardly mattered. In the dark of the room with the blinds slightly flapping and the shapes of the old coconut palms letting the sky in and out between their spiky old fingers, she threw herself down on their wide unmade bed and when her own fingers had finished smoking a cigarette and stubbing it out, she let them wander up her thighs as if they were his.

"You keep going. Far out. Further. You too far in."

"I know my own boat, man, and I know those waters like they was the back of my hand. You're s'posed to be fishing, right?"

They gave him the creeps, these guys, to be honest. Even though they were only kids. There was something going on that he had not been told. He set the tiller, headed out between the shoals.

"This not far enough out, I said. We go far."

He didn't look round. His eyes, accustomed, were on the horizon that was today just a soft line, purple on green.

"Why d'you want to go far? Fishing's good out here."

He spoke to them without turning, master of his ship, every line of his body doing what it was used to.

But as soon as the young man spoke again, he heard it. He swung to face him, and the tiller juddered the boat off course.

"We not going fishing, man." There was something almost soothing in the guy's voice, like he was trying to reassure him. There was something smooth.

"We going to Cuba, man. And you gonna take us." Then he realized what he had thought was a well-hung penis tucked sideways in the taller young man's pants had been a small revolver, which now seemed to grow out of his hand like some sort of weird extra limb; like the claw of a blue crab, he thought, that single lethal necessary claw.

Then Murphy remembered all sorts of things in a rush. He had heard of people seeing their whole lives before them, rushing past before they drowned; but what happened as he sat there in the sudden silence, one hand on the tiller and nothing moving, was a sudden rush of information, memory, fact, little disparate things seemingly rushing together and making a big comprehensive whole.

There'd been that kid from Miami, Domenico someone, couple of days ago, condemned to be executed in Cuba. The other guys in jail. In Cuba they said they were starving, since the Soviet Union broke up. Out in the Everglades on Sunday afternoon, there were hundreds of them, young Cubans, practicing invasions. There'd be no solution anywhere, not here, not in bloody starving Cuba. It was all of one piece, what was rushing towards him in his brain, like you had to understand the history of your own time in a sort of crash course the minute before you died.

But was he going to die?

There did not seem to be anything particular to decide it either way. It was all shallow and indecisive, happening only on the surface. He felt the terror most in his stomach, like the need to shit. But the young Cuban was shaking too. His hand with the gun in it shook as if he were trying to jack off. He stared at Murphy with fine dark eyes, long eyelashes. The other one, the shorter one, stood still and then seized his pal's arm dangerously and said, "No, Carlos, no."

Murphy moved his lips at last and said, "Don't shoot. Tell me what you want."

The thin shell of the boat rocked, so they all tipped and balanced themselves. Murphy cut the engine. The shorter one sat down sud-

denly in the bows. There wouldn't be enough fuel to go ninety miles anyway.

"My brother and I want to go to Cuba to liberate our country. There is no food; there is torture. You take us there."

"I can't. There isn't enough fuel on board."

"It's not true. You are lying."

"It's true. You can try if you like."

Carlos looked at the engine, looked at his brother. Murphy thought, what do they teach up there in the Everglades? War games? Not gasoline engines anyway. Fucking Castro. Fucking Bush.

Murphy said, "I'm sympathetic to your cause, sounds like the shit's hitting the fan over there, but I'll have to take you back to Key West."

For a moment he saw in astonishment the babyish explosion of rage on Carlos' face, and his brother trying to pull him back, grab an arm, take the gun, whatever, and then he was pushed hard in the chest so that his breath went under the spite in the shove, the force of a small bony hand. He was overboard, choking in green pale water that darkened as he went down. Coming up just once, spitting his breath for a last time into the world, he heard the spark and chug of the motor. They wouldn't get anywhere. But neither would he.

Shelley answered the phone when it rang, ten o'clock the next morning, Sunday. She stood at the window in the long T-shirt she used as a nightdress. She had only slept odd half-hours throughout the night. She knew already, before answering the phone.

"Can we come up and see you, ma'am?" It was the coastguard.

"You've found him?"

"Yeah, I'm afraid so."

She let out her breath in a small groan. It was like the creak of bones stretching or sticks or stones rubbing together. Yet it was her body, making that sound.

"Where?"

"Down between Man and Woman Keys. Not a mark on him. It was death by drowning."

She thought, hanging on to it with a sweaty hand, thank God for the telephone, for voices only, for not having to see anybody.

"I'll be right down." *No, you can't come up here. This is where I will hide.*

"I'm sorry, ma'am."

"Yeah." *Was it ma'am then, when your man died, when nobody knew what to do or say?*

"You want me to identify the body?" *Where did I get this cool?*

"Jesus, no, Shelley, we all knew him."

"Okay, so where are you?"

"The Marina. We came in between Christmas Tree and Tank islands."

"I'll be right down."

You could do this then. She dressed, hurrying up her body into clothes, shirt and pants, so that it would be out of her sight. That was it, then. It was the end. She zipped up her jeans in a fierce movement, took dark glasses, cigarettes, keys, shoes. You could just switch on like an engine and steam ahead. Of the hours in which she had missed him, and had lain adrift half-sleeping in the wreck of their bed, while the sea spread him and played with him and dumped him at last, she would never speak again. But as she went slapping down the steps and out under the spiked hands of the palm trees, into a blue morning, she said aloud, "Between Man and Woman Keys was it? God damn it, one day I'll tell them what that means. God damn it, I'll let them know."

But the two young Cubans landed in the Monroe County jail awaiting interrogation were never to meet her and never to hear. Their world was separate. The sentence made sure of that.

*For Captain H.B., who died at sea off Key West, Saturday, January 18th, 1992.*

# The Forty-Ninth Lot Joke

PHOTOGRAPHS always curl at the corners and crinkle up so they look much older than they actually are. Particularly in this climate. It starts happening as soon as you get them back from the developer, so that even last week's events are suddenly set in a distant past. Black and white pictures, though, are automatically history, just as sepia ones were before them. They don't fade, they just get to look more authentic and longer ago.

The era we are looking at is that of the black and white photo. We, that is, my daughter Belinda and I, nearly three decades after these photos were taken. They are all that remains of that other time—except ourselves, of course, except what is stored in our bodies still, in our cells, our minds. We sit on the dusty floor of the house in Key West, Florida. She has crossed the Atlantic Ocean to visit me. The man I've crossed this ocean for myself is walking back and forth, moving things, with a glance at us from time to time as he passes: at two women sitting on the floor in a pile of old photos, apparently doing nothing. It is a day in winter and the sky outside is spectacularly blue. The bare branches of a frangipani stretch their knobbed thumbs outside the window. A pile of debris grows on the sidewalk outside the house. We are deciding what to keep and what to throw out. I've brought all these photos with me, unsorted, a slithering heap now upon the floor.

"God, you look miserable," Belinda says. "Whatever was going on?"

I take the dog-eared picture from her. There I am, aged only a little older than Belinda is now. Crop-haired and scowling in a bathing suit, with a baby in a sunbonnet sitting between my legs. The ones she has picked up are of the summer we rented a house in the Lot Valley, in France. 1969, that must have been.

"That's you."

"I know. But what was the matter with you?"

Why, she is asking, did I look so furious while apparently mothering her? She couldn't have seen the expression on my face, then. But she can now.

"I was having a hard time. It was in France, the year you were one."

"But it looks idyllic, all sunny."

"People only take photographs when the sun's out. It rained a lot."

"But it isn't raining in this one?"

Is she asking, did you hate looking after me? Was that it?

I say, "I was the only one there with a baby. I guess it was just disappointing. Do you remember it at all? No, you'd be too young."

I pick out the one of the house, viewed across fields of maize or tobacco, it's hard to see which. And the one of her naked on the grass with her father holding a glass of wine just out of her reach. And the one that Paul took, of my friend Maria and me outside a local bar, the afternoon before the day I left.

It was Maria who said to me, that afternoon, "Why do you do it?"

"Do what?"

"Set up situations like this. Are you a masochist?"

She was my oldest friend. We were at school together at the age of five, which was when she began also being my rival in everything we did. I think the teachers set that one up, making us both intensely competitive. We both did all right on being intensely competitive, but it would have been less confusing if they'd just left us alone to be friends. She was a scientist and went at things from a scientific point of view. So perhaps "Why?" was the right question. I had no idea what she was talking about, though, and felt vaguely accused.

"Do I? Did I do this?"

"Well, it was your idea, wasn't it?"

"Yes, I suppose it was. But people don't necessarily have to do what I say. They have minds of their own."

"Not really."

"You mean, I made this happen?"

I remembered that one of the reasons that I'd liked her as a play-mate, when we were both young enough to sit in trees and make up scenarios for our lives, was that she never did do exactly what I said. She had her own ideas, lots of them, so we tended to argue, and when we did agree, it had a satisfying feeling about it that was better than just compliance. It was a relief.

Now she said—it was towards the end of that time, that summer that we were all in that house in the Lot Valley—"Anyway, you look as though you could do with a drink."

Drink was our solution to most things at that time. She could see I could do with a drink; it meant that she was thinking about me. Nobody else had thought about me for weeks. The fact that we were surrounded by half-full and full wine bottles was irrelevant. She meant, a Drink, which meant going out, going to a bar, abandoning my post.

"Come on, Imo, we're taking you out."

"What about Belinda?"

"She's got a father, hasn't she?"

"I don't know where he is."

"Well, he has to be within a radius of five miles. I'll find him. Paul can go and find him. Paul, go and find Robin. Tell him to look after his daughter. We're taking Imo out for a drink."

"Fine, fine." Paul, a tall vague man, went slowly off looking over the tops of his glasses for Robin, who was then my husband. Even then, Paul had this affectation of going about like an old man. Maria called him "Professor." They had this energetic sex life. I know, because I used to hear them. I envied them this quite a bit.

Maria herself was small and pretty, still is, with a china-doll look about her and large blue eyes. She has a fearsome intelligence and reads a lot. In the days of mini-dresses, in the era I am talking about, she wore the mini-est dress of us all. In the days of beehive hairdos, hers was the most impenetrable. She was the first person I knew to go without a bra and the first at university who obviously went in for

sex. She it was who told me about contraceptives, in the nick of time. She did it thoroughly and patiently, managing not to be sneery about my astonishing ignorance.

She drove their large new Citroen DS to the nearest bar, which was three or four maize fields away under a large summer sky. She bought us both pastis and sent Paul off to repark the car where it wouldn't smell of manure.

"Imogen, you're quite incredible. Why do you do it?"

"I still don't know what you're talking about."

I watched the water cloud my pastis and the green-yellow fog it made.

"This. This mess. I mean, you're obviously not enjoying it. Why don't you come away with Paul and me? We're going on down to Spain."

"I can't. What about Belinda?"

I didn't want to hear her say again "She's got a father, hasn't she?" It seemed that nobody understood that once you had a baby you were set apart, you couldn't behave like a normal person anymore, you certainly couldn't just get up and go to Spain.

"Paul and I both think you should be rescued. We think you do it to yourself, but now that you have, we think we should rescue you."

I got out my crumpled blue packet of Gauloises and my lighter.

"And we think you're smoking far too much."

"Look, are you trying to get at me, or what?"

"No, Imo, honestly, it's just all of a piece. Look at yourself. I don't think you've looked in a mirror all the time you've been here."

"There isn't one."

"Darling, that isn't the point. I mean, look at the whole picture. You have been caught. You're stuck with a baby and a whole houseful of people who are just exploiting you. Who last looked after Belinda for you while you went out? Who last took you out for a drink? And the point is, you're colluding with your own oppression."

In 1969, people did not talk either about oppression or about colluding with it, as far as I remember. I looked at her with respect. This was my old playmate coming up with some new games to play.

"Women," said Maria, "are systematically oppressed. Right, Paul?"

Paul nodded over his drink. He reached to take my hand, to

emphasize the point perhaps, but Maria frowned at him so he took it away.

"Okay, it's hard sometimes. But I'm doing what I chose to do. I wanted to have Belinda, and I had her. And I suppose I wanted to come here, too."

"Well, that's just the point. We choose it ourselves. Our conditioning chooses for us. We walk straight into all the old traps. I'm just here to warn you, darling. If you can't get out, for God's sake wise up to what's happening. And just for interest, while Paul gets us another drink, why did you want to do this? Can you remember? What on earth made you set this one up?"

She leaned towards me like a kind therapist and waited for my answer, while I smoked and looked at her from a great distance, the one between mothers and non-mothers. I drank up my drink, and began.

I began telling it backwards, the way I'm telling my daughter, all these years later. You couldn't possibly have seen the outcome in the beginning, or so I thought then. But Maria thought differently. She thought it was inevitable. She knew right away. It reminded me of the time we were hiding behind a tree in the school grounds, carving our names with pocket knives, and I got caught and punished because I'd put my name first, and she did not. Getting off scot-free has always been one of Maria's accomplishments. She has skated through more ropey love-affairs with impossible men and more late periods and so on than most, but she has never been caught. She it was who caught Paul, rescuing him, perhaps as she was now rescuing me, from a marriage. So he went around with a dazed look, a man who had been chosen from among millions. She used to cry a lot at parties when we were young, but I don't imagine that she cries much now. She has a lot of money and a respectable career in research, she publishes articles in *The New Scientist* and has matching luggage and sometimes I see her and Paul in their latest large car, setting out to drive across Europe. Then I feel ashamed of still being in jeans with a rucksack, still not looking in the mirror. If I have made her sound heartless, she isn't, at all. It's just that the old competitive stuff goes on.

Oh, it was good to be sitting between them that afternoon in a bar at least five kilometers from the leaking, overcrowded, flea-ridden

house I'd rented. To be drinking my second pastis and feeling the alcohol blur everything, the taste of anis sharp in my throat with the even sharper cigarette smoke, and the blue cloud the smoke made around me; it was like sinking into warm water, like giving up. Like admitting that I couldn't do it, what I'd set myself, that something had gone wrong. Like having parents sitting listening. Like being given another chance. Like being protected, being a child again, being forgiven. When we got up to go, I was quite drunk. It didn't solve anything, but it seemed as if it might. I did remember, through the pastis and smoke haze, some of the things she said. It was the first I had heard of women's liberation. Up till then, things had just seemed normal, and anything that went wrong, my fault. After this particular afternoon, which turned into evening and made me forget the baby's supper and whether or not there were any mashed vegetables in the refrigerator, it was not really like that, ever again.

Belinda says, "So women's liberation meant forgetting about feeding your child, and getting drunk."

"Look, I know this all sounds very old hat to you. Our generation, always going on about what's hard, always complaining, moaning, going on about oppression. But hang on, I'll tell you how it was. You asked. You're the baby in this picture, I'm the mother, I'm twenty-seven years old, full of dreams and frustration, look, there I am looking really quite sexy in my bathing suit with my hair on end and that scowl. You've no idea what it was like to hear that everything wasn't all your fault. That was what was liberating. That was it."

There seemed to be a debate going on in 1969 about how to change your life. There was stone-throwing and revolution, there were sit-ins and marches and protest songs and banners. It was out in the open, something was wrong with society, but also with us. You couldn't pretend not to know, the way you could in the fifties. You had to be on the alert. I was married, in this age of so-called free love, and had a baby. I lived in a town in the midlands of England where my husband had a job. I didn't have a job. He went off every day to his job and I stayed with the baby. I wheeled her round a big park every afternoon in a cold wind because my parents had told me you had to have exercise and babies had to have fresh air, however cold

and damp. I counted the hours in the day, willing away time. Some-
times on the way back from the park I stopped at a cake shop and
bought cakes full of chocolate and cream to eat when I got home.
When Robin got home, we had a drink and cigarette each and I
pestered him to tell me about his day, because there must have
been some people in it, some incident. He said that it wasn't like that,
there was nobody I would find at all interesting. He wanted to know
what was for supper, that it wasn't spaghetti again. We ate an elabo-
rate meal, to cheer ourselves up. There was something missing.
It seemed to be my fault. It was my ability to be happy and cheerful
that was missing. Surely, with a husband who went out to work and
came home each night, and a baby, and a life in which nothing aw-
ful happened, one should be happy and cheerful. That was what we'd
all been told. I thought of the banners and posters in the outside
world, the faces on TV, the bold brave faces of student leaders,
protesters, young men refusing the draft, people of my age across
the world all saying a resounding NO. No, this is not what we want.
I arranged to go and see a psychotherapist. It was what most of my
friends had done, in the university town where we used to live, where
everybody was more or less disturbed and quite proud to be so.
People mentioned it casually in conversation, "My shrink says," "I'm
off to see my shrink." People who went to the same shrink made
themselves into siblings. Jealousies raged. We all bandied the jargon
about, making ourselves feel safer, because not alone. But now, in
an industrial city in the midlands of England, I was alone. Robin
made it quite clear that it wasn't he who was crazy. I took to the idea
of craziness with some relief. I'd had a grandmother who was crazy,
and it seemed to let you off quite a lot. Also, it would explain why
I never felt happy. That one had begun to bother me. Better to be
crazy, in the crazy sixties, that era of extremes, than just plain miser-
able.

I told him, "I'm going to see the student shrink, Robin. She'll see
me for nothing, since you're on the staff."

He looked alarmed, perhaps not wanting to be associated with a
mad wife in public. "Are you sure?"

"Yes, I've made an appointment."

"What about Belinda?"

"Oh, she can go with me. She can go in her pram outside the place, they have a garden."

"Oh, okay. Hey, it isn't my fault, is it?"

"What?"

"That you're, you know…"

"Crazy?"

"Well…"

"No, of course not. It's probably hereditary."

"I mean, if I can help?"

I couldn't honestly think what he could do, except not go to work, look after the baby all the time and have sex with me every night. But they all seemed impossible. So I changed the subject.

My shrink was one of those who believed in saying nothing much and letting you do all the work. I went to see her on Wednesday afternoons, parked the baby in her pram under a barely-leafed chestnut tree in that chilly spring, and watched her with some anxiety through my session. When the pram began to rock with her distress, I forgot my own and waited for my hour to be up so that I could go and rescue her. I wondered if she would remember being stuck in a psychiatrist's garden looking hopelessly up at buds and twigs and whether it would mark her life. In between wondering this I mostly cried. Sometimes the woman opposite me made a remark, asked a question. But mostly I just talked, and cried. It was more like talking to a statue than to a real person. Sometimes she just repeated back to me what I'd just said, which made me want to scream. I thought if I was paying for this, I would complain. But it was better than not talking to anyone, better than being alone, better than pretending, better than telling Robin that I was fine. It was a lot better than walking round and round that park.

One day, after crying quite a bit, I had an idea. It was about doing something different. If you weren't happy, maybe it would be a good idea to do something that made you happy. If you were lonely, maybe it would be a good idea to be with people. If you hated gray skies and cold weather, maybe it would be good to be in the sun. If you didn't like your present reality, maybe you could change it.

I looked across at the shrink, suddenly clear-eyed. I thought, she does this day after day, week after week, listens to people in this room.

She doesn't know any other way. She can't imagine anything else. But I can. Suddenly, I can imagine doing something quite different.

But I didn't tell her what I was thinking, not then. It seemed dangerous, as if she might prevent me. I knew what she would say, that I should analyze the causes of my feelings, not just go and do something else. I should get to the bottom of my problem. Get to the roots of it. But what I was thinking was, I am just fed up. The life I lead is boring and limited and I want something else. It was not the kind of thing you could say to a shrink who was sitting there waiting to hear how you felt about your father.

Very soon after that, I found the advertisement in the Sunday paper.

"Look," I said to Robin immediately.

"What?" he was reading the sports page.

"Farmhouse, Lot Valley, Southwest France, to let, fifty pounds a week."

"What about it?"

"We could rent it."

"What are you talking about? We can't afford it."

"We could if we stopped paying rent here. We could save money. We could live off bread and potatoes."

"In the Lot Valley?"

"No, I mean here, we could economize."

"It's an awful lot," he said. That was I supposed the first Lot joke. I didn't notice it at the time.

"But why not? We could invite all our friends from Cambridge to come. We could run it like a commune, get everyone to contribute. Share the cooking and everything. Rob, we aren't living at the moment."

"Aren't we?"

"Not the way we always wanted. What happened to all our ideas of sharing and communes and bringing up children with other people and staying close to all our friends? What happened? We're bloody miserable. We just go along in the same old rut, we don't even make love anymore."

"Don't start on that," he said.

"Well, you know what I mean."

"I have a living to earn, you know."

"Well, don't start on that. Just think, we could have two months

at least, once your vacation begins. We could live in the sun, eat wonderful food, swim. Look, it says river nearby."

"I thought you had to stay here all summer to see your shrink."

"Well, I've just realized I can do without her."

"Oh, good. You do sound better, come to think of it. Are you better?"

It was as if I'd had a cold, or flu. I didn't know if I was better, I just knew I'd had a good idea.

I said irritably, "It isn't a question of being better, it's about deciding to do something different. It's a question of remembering what's really important, what our ideals are, what matters."

"I don't see what it's got to do with ideals. But yes, it would be nice, I admit."

I wrote to Madame White, whose address was not in the Lot Valley but in Tonbridge, Kent. Apparently she liked to be called Madame even in England. We began to eat rice and potatoes for every meal and we gave up coffee and wine. It seemed worth it. After all, we could have all the coffee and wine and delicious food we could hold in France. Thinking of tables spread with it, I sometimes felt a little faint.

Our friend Tristan came to visit us in his second-hand white Jaguar and we told him of our plan. He arrived when Robin was at work. I saw the car turn into the driveway off the main road and saw with a rush of love his dark head emerge from it. I hadn't realized until then just how lonely I had been feeling—for old friends, the old life, the one I had never thought I would have to leave, in which we all went on being students forever. I threw up the sash window and shouted down to him. He had flowers in his arms and a bottle of champagne and a packet of books, and with all this he came struggling up our steps. He came to kiss me French-style on both cheeks. His hair was short, like fur, and his cheekbones clashed with mine. He had been christened something more ordinary, like Gerald, but he had been Tristan ever since he was about sixteen and had started wondering whether or not he was gay. I felt the straightforward affection for him that a certain sexual ambiguity can allow you. These days, he would probably say he was bisexual, but I don't think we thought of that then. There was just something undefined and intriguing about his

relationships with both Robin and me. Oh, I was so pleased to see him that afternoon. I remember Belinda jumping and shouting in her high chair too and waving her jammy hands.

"Darling," he said, "you look wonderful."

"I don't believe you. I can't look wonderful. I feel awful. Or rather, I have been feeling awful but now I don't anymore. I've got something to tell you. We've got a plan."

Tristan loved plans, or ploys as he called them.

"I can't wait," he said. "Is this tea? Can I have some? Shall we save the champagne for Rob, or has he left you? Hasn't the poppet grown amazingly? And really, you do look absolutely stunning, motherhood must suit you. Here, I brought you some books."

I opened the packet of new novels from Heffers, and it was like living in Alaska and getting something sent from Peru. There were white carnations and lilies all over the table smelling wonderful, too. Tris always brought me white flowers, for some reason, and all this and the champagne in its glamorous bottle and his exaggerated compliments made me want to cry. I hadn't had anything like this for a while. He handed me his clean white handkerchief and put his arm round my shoulders and laid his furry head against mine.

"Sorry, I seem to cry a lot these days. I don't know that motherhood does suit me at all, really. Or maybe it's something else."

"Crying's good for you, apparently. Have you read *The Primal Scream*? Screaming's even better. I must send it to you, it's the latest thing, it cures everything, and it's much, much quicker than seeing a shrink. I met a rather wonderful man who does it in America. He wants me to go to L.A. and give it a go. God knows, I've enough to scream about. But I suppose, so has everyone, really."

"Oh, I've missed you, Tris."

"Have you? I'm flattered. Well, let me tell you, life is very definitely not what it was, without you and Robin. Now tell me, if it isn't premature, what is the ploy?"

I told him, and by the time Robin came home from the polytechnic we were crawling about on maps of France on the floor and Belinda had jam all over the Michelin guide of several years ago.

"Rob!" They embraced, or rather, Tris hugged Robin, who had his hands full and looked embarrassed.

"You two look wonderful." Tris pushed us gently together and looked at us as if we were posing for a wedding photograph. We looked at each other. Did we? Why had we not noticed? I could see that Robin was beginning to feel better too. He put down his books and went to the bathroom and Tristan opened the champagne carelessly, as if it didn't matter about saving every drop. We drank from foaming glasses.

"The toast is: a fair wind to France!"

"So you'll come?"

"You couldn't keep me away. God, how I long to get across the channel. Can you imagine, we'll be all tanned and naked and wander through flowers all day long, and drink delicious wines and eat grapes. Oh, and of course, cigarettes will be cheap. And petrol. Quick, more champagne, my romantic images are turning into mere practicalities. My dears, you are geniuses. I can't think how I've lived so long without you. Another toast!"

Belinda watched him with delight and banged her spoon. There hadn't been so much cheerful noise in the house for weeks. When she was born, Tristan sent me a whole room full of white flowers. I woke from too much pethadine and thought I'd died. There was a box the size of a coffin being carried in, and white flowers overflowing from it. Soon my room was like a flower shop. At the time I thought the associations with virginity were a bit out of place for someone who had just given birth, but perhaps they were for my new virgin child, not for me. I think Robin was slightly annoyed when he came in with his tight bunch of daffodils. Tristan, he often said, does not know where to stop. It was true; and I loved him for it all the more. We heaped this time's flowers into all the jugs and vases we could find and I had no more thoughts about virginity or appropriateness. The scent of lilies filled our little flat, and my idea was born. We were already under way.

If it seems a little strange now to be so excited about renting a house in France, all I can say is that in 1969 it was not the way it is today. The English newspapers were not stuffed with French property for sale or rent, and half the population was not talking about traveling, renting, or buying in Europe. Madame White's advertisement was one on its own.

My brother Pete, who is a sarcastic fellow, once accused me of being a knee-jerk Francophile. It was true. I believed sincerely and for a long time that everything was better in France than anywhere else. Some of it really is. Food, fashion and sex, they are rightly renowned for, the French. And window-dressing, movies, wine. In the sixties, we English all turned to France for our inspiration. I wasn't alone in assuming that you only had to cross the channel to assure yourself of a happier, sunnier, better-fed and better-educated life. In 1969, they'd just managed to have a proper revolution again, while all we had was student sit-ins. We'd learned from them how to cook properly and how to light up cigarettes after sex. They had Sartre and real intellectuals and the Left Bank, while we'd just had angry young men and the Chelsea Arts Ball. Elizabeth David had told us all how to behave around food, Jeanne Moreau showed us how to look sexy, Jean Paul Belmondo showed us what to expect in bed. It was all a pretty hard act to follow. But follow it we did, and follow it we still do, even with McDonalds being Le Trend for French teenagers and Disney building palaces in the French countryside, Le Tunnel linking us banally as if we were really equals, and fascism building its mean little outposts in all the French suburbs.

Anyway, in 1969 my Francophilia was in full swing, and so was most other people's. Otherwise we probably wouldn't have had such an enthusiastic response to our plan. Tris was coming, and Maria and Paul, Pete and his wife Gina, my younger brother Alex and his friend from college on their way to Bulgaria, Robin's parents, to my surprise, and his younger brother Laurie. And this was just a start. I mentioned it to my own parents but they shuddered and declined with thanks. Communes in the sun were not their idea of fun.

"It's rather an odd collection," I said to Robin, "D'you think it'll work?"

We were still in the midlands, and the village we were heading for was still just a dot on the vast green hexagon of France.

"We'll have schedules," he said.

"What for?"

"Shopping, cooking, cleaning. Childcare."

I looked at him in surprise. Where had he found that word? Childcare? Did that mean I was going to get time off from looking

after Belinda? I had had no idea, when I gave birth to her, that children took all day, and most of the night too.

"Well, that was part of the plan, wasn't it? Look at the kibbutzim. They have a children's house. It's in all the best anarchist literature, too."

"But we're the only ones with a child."

"That's true, yes, but childless couples often long to look after children. They just don't get the chance, so they suppress it, I suppose."

I wondered what he'd been reading, and if this theory could possibly be true. I thought of the assortment of people who were coming. My parents-in-law, yes, they were bound by the rules of grandparents. But my brothers? Our friends, with their notoriously single-minded pursuit of pleasure? Were they really all longing to mash up vegetables and supervise our child as she rambled about on her belly on dirty floors?

"What about free love, that's in the best anarchist traditions, too?"

"Well, is there any of this lot you fancy?"

"Not really. Half of them seem to be our relations."

I did not tell him that I had a persistent fantasy of a tanned and muscular French farmworker gazing desirously at me while I stood knee-deep in some cornfield, and carrying me off to scenes of passion among flowers and butterflies and no prickles, while somebody else looked after my baby. This person in my imagination could have merged with Robin himself, if he got a tan and some muscles and managed to lose some inhibitions about making love out of doors. I still had hopes of something like that.

The house itself was not particularly old or beautiful and it stood right on the village street. At the back of it, maize fields stretched away to the local farm buildings. At the front, on the other side of the street, was the river. It flowed fast beneath overhanging dark red rocks that looked like slabs of meat. In the village there were very few people visible and everything appeared overshadowed by these rocks. When we first arrived I thought it was just because the sun was low, but the light was like that a lot of the time because the sun was often behind the cliff. The river had a single-minded vicious look about it

as if it couldn't wait to get to the sea. There was a hydroelectric station a little way up and the water there was dammed and deep. Then the water came hurling down between broken trees and rushed past the village.

"So, here we are," Robin said as if I hadn't noticed. Here we were, indeed. If this was paradise, it didn't look like it. The baby was beginning to whimper in her seat in the back of the car and the dark sky looked like rain. We'd driven all day, taking it in turns in our heavy old car, telling each other from time to time how marvelous it was to be doing this and how free we felt.

"Maybe we should have stopped at that last restaurant."

It looked like this was the only village in France without so much as a café.

"Oh, we'll soon get something to eat going. I'll just nip into the shop and get the key. That must be the shop, there."

I felt my heart and stomach shrivel to the size of shrunk balloons. He turned off the engine and all we heard was the roaring of the river. I got out and went across the street to the little shop where a woman with a tight bun of white hair handed me the key. This seemed symbolic, as she handed it in a very deliberate way. I said we'd be back to buy food in a minute. The floor was covered with boxes of old-looking vegetables, but she had the right things on the shelves—oil, wine, olives, sardines, cheese, as all French shopkeepers will, even in dead-looking villages at sunset.

"*Elle n'est pas venue, Madame Veet.* For some time now, she has not come."

"*Eh bien, merci, madame. Au revoir.*"

Was it a warning? Probably the house would just be a bit dirty. I did all the repetitive *au revoirs* and *mercis* that people do when they've only bought a loaf of bread, and went out feeling better. Robin was sitting in the car with the window rolled down and the baby was screaming.

I recrossed the road. "Why don't you pick her up? She's miserable, poor thing. She's probably as hungry as we are."

He turned and offered his daughter a crust of the bread left from our picnic lunch. She gnawed it, sobbing. I felt sorry for having made her come this far with parents who didn't know where they were

going, only hoped for paradise. She would probably grow up to hate foreign travel for life.

"She says Madame White hasn't been here for ages."

"Maybe she doesn't exist. Well, let's get in there and have a look. That's it, number seven. Lucky or unlucky, do you think?"

"It's bound to look better in the morning."

Robin said nothing, just looked pale with exhaustion, the way he often did so that I began running around him trying to make things better. I took the key back and like someone in a fairy tale, let myself in to the house. Robin came behind me with our daughter still slobbering bread and hiccupping in his arms. The heavy wooden door moved open and we saw a large room with a black-and-white tiled floor and lots of heavy dark furniture that looked medieval. The shutters were closed and the smell was possibly the droppings of some animal.

"Jesus," said Robin.

"Hang on, let's find the light. *L'electricité est derrière la porte*, the woman said."

I pushed down a heavy switch on the wall and electric light flashed into every corner, showing cobwebs, mouse droppings, dust. Madame White was obviously not interested in housework. The black-and-white squares of the tiled floor were filthy, although still visibly black and white. The heavy dining table and chairs looked immovable. I blinked away tears. Did everything always have to be this disappointing?

"Candles," Robin said. "We'll light candles and have a drink, and clear up in the morning. Let's just have a look at the beds."

The dark wooden stairs led straight up to the main bedroom, which led into three other bedrooms, all of them with beds with stained, saggy ticking mattresses, but no dividing doors.

"Let's just get some food. Open a bottle. We'll feel better."

Robin was a great believer, as I was, in opening a bottle to make you feel better. I didn't remind him that this whole trip was supposed to make us feel better, and here we were, feeling much worse.

I warmed some milk for Belinda and sat her down on the sofa, where clouds of dust rose around her. She didn't seem to care but set about guzzling her milk in the sensible way babies have of concentrating on the one thing that matters. Robin sat next to her with a

corkscrew and bottle of wine from our store in the car, to do the same. I went to pick among the dry earthy vegetables in the shop and enthuse about how wonderful it was to be able to buy cheese and olives just anywhere in France at any time day or night. The old woman was out of bread but said that the bread van would be round in the morning. The fish van came on Tuesdays, she told me, and the mail in the afternoons. How was I doing in Madame Veet's house? Ah, *la poussière!* She threw up her hands as if a cloud of it had arrived in her face, then gave me a tin of furniture polish and some insect spray. I went off with a tin of rillettes, one of sardines, some carrots, a tired-looking lettuce, and a bottle of oil. We still had cheese and chocolate melting in the car. Tomorrow would do for all the wonderful things I would find in order to produce wonderful French meals.

Belinda fell asleep on the sofa, the bottle still in her mouth and her hands spread tenderly upon it. Robin and I drank half a bottle each of the roughish red, ate a picnic by candlelight, smoked several cigarettes each, and fell into the bed nearest the upstairs window, where the river roared at us all night among our disturbing dreams.

In the middle of that first night I rolled towards him across the lumpy mattress and said "Rob?" in what I hoped was an alluring but undemanding voice. He shrugged away and muttered something about it having been a long day. I lay on my back listening to the river. My mind and body were in confusion and I wanted something straightforward, like sex, to do. The shutter was open and the moonlight turned Robin's hair white and the sheet almost blue. I got out, lit a cigarette, and leaned on the sill, smoking. Something was going to have to change. If people really were going to babysit for me and take turns with the cooking and clean up this appalling house, I might have a chance.

I fell asleep at last with the muscular French farmworker saying some surprising things about vegetables, but that is what happens when fantasies turn into dreams, you lose control of the script. "Black eyes," I muttered into my deepening dreams.

"What?" said Robin. "What's the matter? Can we get some sleep?"

"I was asleep."

"You were talking."

"I was dreaming. About vegetables. Black-eyed peas."

"You woke me up."

"You woke me up first. I was dreaming."

I tried to find my way back into my dream, but it was gone.

The next day, the sun was out and heat was building up over the fields of maize. We sat over our coffee. Belinda slept, one arm thrown up above her head in her carry cot. The dust was thick in the air around her, but looked good dancing in the rays of sun. We were eating the remains of yesterday's bread with our coffee when we heard a sudden long hoot from the street and there was the boulangerie van delivering, and a little crowd of people buying bread. I felt relieved. In France, you are supposed to have fresh bread for breakfast.

Robin went out for croissants and a baguette and to practice his French. It annoyed him that I could speak French. With me out of earshot, he could go all Gallic and wave his hands about and shrug. He came in looking pleased with himself and we had a delightful breakfast, finishing up with a blue curl of Gauloise smoke around the two of us and that satisfying rasp in the back of the throat that caffeine and nicotine together bring. Things were just possibly going to be all right.

"It's a gorgeous day," he said. "Let's just go out and leave all this till later."

I never needed a second invitation to leave things till later, if "things" included cleaning up someone else's filthy house.

"When are your parents going to turn up?"

"Oh, they won't be here for days. They were going to potter down through France, taking their time."

Robin's parents had never been to France before and were scared of driving on the right, so his brother Laurie was going to drive them. They would have a chance to get used to France before they arrived here; or so we thought.

"Isn't it funny how one's appetite shrinks?" Robin said, after breakfast.

"Appetite for what?"

"I meant food. It was such a shame about that dinner in Normandy. I was thinking about all the things I couldn't eat, before I went to sleep last night."

Our first night after the channel crossing, we had picked a hotel in Normandy where the food would be good and greedily looked forward to our first French meal, after weeks of rice and no wine. We sat opposite each other with a starched white table cloth between us, starched white napkins on our knees, and enough heavy silver knives and forks stacked around us to let us know that several courses were involved. Belinda slept upstairs, and we were on our way. The first course was ham in cream sauce, with mushrooms. The second was steak. The third was a wonderful selection of cheeses. The fourth was fromage blanc with raspberries and more cream. Our stomachs, bored and shrunken with our ascetic diet, had not responded. Neither of us could go on after the ham and cream one and we sat looking sadly at each other, tasting things and waving them away. I wondered if other appetites, fed for long enough on a starvation diet, similarly faded away.

After the gastronomic humiliation we stuck to picnics and ice cream. We had crossed the whole of France without venturing into another restaurant. This was something we would never be able to admit to Tristan, or to Paul and Maria, when they arrived.

My parents-in-law emerged from their car in the pained silence of people who have suffered unmentionable hardships. Their younger son stretched his long legs in jeans and lit a cigarette. The afternoon was cloudy and warm, with a hint of thunder in the distance. Robin and I had drunk some wine at lunchtime and been to bed, and our baby was still sleeping. I was vague and happy as usual after sex. There was that foosty afternoon feeling around. It was a time when nobody should have arrived.

Robin embraced his parents rather carefully, and then I did too. He cuffed his younger brother in a desultory schoolboyish way and they gamboled around each other, and I stood there with the taste of my après-sex cigarette in my mouth, wondering what I had taken on. I remembered how thrilling it had been to make lists of everybody we wanted to invite, to imagine having open house and living generously in the sun. Now the sun was not even visible and by daylight the house still had a mean look about it where it squatted beneath the cliff. It wasn't what I had had in mind. I decided that there must be

something wrong with me, that I found it so hard to enjoy myself.
We showed Robin's parents the house and heard them enthuse in a
fatigued way that didn't sound very convincing. When they saw their
bedroom, they exclaimed gamely to each other about views and
atmosphere. We left them to unpack and complain to each other in
a quiet chant that they must have thought we couldn't hear.

"Poor things, sounds like they had a hell of a journey," said Robin.

"Why, what happened?"

"Oh, they got lost, and mum had a stomach upset, and it's their
first time here."

"There are perfectly good road maps of France. It isn't like going
through the Sahara."

I knew I was being nasty again. There was something about
Robin's family that made me turn nasty. The thing is, they were so
nice. They'd never complain loudly and angrily about things the way
my family do. They'd never find fault with me, or anyone. It baffled
me, this instant changing into a nasty person that happened to me
whenever they were around.

"Don't be nasty," said Robin. "It isn't as if they've been over here
all their lives, not like you."

The conversation seemed about to turn to my privileged child-
hood, in which my parents had driven me around France without
any apparent anxiety about where we might spend the night, and
how not everybody had the advantages that I did. So I said nothing.
At the time, I used to wonder if it really was an advantage to have a
father who thought that money was well spent on wine, food, and
petrol to get you around, but not on hotel rooms. I'd slept in some
pretty strange places in this country where I now had rented a whole
house. But I could see that Robin was feeling protective towards his
parents and their suffering, so I kept quiet. They stayed in their
doorless room for most of the afternoon and emerged around five
o'clock, only looking a little puffy about the eyes. I didn't mention
the road maps again, or even the helpful section at the back of the
Michelin book where the restaurants are marked with little knives
and forks, to show you where you will be able to avoid getting a
stomach upset.

When members of my own family started showing up, I thought

I would feel more at ease. It's funny how easy it is to forget, in their absence, just what irritates you about other people. When they weren't there, I loved them all. That was probably why I had wanted to rent this house and invite them. In my loneliness, I had forgotten what they were really like. I'd missed them, that was it. I'd missed family, belonging. I wanted them back, with all their lovable idiosyncrasies, easily peopling my life. When you have lived in a big family, a marriage with its two protagonists can seem like a small cast of performers.

Pete clambered out of one side of his old green Saab and looked around with his usual pitiless accuracy. He could always see exactly what was wrong with things, right away. Here, in force, was that irony I had missed.

Gina came out prettily from the other side of the car and came to hug me. I loved watching Gina do things. Even getting out of a filthy car on a sweaty afternoon, she looked like an unfolding butterfly. Her long blonde hair was swept back and held in one hand at the nape of her neck as she stretched and breathed beside me, coming out of her chrysalis.

"Fabulous to see you," she said. We gazed at each other, while my brother kept his scrutiny for our surroundings. Gina had—has still, I imagine—eyes the color of harebells, set wide in her face. I thought she was perfect. I think my brother Pete did too, only this caused him anxiety rather than pleasure. My admiration was detached. I was not implicated, except that, years later, in losing a sister-in-law, I also lost a close friend. When Gina arrived in places, you felt relieved, because somehow she made them seem all right. While Pete stared scornfully around him, ill at ease and critical, she immediately arrived. She spread her skirts, as it were, and alighted. Only now she was wearing threadbare Levis and a skimpy cotton top and her bare feet were dirty in the dust. She sat down on the steps and began rolling a cigarette, laying out her tobacco on one knee of her worn jeans. Old Holborn and Miss Dior. I recognized the mixture, and the way her hair fell in tawny chunks around her shoulders. Perhaps, now that she was here, everything would after all be all right.

There came the moment when we had to show people the bedrooms and hold our breath while they either reacted, or did not. I

could hear Robin breathing at my side and thought, he knows, he does know, there is something wrong with this.

Pete said, "Oh, so we're all going to be merrily screwing away in the same room, are we?" He bounced on the hard bed and giggled. Sure enough, every movement had its creak. "Well, this is keeping it all in the family, isn't it?"

Gina said, "It isn't exactly the same room."

"Acoustically speaking, it is. We're going to get to know each other awfully well."

Robin said, "We could rig up a partition quite easily."

"Bring your DIY kit, did you? No, it's okay, it won't matter, we'll all be too drunk to care. I've got a bottle of pastis in the car, shall I get it out?"

Gina said to me, "How's Belinda?"

"She's okay, she's asleep, she loves it here, it's all food and sleep to her so far."

Gina was the only person who asked after my daughter as if she were an equal human being. She was a jeweler by trade and she made Belinda tiny silver bracelets and pendants, dangling wispy and fragile as a fairy's, and sent them to her in used brown envelopes with the addresses of previous correspondents crossed out. My daughter had a little store of precious things waiting for her to be old enough to notice them. It was all Gina's doing, it was Gina giving her a future. Stuck as I was so often in the day-to-day, I found it hard to do this myself. The baby's bedtime, bathtime, teatime, and whether she had any clothes to wear was as far as I could get in thinking about her future. If it were left to me, it seemed as if she might not even have one. But Gina made sure of it with her stream of tiny, almost weightless presents, silver, gold, thin webs and chains.

"I'm longing to see her. Could we wake her up?"

Again, in a world in which most people were relieved if my child stayed out of sight, asleep, this was Gina's gift to me. Together we tiptoed into the stuffy room in which Belinda lay spread out on her back. In the gloom she was pale and rounded as a Rubens baby, all clefts and tucks and folds. Her dress was rucked up around her armpits and sweaty and wet around the neck, and the rest of her was bare. Her fat legs, her belly, her small reddened sex. I'd let her sleep without a nappy and her

pee had spread a wet fan beneath her, but at least it was not imprisoned against her sore and tender skin. Gina and I bent over her, our attention taken completely by her still sleeping form.

"She's gorgeous." Gina's whisper had a yearning hush to it, and I heard how she wanted babies. It was what I had felt like before this surprising one of mine was born. I too had leaned over cots with a catch in my throat as I whispered something that was only half of what I meant. Men were outside this, as ours were at this moment joking with each other and opening the bottle of pastis and settling down to drink. Gina raised her glance to me and I nodded to her. Something about my brother and her and babies, something that could not yet be said.

There was all this to it. You got together with people, you made plans, and you didn't quite know why. It was full of anxiety and disappointment. Sometimes you couldn't lay hands on the part that was hope. But there were moments when something happened between people that felt almost magical. As I tiptoed from the room with Gina, I remembered. I remembered why.

We made schedules, in the spirit of the age. Schedules for shopping, cooking, housecleaning, for who would have the beds and who would camp on the floor. There was a pot into which everybody was supposed to put the same number of francs each day. There was even a pot for cigarette money, for those who smoked. In planning everything to be completely fair, we thought, we would be able to avoid the things that went wrong between people. Our generation believed in paradise, and schedules; the two went together. All this was written out and pinned on the kitchen wall. There was no schedule about child-minding, I do remember this, in spite of what Robin had said. There was only one child, and she was mine. So she might as well have been my solitary vice, and because I hadn't read any books about feminism, I took to this interpretation as if I'd been the only smoker.

"I can't believe it," Belinda says when I tell her all this. We are by now in the Chinese restaurant on the corner of Fleming and Simonton.

"Well, nobody in those days thought looking after children was work."

"But didn't you ask anyone? What about Gran and Grandad? What about Dad?"

"I suppose I thought it wasn't work, too." I can't remember. There are photographs, in which Robin is carrying Belinda on his back, in which other people hold her, pose with her. But the memory is of responsibility, like tablets of stone. My daughter, my choice, my responsibility.

"There was Gina," I say. "Gina loved you."

"I wish you hadn't given me all the jewelry she made for me when I was too young to appreciate it. It all just got broken. I wish I had it now."

"It was all tiny. It was baby-sized. It was then or not at all, really."

And there was no question, ever, of my holding back anything from anyone, not in those days. Our hands open, our heads in the clouds, we had to give and give and give. Or I did. Or somebody did. It was the way it was, there couldn't be another way.

But we did have schedules, so that everything would be fair. Two people each day were to shop and do the cooking for the evening. It didn't matter how skilled or not these people were, so the meals varied disastrously. But by the time they appeared on the table, we had all drunk so much red wine that it didn't seem to matter. The house-cleaning sometimes amounted to not much more than a whisk with a broom. The money pot went empty or full according to the relative frugality or common sense or ignorance or greed of the two cooks of the day.

For a day, we were entirely taken up by the arrival of Tris.

The white Jaguar was at the door and there he was on the doorstep with his air of triumph and exhaustion. I seemed always to be watching people unfold themselves out of cars, these days. There were their faces, relieved, pained, or angry because they'd driven in circles looking for the place, expecting anyway to be rescued and revived. Their limbs, stick-insect-like and usually in blue denim, emerged from the cramped insides of their dusty cars.

"Marvelous," said Tris, grimacing. "Darlings, marvelous. What an incredible place. Sublime, in the true sense of the word. But how are you? You look wonderful, all tanned already."

I looked at the inside of the car, its seats piled high, and all the objects lashed to the roof.

"Leave it till later. Come in, have a wash, a drink, whatever."

"Who's here? Has it all begun?"

It sounded as if he were expecting a stage play. "Jim and Helen, Pete and Gina, so far. Oh, and Laurie, Robin's brother. My youngest brother's coming on his way to Bulgaria, with a friend, they might be here tomorrow."

"Imo, you look so, well, so French rustic already."

I was wearing a long stained apron to mid-calf and probably had flour on my face. It had turned out that I was first on the cooking rota, along with Pete. I'd never worked in a kitchen with my brother before, and so far it had meant Pete sitting perched on a stool with his pastis in his hand, telling me stories about people we knew and occasionally saying, "Can I do anything?"

"Well, Tris, it's certainly French rustic, you can say that again. I hope you don't want anything so grand as a bed?"

"Oh, no, I brought my own. Always do. It's in the car, it's inflatable. I can put it down anywhere. I've got my duvet, too. And my shower."

"Shower?"

"Portable, runs off the car battery, you can hang it from a tree and have a shower anywhere. Marvelous. I can't live without my luxuries, you know that."

I imagined him standing naked under a tree in the middle of the French countryside among hot water and fluffy towels, something like Saint Sebastian, only the opposite of tortured. He had a skinny body that I had never seen naked. Once, he had sat on the edge of a bathtub that had held Robin and me, one at each end, our legs tucked around each other, and handed us glasses of gin and tonic. I remembered his dreamy appraisal of our bodies through the steam and gin. Where had that been, and why? I couldn't remember. But it was another story, and all that remained from it was a sort of familiarity and ease.

"Well, you're going to need them here."

"Oh, good, I like being well-equipped for survival. Imo, I must tell you. I've had a quite amazing time. I think I've fallen in love."

"In love? On the way here?"

"Yes, I picked up a hitch-hiker, outside Orleans, he was going all the way to Toulouse, but I dropped him off in Villeneuve. There's still a chance that he may not go all the way to Toulouse. He's a Basque. Wonderful; black eyes, terribly intelligent. We talked about Georges Bataille. He was like somebody out of Pasolini."

"He?"

"Yes, what did you expect?"

"I don't know. So you've finally decided to be gay?"

"I always knew it was just a matter of crossing the channel."

"What happens when you have to cross back again?"

"I'll cross that bridge, or rather, ferry, when I come to it. Meanwhile I'm definitely in love. His name's Jean-Paul. It must have been Juan Pablo originally, I suppose. He has eyes like Picasso's when young, you know the earliest self-portrait? Wonderfully arrogant."

"Hmmm. Sounds great."

"Imo, you know, I think this is going to be the liberation of us all. This house, this time. It's just wonderful that you have set it all up. Mmmouah!" He kissed me. "It's going to be what the sixties is all about, don't you think? We're going to really do it."

"D'you think so?"

I'd lost track of what the sixties was supposed to be about, over the last couple of days. We'd discovered that the house was infested with fleas, we were all coming out in rows of red bites on our legs where the fleas had been for their walks, and my mother-in-law had not come out of what she called her room.

"Yes! We're going to discover what it's all about. We're going to push back the boundaries. We're going to put flesh on the bones of theory!"

He was cheering me up, anyway. I made tea with some Earl Grey he got out of his zipped bag's pocket and we sipped rather primly together in another cloud of steam. It was a relief to me after all the alcohol. His enthusiasm was a tonic. I knew why I'd done it again now, why I'd set this all in train, why I'd asked him to come. The Jaguar stood outside the door with its own doors white and spread like open wings, bulging with all the gadgets and luxuries Tris had brought with him. It said glamour, freedom, speed. Then Robin

appeared, clutching Belinda, whose behind was still reddish and naked, and asked me angrily if I hadn't heard her crying, and where was the cotton wool?

I put dinner on the table with a feeling that in spite of schedules and the spirit of the sixties, nothing very much had changed. Pete had told me a lot about the book he was writing about Kropotkin, which he thought might get him fired from the Polytechnic he worked in, and had broken off bits of baguette and dropped crumbs on the floor as he munched them. He'd refilled our glasses every now and then, saying that to be a good cook you had to be slightly drunk. So I swayed a bit, setting the large quiche lorraine I had made between two bowls of buttered potatoes. There was salad, cheese, fruit, and that was that. Pete sashayed out with a bottle of wine in each hand and set them on the table as if this were his contribution. We all sat down.

"Just a very little for me." My mother-in-law, Helen, spoke in a quiet suffering voice, so I placed a small slither on her plate. She wore a fawn cardigan pulled tightly around her on top of her summer dress, as if it were cold. "I must have eaten something on the way. Yes, I'll be fine. Just water, please. Don't worry about me, I'll be fine."

In those days, I was intolerant of people feeling ill, and scornful about most aspects of the life of people over forty. I am sorry, now. I am sorry, Helen, for having been so unsympathetic, for not having appreciated your coming to stay with a bunch of selfish young people, and for your feeling ill. Perhaps you were having the menopause. Perhaps it was just all too much. But I remember slamming your plate down with a sniff. This was not the era for sympathizing with people who were at all unlike yourself. The generation gap, this was called, as if it were inevitable. It was pretty brave of anyone to try and bridge it, particularly on their summer vacation, is what I think now.

Jim, my father-in-law, was asking Tris about his teaching methods, and Tris was being outrageous about lovely young men in his classes. We all more or less taught part time in adult education of one sort or another. It was the only paid job that allowed you time off to take long trips abroad and write books about anarchism. Tris was making it sound like a sort of harem for gay teachers.

"Really?" Jim was saying, "Really?"

"I thought I must take them all to see the movie, though of course we aren't really supposed to go off site during classes. Then they all came back to my place, so it all got a lot more relaxed. There was one, a young Scottish blond, frightfully bright, frightfully sensitive, and I thought, he's the one, I'm just going to have to rescue him from a life of drudgery. I mean, plumbing! They were all working away at their City and Guilds, and what could they do with that? Just be plumbers, with a smattering of culture. He was far too good for that. So after the movie, we had a frightfully good tea— "

Pete said, "Tris, I'd no idea you were so susceptible."

"He's always been it, he's just been too scared," I whispered back.

"I thought he was crazy about you—"

"Well, so did I, but I think it's sisterly. I think it's really Robin. Sssh. Look, take the plates, will you, you're supposed to be the other cook."

"Do I have to? Can't we take them all later?"

"No! What about Kropotkin and anarchist theory? Go on, don't be such a slug."

He went out, carrying a slipping stack of plates, and came back with a camembert held as if it were a discus, and another opened bottle of wine. He filled his glass.

"Tris, do you have an announcement to make to us? Is there something we ought to know? Should I propose a toast to your—"

"Liberation!" said Tristan immediately. "Yours, mine, Imo's, all of us. The summer of our liberation! For we are all about to come out of our shells. We are to be new-hatched, unrecognizable! *Santé!* My dear brothers, Pete, Robin. My dear sisters! Nothing will be as it was. Nothing will remain. The winds of liberation are sweeping across Europe and we are in their path. *Liberté, egalité, fraternité.* Tomorrow is the first day of the rest of your life. You know what they wrote on the walls at Nanterre? *Plutôt la vie! Plutôt la vie!*"

"Tris, you're drunk."

"Yes, I am! Drunk on new wine, drunk on the ideology of freedom, drunk on love, drunk on our liberation!"

Jim and Helen, one on each side of him, looked bemused and raised their glasses uncertainly. Robin and I exchanged a glance.

Pete said, "Haven't those three words been used before, with rather

more effect? Have you forgotten the rivers of blood, Tris? Have you forgotten the Terror?"

"Pete, my sweet. That's good—Pete my sweet. This is the new age of revolution. This time, we have not forgotten love. To love's freedom. To love's perfect face!"

"And ass, no doubt."

"Pete," said Gina, "don't be horrible. He's right. It's all that matters. And this is our chance, here, now, among ourselves."

She went and sat on Tristan's knee, curling there like a child and smiling at us all sweetly while Tris stroked the top of her head.

I thought, he's crazy, Pete's right, this is all absurd, the reality is Robin and me and our baby and ordinary life. But there was something I wanted, that was more than that. Something I missed so badly that it hurt. I didn't know what it was, but it was there, in what he was still saying. Like a nugget, I thought, in a sandstorm.

The dishes were always still there in the morning, stained plates heaped on the worn wood of the draining board, flies buzzing, wineglasses stained purple. I put on my apron and began pouring hot water into the deep cracked china sink. If I didn't do it, nobody else would, and I did not want flies around Belinda. She was sitting naked on the cool floor, among crumbs and dust. I thought she looked very pure sitting there, staring around her with an expression of curiosity. All over the world, babies were sitting like that, naked among flies and dust. She would be all right, it was just the way things were, I said to myself. But there was some unease beneath this. I thought of the fleas and the way Robin had tried to pretend to his mother that they didn't really exist. I worried, as I plunged my hands into the sink.

Helen came in. "Imogen, is nobody helping you? I think that's terrible. Give me a cloth, and I'll dry. Is this the only one there is? Well, I suppose it'll do. Oh, and look at poor little Belinda, should she be down there? She's naked, and she's getting filthy on that floor. Oh, Imo."

"She's cool on the floor. It's so hot. I'll wash her later."

"Oh, I'll take her for you. Have you got a clean cloth? Look at her little face, it's all filthy. Oh, Imo, do you think it's a good idea? Look, I'll clean her up and Jim and I will take her for a walk."

"Okay, do if you want."

I couldn't do anything. I couldn't pick her off the floor, I couldn't keep her clean, I couldn't scrub these sticky plates or get the wineglasses clean. I couldn't speak to Helen without resentment. I stood and trailed my hands in the hot water and kept my back straight and let Helen pick up my daughter, talking to her all the time, soothing her, apologizing to her for the state she was in, and take her away. It was better that way. I couldn't be a mother. I couldn't be anyone. I'd lost the person I was supposed to be and nobody would give her back to me. At ten o'clock in the morning on a hot July day, in this house in the Lot Valley in a beautiful part of France, I began at last to cry.

"But what is it?" Robin asked me urgently. "What is the matter?"

"It isn't the way we thought it was going to be."

"What isn't? The house, the place, what?"

"You always think it's the bloody place. No, the time."

"What d'you mean, the time?"

"This. Our lives. There's something going on and we aren't in it. It's happening out of sight. I want it to be here, I want to be able to do something. I'm getting to be able to do less and less. I can't even look after Belinda. I can't even wash the plates. Everything is just so dirty. Robin, what's happening? Do you know? Do you know why it's all so bad?"

"You've probably got a hangover. I know I have. That wine from up the road is pretty rough stuff. I think we should go to the Caves Co-operatives."

"Oh, you always make everything sound so simple."

"And was it?" asks Belinda, opening her fortune cookie.

"Was it what? Oh, just a hangover, you mean. Well, we were all drinking far too much, that was for sure. People started opening bottles halfway through the morning. Yes, looking back, I think that was the main trouble. Plus a kind of addiction to unhappiness, it seems to me now."

She says, "It does all sound kind of desperate. Kind of bitter. Not really fun. But it seems to me that you didn't really have anything to complain about. Did you? I mean, compared with people now."

"I know, it must seem like that."

"What happened, anyway? What did you do?"

"Ran away, in the end."

"What, from me?"

"It wasn't really you, darling. None of it was your fault. I was running away from me."

"But you came back again."

"Yes, I came back again. And a lot of things happened in between."

The place did have its own sublime beauty. The river drew me to it, where it came through the dam and the hydroelectric plant just upstream from the village and hurtled down, brown, thick, and carrying sticks and whole branches down to join the Garonne and swirl to the sea. The river always seemed too fast for the pace of life in a village. It was like living beside a highway, with its noise and constant movement. But there was something about all that swirling water going somewhere that was a relief. It wasn't stuck, at least. It was constant change.

The village itself contained few people under the age of eighty. It crouched in the shadow of that huge reddish cliff on the other side of the river, which so often shut out the sun. The cliff had bits of foliage sprouting from it horizontally, reminding me of nineteenth-century drawings of landscape. The whole thing alarmed and impressed me just the way nineteenth-century romantics thought it should. It did nothing to sooth my mid-twentieth century soul.

The woman in the shop, who wore black and whose vegetables were as wrinkled as she was, told me again that *Madame Veet* seldom came. We began to blame Madame Veet for everything we didn't like about her house.

*"D'où elle vient, Madame Veet?"*

*"C'est une anglaise.* English."

*"Oui, mais...* where does she live? She does not come here?"

Madame Peyrevet shrugged, not caring. What strange English women did was none of her business. That was before English people became absentee landlords in so many small French villages, and I was intrigued about what brought Madame Veet to this one. This village had the look of a cul-de-sac, in spite of the uncaring river

roaring through it. I thought, one would only come here to hide, or die. But Madame Veet had written a letter to us from Tonbridge, Kent, and she had cashed my check, so she must be alive and well somewhere. I wondered if others had rented her house sight unseen, and what had happened to them.

At the back of the house, huge fields of tobacco and maize stretched to the sky. I liked watching the wind pass through these fields, making paths in the whiskery crops like partings in hair. When the wind blew, there was movement, less threatening than the movement of the river. It was like watching the breath of life. There was a narrow path that ran along the edge of these two fields, that led to the nearest farm. We took to walking there to buy our vegetables, partly to avoid Madame Peyrevet's wrinkled beets and carrots, partly because it was an expedition with some point to it. The people at the farm were a squat, friendly couple who could have been brother and sister, apart from their wedding rings on broad brown fingers, and they had a son who was surprisingly good-looking and could almost have stood in for my fantasy of the French laborer who would have me among the corn. He was often to be seen shirtless and sweating, heaving a wheelbarrow, driving a tractor, or unloading bales of tobacco leaf.

Robin and I walked there, he carrying Belinda, who bobbed on his back wearing her sunbonnet so that she looked like a tobacco flower herself. The evenings were hot and still and for weeks they all seemed to be the same. On this particular one, we had decided to buy corn and cook it for dinner. When we added ears of corn to our basket of *courgettes*, tomatoes, and onions, the farmer's wife asked if we were intending to feed animals with it.

"*C'est pour les bêtes, ça.*"

"*Non, c'est pour le diner.*"

"For animals. Not for men."

"For men too. With butter."

"*Ça, alors.* You eat that?"

"The Americans eat it. *Beacoup.*"

"*Ah, les américains… C'est pas bon.*"

Robin said, "What's she saying, that we can't eat it?"

"She says it's only for animals. I told her, Americans eat it all the time. Corn on the cob. She says it's not good for humans."

"Well, let's take it anyway. She's probably never heard of corn on the cob. It's incredibly cheap. If we can live off that, we'll spend hardly anything."

We took a basket load of whiskered cobs to boil and eat with butter. The woman watched us with distaste. *"Eh bien, si vous voulez...."*

"Maybe we could take some tobacco and roll our own, too."

Jean-Pierre, the son, came into the yard on his tractor and jumped down from its high seat. He strolled over. There was corn-dust on his shoulders, on his singlet, and in his black hair. I couldn't help staring at him, but also couldn't help noticing that he looked stupid, his eyes close-set and empty of anything very interesting. Ah, well. I edged closer to Robin and said that perhaps we should go.

*"Au 'voir, M'sieur-dame. A la prochaine."*

We stumped off with our heavy baskets toward the setting sun. At moments like this, I could feel fulfilled. It was enough to be carrying a lot of fresh vegetables that we had bought for very little, and to be walking home at the end of a hot day behind my husband and child. It felt right. I thought that both Elizabeth David and Prince Kropotkin would approve of me, and they were two bright if unlikely stars in my firmament at this time. I didn't need a love affair; I didn't need anything. Just to be walking home at evening across the fields of France, with a load of wonderful fresh vegetables, to cook in a French kitchen and share with all my friends. I hadn't yet read Germaine Greer or I would have known not to trust this feeling of bovine simplicity, but never mind, it probably had its place.

"Robin?"

"Mmmm. What?"

"Rob, come here."

"Sssh, the others'll hear us."

"I've just been hearing them for the last ten minutes."

"These damn beds."

The one across the gap from us creaked and there was a muffled giggle.

"This is ridiculous."

"What are we going to do? I know, we could do it outside."

"For God's sake, Imo, can't we just get some sleep?"

"I can't bloody well sleep. Look, if they can do it, so can we."

"Well, I can't. Not in front of your whole bloody family."

"It isn't my whole family, it's only Pete and Gina."

"Well, that's just as bad."

"We could go outside. In the moonlight."

"I don't want to go outside."

"Just because you have a hang-up about making love out of doors."

"I don't have a hang-up. It's you who has hang-ups, not me."

"I do not."

"Anyway, it's all prickly, always, and people can see you."

"Not this time of night. Think of the moonlight."

Pete's voice came across. "Are you two going to shut up talking? We're trying to get some sleep."

The giggles and whispers came to us as if magnified by darkness. We were silent for a moment, each of us hardly breathing. Then Robin said, "The corn was awful. She was right, it was *pour les bêtes*. I've a stomachache. And I'm never going to share a room with your bloody brother again."

"Cozy, isn't it?" said Pete. Then there was silence, in which I could hear us all trying not to breathe. The moonlight made its way through the shutter and lay across our bed in its obstinate bars of white. Robin's hair was white in its beam. He turned away from me and pretended to be asleep. I knew I had no hope of either approaching him or sleep. What were you supposed to do with the bloody moonlight? Ignore it?

I got carefully out of my side of the bed and walked to the stairs, uncurling my feet slowly so as not to make any noise. Tiptoeing doesn't do it, you have to walk like a big cat to be really quiet. I went down the stairwell that divided Pete and Gina's part from ours and stepped into a checkered room. The floor was already squared in black and white, but now the walls were too and the whole of the downstairs seemed full of light mist or fog. I found a pack of cigarettes and a lighter on the table, stepped past the sleeping bodies, Tris on his blown-up mattress, a village cat curled in a tight brioche shape at his feet. I went out into the night. It was the only time I saw the whole place transfigured, not by wine or fantasy, but by light. The

moon was up and full above the cliff and it shone directly down on me. I stepped into its immediate path. There was the churning sound of the river. A slight breeze lifted my nightdress. There was the whole landscape, drawn in black and white. I sat down on the cold step in the moon's eye and smoked my cigarette. A large toad came and sat beside me, then another. I was communing with toads. I was crazy, a witch caught at last by the full moon. Sometimes the full moon made people howl and commit unspeakable crimes. Then they went back to normal, and nobody guessed. Behind me the house I had chosen and rented loomed like some enormous mistake. Yet it was full of my sleeping friends and relatives. It contained my husband and my baby. How could I just walk away? I knew, all the same, that I could, and one day, would. Not yet, I said to the moon, but one day. One day soon.

"So, what did they say to Lot when his wife was turned into a pillar of salt?"

"That's your lot."

"And what did he say?"

"Hey, thanks a lot."

"And what was the animal Pizarro found in his soup?"

"I don't know."

"An axolotl."

"Don't you mean Cortez? Anyway, I don't think axolotl counts."

"Yeah, it does. I make that nineteen."

Tris and Pete were down by the river, spinning pebbles into the water.

"What are you talking about?"

"Counting Lot jokes. We've got to twenty. We reckon we can do fifty before we leave."

I sat down beside them in my swimsuit, Belinda linked to me by her reins. She tugged away from me towards the river, and I held her like a small restive pony.

"Will fifty be your lot?"

"Sorry, Imo, we've had that already. Just wait. By the time we get to forty-nine, all will have been revealed. Meanwhile we have a whole lot of Lotting to get through."

Pete said, "We've got a job lot, and empty lot, a parking lot, we have lotteries and—"

Gina joined us with her sleek black swimsuit, her hair tied up in a knot.

"Do you love me a whole lot?" asked Pete.

"Yes, I do."

"Well, swim the river Lot with me, then?"

"Okay."

"You're crazy," Tris said. "You'll never make it. You'll just get carried away."

"The river's low today, look, after all this dry weather. I bet I could get across."

At the center of the river between us and the cliff on the other side, there was a strip of pebbly beach, a tiny eye-shaped island around which the river divided. Whippy small bushes grew on it, their thin branches streaming green weed. We could all see how the water moved past it in sinewy ropes. But the river was lower than usual. It didn't have its most violent brown look today. Pete stood up.

"I dare you."

Tris said, "I wouldn't go near it if you paid me a million francs."

"New or old?"

"Either."

"I'll come," Gina said. She stood beside him on strong brown legs and began retying her knot of hair, tucking it up higher.

"Imo?"

Tris said, "For God's sake, all of you. Don't be idiotic."

Pete said, "It's worth ten points in the Lot joke race."

"It's dangerous, Pete. Don't do it."

But Pete was hopping into the water, stumbling over the stones. Gina followed, one foot after the other, wading in, wincing. "Ouch! Hey, it's cold!"

I handed Belinda's reins to Tristan and said. "Take her back to the house for me, Tris? And don't tell anybody. We'll see you soon."

"Open a bottle for us!" yelled Pete.

"You're going to make this child an orphan. Imo, how can you do this?"

"No, no, don't worry, I'll be back!" I wasn't sure if he heard me.

The voice of the river removed any communication, once you were in it.

The water was surprisingly cold. I stood in it up to my thighs and watched it snake past my legs. Gina was in it up to her waist, her arms raised as if to balance herself on a tightrope. Pete was already just a dark head bobbing. He yelled back, "Come on! It's okay!" Or that might have been what he yelled. I looked back for a last time to the shore and saw the tiny figure of Tristan in his white shirt and shorts carrying Belinda tucked up against him as he scrambled back up the path. Would he tell on us? Would he be going for help? Behind me, the arch of the hydroelectric plant was like a gateway, through which nothing was held back. The current tugged at my legs. I turned to follow the others, feeling sick, felt the cold water rise around me and a pressure like giant muscles push and pull me. Pete was already past the island and a little way downstream, swimming strongly against the current. I saw Gina carried swiftly downstream for a minute and panicked. If we were carried too far down, there was no way we could land on the opposite beach. Further down, there was just the cliff, with no shore at all. But she turned and righted herself and began swimming back upstream like someone on an exercise machine. The one great movement was the river itself. It was too much for us, we wouldn't make it, we would die. This day, this morning, was the one when we were going to die. I screamed, but seemed to make no noise. Then I saw Pete pull up dripping from the water on the far side, his body very small and pale against the redness of the cliff. Then he went back in and pulled out Gina. She went stumbling up the far beach, leaning against him. It was possible, then. I kept swimming, past the little island, keeping a lump of foliage lined up against a high cloud in the sky. Then I felt something bump into one of my feet. A rock, a stone. And the beach shelved, suddenly shallow, and I was falling, lying on it, unable to stand.

"Imo? Are you okay?"

"Mm-hm. Hm." I couldn't speak, I was shaking so much. We sat, the three of us, with water streaming off us, and shivered noisily in the warming sun. The strange red cliff was behind us like a shield now; we had crossed over and were on the unreachable shore of the other side, looking back to where we had come from. The shrunken

village, the bending hazels and willows on the other shore, the patch of pebbly beach where we had sat with Tris. There was no one over there, no search party, no angry people. For a moment it felt like not existing.

"God," said Gina, "we made it."

"I thought we weren't going to. It's so strong, midstream."

"There's going back, too."

"Maybe we're here for ever."

"Would anyone miss us?"

"Belinda would."

"Would the world, though?" asked Pete. "Three brilliant young people, cut down in their prime. Or before their prime. I don't think mine's started yet."

"Belinda is the world. She's the future." I wanted to cry, even now, for having done this to her, or nearly done it. She might still have a mother who drowned in her twenties. I thought how angry Robin would be with me for doing this. He hated anything that smelled of danger, hating exploits and dares and the things my brothers liked doing, and hated this tendency in me. He had been brought up to believe that everything was dangerous and to be avoided. I had been told, yes, everything is dangerous, but danger is exciting. It was a very big difference.

I looked across at Gina. She was clear-eyed and smiling, though her shoulders still shook with cold or fright. She smoothed back her wet hair, raw honey, to dry in the sun.

"Wish I had a cigarette," she said.

There was a recklessness in her, too. But it was not self-destructive. It was simply her way of being in the world—airy, light-hearted, unperturbed. If there was a river to swim, she would swim it. And Pete, well, Pete just always had to be pitting himself against things. My father was like that, too. For them, the universe was just there for that, to issue challenges. For me, there had been a temptation in the tug of that water. The desire to give in. Just for a moment, it had seemed like a solution. Then I had swum as hard as I could, to avoid thinking that. I must have made a decision then, to live. Until that morning, I wasn't aware that there had ever been anything else.

From the far bank, I looked back at my life—house, husband,

child, friends, car, kitchen, all of it, the life that I had been busy making up till then. It was a little like having died.

"Looks weird from over here, doesn't it?" Pete said.

"I wonder if anybody's ever been over here to look at it before."

"I expect some cave man did. Probably one of those people who did paintings on the wall at Les Eyzies."

"An artist."

"Well, you have to have that curiosity, don't you? To see what things are like from the other side. Or you'd never bother drawing anything on a cave wall."

"We still have to get back." I couldn't image it, now. I couldn't go back into that water.

"Easy," Pete said. "Now we've done it this way, we know how to get back. Just keep swimming upstream, and we'll be deposited on that little beach. Look at the patterns of the water. All we have to do is keep swimming, to stay in the same place. Forget moving, just concentrate on not being moved."

He waded off to test the water, find the best place to go in. Gina and I followed. I saw her glance back to me, just a glimpse of her terror as she went back in again. I thought, yes, he would be a hard mate, my brother.

"Line up that beach with the pylon. Don't get off course. And keep clear of the island; look, that's where the current runs fastest."

But he was right. If you kept on thinking and noticing, there was a way through. The water was like ropes and chains on tired limbs. Going back was harder, because of the fatigue. The river tugged at us, to pull us under and away. The branches that whirled past were easily carried away downstream, tumbling over and over like twigs. The roaring noise of it, all around, inside, outside, was all there was. I fought against water as if fighting my way through a crowd. It was solid, it hauled and went tight and would not give. A desperate scared cry rose in me; it wasn't a question of giving in now, of choosing or relenting, but of being taken, of having no choice. But then I saw Pete land, and immediately the water picked me up and hurled me onto the beach at his feet, and there was Gina too, beside me. We were like newly delivered twins, beached, gasping and sobbing, water running from our eyes and mouths.

Pete reached across the stones to his little pile of shirt, shoes, cigarettes. We sat in a row and smoked and shivered, not speaking. We'd done it, whatever it was. We'd come through.

There was, in the philosophy of existentialism, the notion of the *"acte gratuit,"* an action which might in itself be meaningless but which defined the life of the person who did it in a certain way. The belief was that you had to perform these acts from time to time in order to be really alive. Or at least, that was how we interpreted it. Our heroes were people like Camus', Sartre's, and Dostoevsky's, desperate men on the edges of society, not middle-class people with comfortable backgrounds. Sometimes I thought, there aren't any women existentialists, not real ones. I was reading Simone de Beauvoir that summer, but all she seemed to do was fly the Atlantic to have a love affair with someone who wasn't Sartre, as if she needed some time off. When I ran away, later, it was with Simone's memoirs, a bottle of perfume, and a large pocket knife. I hoped she would inspire me, and the other two objects would be useful to seduce and protect.

Belinda says, "I don't see the point of doing dangerous things if they are pointless too. I mean, isn't there enough real danger, in real life?"

"It was the *acte gratuit* idea, I think."

"But what does that mean? It's just a game. It's not connected with reality. Anyone can see that. It's infantile, if you ask me."

"Well, I think swimming the river that day sort of proved to us that we were alive."

As I say it, it sounds insane. And my daughter, whose great quality is common sense, looks at me and sighs over the jasmine tea.

"But you were alive anyway. I don't get it. It just seems crazy to me."

"Well, it was just one of those things you do when you're young, I suppose," I tell Belinda, who is twenty-five.

"But what about me? I might have been an orphan. Ben might not even have got born. And what about Dad? He didn't even know you were doing it, did he? He would have been furious."

Robin's daughter, looking so like him, voicing his own sentiments in just his tone of voice.

"You don't think that there's a point in—renewing your decision to live—from time to time?"

"No, I think that's all sixties rubbish. I think you need your heads examined. There's enough real danger and horror and everything in life, without making it up. It seems like you were sort of flirting with it, death, sex, danger. And we're the ones who have to have it for real."

I can see what she means.

I never told Robin what we'd done, and neither did Gina, Tris, or Pete. We came back quietly into the house we had left. Helen and Tris had laid the table. A bottle was open on it. The food was laid out for a late lunch. Nobody asked where we had been, and we told nobody. It was between us, its significance or not to be decided on among ourselves. I sat down at the table. For a while, everything seemed vivid, real, enough.

When my oldest friend and her lover turned up, I was back in my Elizabeth David persona, enthusiastically cleaning and cooking vegetables. It seemed to be the best way to feel happy, raving on the way she does about some wonderful sauce. I notice I said "lover" here, while other people simply had boyfriends or "mates" and men were said to have "ladies." It's because they had this adult-passion look about them, as if they had a secret the rest of us were too callow to share.

"Imo," said Maria, "where are you? I have come to get you out of the kitchen. Why are you stuck in here scraping carrots? This is France, Imo, there are restaurants."

"I know, I just felt like doing this. It's okay. Anyway, it's meant to be my turn to cook."

"Your turn?"

"We're taking it in turns. We have a rota."

"We had a wonderful lunch on the way here. Wild mushrooms, duck in champagne sauce, wonderful little *pommes rissolées*. It was in a very ordinary looking place, the Hotel de la Gare, believe it or not, in Villeneuve-sur-Lot. We must take you there. Where have you tried so far?"

"We haven't actually eaten out yet."

"I don't believe it. You're in southwestern France, right? And you

haven't actually eaten out. What have you been doing? Scraping car-
rots and changing nappies? Well, it's a good thing I've come. Take off
that apron at once. Go and put on something decent, we're going
out."

"But you've only just come. Don't you want to—?"

"You can show us all the ghastly details later. I'm sure it can all
wait. Come and try our new car. We'll take you for a drive. We'll find
somewhere lovely to have a drink. Professor, look, here's Imo stuck in
the kitchen again. She's going to get dressed up and we're going to
take her for a drink."

Paul swooped across the kitchen gloom in one stride to embrace
me. I wiped my hands on my apron.

"Tell me," he said, "is Gina pregnant?"

"No, I don't think so. Why?"

"She looks ravishing."

Maria said, "She always does. Haven't you noticed? Come on,
Imo, get going, you can't go out looking like that."

"Why does she have to change? She looks all right."

"Because it's good for her morale. She looks like a skivvy. She looks
all downtrodden, can't you see?"

Paul studied me. Then he said, "Yes, I see what you mean. Where's
the gorgeous Imo we used to know?"

I fled off to change into a purple and pink mini-dress with a frill
round the neck. It was one that I had worn when pregnant with
Belinda, but I still liked. Had I really gone downhill so fast? It seemed
that people could turn me into what they wanted, at a word. We got
into their glamorous car and went off to the next village for our
drink. I saw in their eyes then that there was something wrong with
this enterprise, it wasn't just me.

When we got back from our drink, the dinner game was in full
flood. The cooks for the evening turned out to be Jim, Robin's father,
and my youngest brother's school friend, who was called Hazel. His
name was not really Hazel at all, but he had the nickname, presum-
ably for looking rather pretty and feminine. The two cooks were in
the kitchen, and everybody else was quickly getting drunk on empty
stomachs.

"What are they cooking? Do you know?"

"Fondue. That's what they said."

"Fondue? But do they know how?"

"No idea. It's up to them, anyway."

The rule was that nobody interfered with the cooks, either to help or hinder. They were in it alone, and we ate whatever they produced. But now it was eight o'clock and nothing had appeared. My youngest brother, Alex, told me that they had lived on cornflakes ever since Calais, because it was cheap. They had an immense store of cornflakes in their van, to eat in Bulgaria. Hazel's mother had thought it was a good idea. They had arrived this evening, just after Maria and Paul and I had gone out.

"Alex, does he know how to cook, your friend?"

"I don't think so. His mum does it."

"What about Jim?"

"Dad can't boil an egg, as far as I know," said Robin.

In the kitchen there was a warble of song, the falsetto version of a naval ditty that Jim obviously associated with manual work. Then a crash, and a moan.

"D'you think we could help?" Helen asked, pleating up her skirt with her fingers.

"No, we're not supposed to help. It's their go," Pete said.

Tris said, "Otherwise, how will the poor things ever learn? Look, if it's inedible, we go to a restaurant, right?"

"Restaurant, where? This is the sticks, remember."

Maria raised her eyebrows at Paul in mock despair. I could already see her reading the menu in her head.

Then Hazel stuck his blond head round the door. "Not much longer now."

Jim looked out, just above him, around the door, so they looked like a comedy act. "We just need one more bottle of white wine.

"Whatever for?"

"The fondue. It needs a bit of lubrication."

Pete and Tris snorted together and doubled themselves up with laughter. The wine bottle slid down the table.

Helen called out, "Darling, are you sure you're all right?"

"Never better," said Jim, and went back to the kitchen whistling.

There was the pop of a cork and a glugging sound. Then somebody swore. A minute later, Jim was back, flourishing a napkin like a demented waiter. "*À table!* Tea's up, or whatever you say in French."

We all huddled around the table. Only Helen looked serious. I think she was seriously worried about the meal she was being offered for the first time in thirty years of married life. And Alex, cornflake-fed for the last three days, was enjoying himself too much at seventeen to worry about anything.

The thing that was set in front of us was a vast ball of chewing gum lying in a yellow lake of tepid wine with all the alcohol burned off. Jim leaned over it and sniffed.

"Hmmm, I think it's done."

"Done? It's solid, it's implacable! It's been done to death!" Pete gave a hoot of laughter. Jim stuck a carving fork into the rubber ball so that it shot across the bowl and splashed hot liquid that looked like urine.

"It knows it's under attack," said Tristan. "Poor thing, it's afraid to die."

"Sharp knife, someone," Jim muttered.

"Darling, you're supposed to dip bread into it, aren't you?" Helen leaned forward to be helpful, but at the ready.

"Dip bread into it? We're going to need a depth charge to shift it at all." Pete rocked with laughter.

Robin said, "Dad, is that a week's cheese ration in there?"

"Well, yes, probably, but there's no sense in going hungry, is there? There are a lot of mouths to feed. Can I give you a slice?"

"You can have a go. Didn't you know you aren't supposed to cut up fondue with a carving knife?"

Jim looked around him. Hurt, he sat down in his chair. "That's it, they don't appreciate us, do they, what's your name, Harriet."

"Hazel," said Hazel. "I don't know, Mr. Denton, I think it looks rather good."

Tris murmured, "Fondue, that comes from *fondre*, to melt, doesn't it? as in melting in someone's arms?"

We chewed at stringy pieces of the stuff and pulled it about like elastic and spun it from our mouths like chewing gum. Jim said nothing for the entire meal. We all giggled and drank a lot and behaved

like six-year-olds. Helen said from time to time, "Really, it's rather good. Darling, it does have quite a good flavor." Halfway through the meal, Jim got up and left the room.

Helen said to us, "Really, you could have shown a little more appreciation, I do think, after all he's done."

We lounged and tipped our chairs back and lit cigarettes. We were abominable, that night. Maria and Paul, who hadn't eaten anything except pieces of bread, got up to go too. "Excuse us. We're going to get some dinner."

Hazel said, "Didn't you like our boiled chewing gum?" He and Alex were having a ball. We were all of us nearly at the food-throwing stage, which in monkeys is said to be close to social breakdown and in small kids is the one thing parents can't stand. Pete rolled a small ball of fondue between his forefinger and thumb and shot it across the table at Tris. A wine bottle at his elbow tipped, so that red wine flooded and dripped everywhere. We had done it, we had reached the stage of barbarity. I can't remember much about the rest of the evening, except standing for a moment at the door, looking out, seeing the river snake by in the treacherous moonlight, hearing the toads again, and feeling sick. Belinda cried at one point, and I went to find her, feeling my way up the stairs. I stood at her cot and looked down on her. She writhed and cried, but when I picked her up and plugged her mouth with the bottle, she stopped at once and began glugging it down with the same persistence as all the rest of us, her eyes round, her fingers moving in a kneading motion like a cat's. "Sorry, baby," I said to her then. "It doesn't get much better, or much different. Sorry, but I'd better tell you now." And she drank, drawing the nipple in with her lips so that I had to pull it back and squeeze it to expel the air. Bottles, nipples, liquids, immediate satisfaction, that was what life seemed to be about, in general. When I laid her back down again, she went straight back to sleep, and for a moment, so did I.

I woke with the knowledge that this was the day to leave. There was that sudden energy that makes sleep impossible, no matter how tired you may be underneath. I slid out of bed, dressed in the clothes I'd been wearing the day before, and stood for a minute looking at Robin asleep. I had no idea how you justified this, just knew that it was

essential. I couldn't tell anymore whether I loved him, or anybody. Belinda in her cot was a different matter, but it was still hard to tell if it was love or guilt that tugged at me. Babies, my mother used to tell me often, are hostages to fortune. I never knew what she meant by this exactly, but the phrase came into my mind as I watched her sleeping, the morning I left. She'd wake, cry, look for me but accept Robin quite happily, and the bottle he would stick in her mouth, and the breakfast of baby cereal and warm milk, and mashed banana, and everything else that happened during her day. It had to be true. I wasn't essential, to her or anybody. They would all carry on exactly as if I were still here. If I couldn't make one jot of difference with my presence, then my absence could not count for much either.

I left a note for Robin downstairs, saying that I had gone away for a few days and would call him. I found the car keys in his jeans pocket on the floor. I took a swig of cold coffee from the pot left over from the day before and collected up all the money from the kitty, as well as my own small supply of travelers' checks. I reckoned they all owed me something in the way of rent.

In the black and white main room, there were Tris in his grand new sleeping bag, Paul and Maria tightly entwined with each other on their futon in one corner, and Hazel lying on his back in the middle of the floor, snoring. Alex must have been sleeping in the van. I crept between them all and opened the heavy front door with a loud creak that didn't wake them. Outside it was gray still, with that expectant feeling that happens just before dawn. I love seeing the dawn. It's like having a promise made every day that you can start all over again, only mostly we are too lazy to get up and witness that promise, so that we forget. Outside in the street, a local cat was asleep on the front of our car and all the cars had a sheen on them from the dew. There was Chris' Jaguar, Paul's Citroen DS, Alex's old van, my parents-in-law's Rover. We had made quite a difference to the parking arrangements in this village. Our old Citroen Light 15 was down the street. I picked the sleeping cat up carefully and set her down to yawn and stretch, like a person with a hangover, and walk stiff-legged away. Across the fields, a cock crowed, over and over. I opened the unlocked car door, slung my small bag across the seat and fitted the worn key in the ignition. Robin and I loved this car. For him to wake and find it gone would be almost as

bad for him as waking to find I had removed Belinda. I turned the key. The petrol gauge showed almost empty. I prayed that the battery wouldn't be flat, as we hadn't driven anywhere since we arrived. I pulled the choke right out, pumped the accelerator a couple of times and prayed for success. The engine turned over, once, twice, without firing. A third time and it coughed and then went out. I put the choke in. The cocks called again, across the fields, to wake everybody up and send them out to stop me with cajoling and promises, so that I would not go. I tried again. Cough, cough. I pressed down the accelerator, gentle-footed as a thief. Just enough, no more, and the choke out just a tiny bit, and maybe this time—cough, purr. The sound of an old engine in action, gallant, brave, I said, oh, you beauty, as if to a horse, come on, come on, let's go. A little less choke. A little more accelerator. Still the sky was lightening, minute by minute. In a minute Belinda would wake and cry, and I would be lost. Damn. Damn car. Oh no, please, you beauty, dear car, please go for me, just this time, just this time, please God. There. The roar, far too loud, of an accepting engine. This one had been doing its best since 1954, when it was made. I pushed the choke right in, balanced accelerator and clutch, put her in first and urged her on. In a minute we'd be out of here. We, my electric-blue front-wheel drive leather-seated temperamental first-ever car, which had miraculously brought us all the way here without so much as a flat tire, and I. We'd bought this car for a hundred and twenty pounds. She was the most precious thing we had.

I turned the wheel and backed onto the road. Behind me the sun was rising, a red stain out of the mist over the fields. When that mist cleared, it would be hot. I'd forgotten to put water in the car or in a bottle for myself. Still, there'd be garages. Just get her a little way down the road.

I was out of the village, driving back towards the main road, the Nationale on which we had come. On both sides of me, the fields were golden in the new light. The river gleamed and churned, but I could no longer hear its noise. The sky above the fields was very pure and open and wide. I rolled down the window and opened my lungs and heart to the morning. Don't look back, don't look back, don't hesitate. Just keep going. Just don't regret one single move. Drive. Drive for your life.

I had no clear plan about where I was headed, but had vaguely thought of going west, towards the coast. There was a road map of the whole of France in the glove pocket and I could plot my course once I'd got far enough away. I'd stop to fill up and have coffee in a little café in an unknown place and smoke a cigarette in the new sun, all by myself. Suddenly, I felt happy. It was easy. It was this easy to be happy, after all. It just meant being by yourself and doing the next simple thing that you wanted. It was a matter of just doing them, the one simple thing after another, with no explanations, no checking with anybody else, no fuss. Nothing to carry with you, no expectations, no baby, none of the heavy, heavy baggage of a shared life. If only I could have told the shrink this, back in the midlands, back before this whole expedition began. If you were miserable, the thing was not to surround yourself with other people, it was to be alone. Free, alone, with just a car and the open road and a beautiful morning starting up, and a café somewhere where it would be easy just to sit in the sun and drink coffee and not say anything, or be anything, or mean anything particular to anyone at all. I could send the shrink a postcard, I thought. I have discovered the secret of life.

In Villeneuve-sur-Lot, where the little road joined the main one, I stopped at the garage and said to the young man in blue overalls, "*Le plein, s'il vous plaît.*"

"Ah, these cars, they drink it up, *n'est-ce pas*. But she's a good one. They don't make them like this anymore." He slapped my car as if it were a horse, and inserted the nozzle.

"Oh, and put in some upper cylinder lubricant too, please."

"*Bien sûr, madame.* Yes, these *tractions*, they go on forever. Pity that they stopped making them. You remember them in the old movies? Maigret, you remember?"

I was used to having my car admired. All over France, mechanics came out to fuss and pat and talk to it, nostalgic for some past time of French greatness, perhaps, some old time that would never be again. I thought of the movies. *Quai des Brumes, La Ronde.* My car was a movie star, a Marlene Dietrich of a car, or perhaps more of an Arletty, being essentially French. Only now I realized for the first time how easy I would be to trace, if anybody wanted to find me, driving

an electric blue *traction avant* with English plates. I could just imagine Robin, in a panic about his car if not about me, phoning the police, having me tracked down. I could imagine being driven back in disgrace. I had to get out of the region, and fast.

I looked at the worn, fingered smooth map on the garage wall and decided on Bordeaux. It was pretty much due west, and the wide stretch of the Atlantic beaches looked good. Also, I'd never been there before on any of those family trips round France, when I had sat in the back of my father's latest fast car watching my nails grow and waiting to escape. I remembered the boredom of those hours on the road, the long endlessly straight roads of Napoleonic France, with their plane trees peeling like old walls in the sun and their stands of Lombardy poplars flashing by. The back of my father's head, his neck red and creased with sunburn, a beret perched on his bald patch. My mother with a scarf tied gypsy-fashion behind her head, the open map upon her knees, my brothers and I all scrunched in the back, the boys squabbling and I pretending to be aloof. Just waiting to get into the driver's seat. The Triumph, the Alvis, the Jaguar. My father in the driver's seat, cursing like a Frenchman, showing off. My mother calm, placating, map-reading, only driving when he wanted to take a nap. What would my father say now, if he could see me setting off alone at the wheel of my car, across his beloved France? Good for you, Imogen, independence at last? Or, go back to the passenger seat, you're a woman, aren't you, only here to support men? I didn't know. But what I did know now was that I loved the driver's seat, loved knowing how to put upper cylinder lubricant into my car, and how to lean into the engine chatting with the mechanic in French and pointing out that the oil was a bit low, maybe we should have another half-litre after all. This was what I had learned as a small girl in the back seat, as a growing teenage girl in the back seat, and as a wife in the passenger seat. Get into the driver's seat, woman, and stay there.

"Mademoiselle?" The mechanic was talking to me, and I was standing there in this daze. I straightened, folded down the bonnet and slammed it shut. We'd done the water, and the oil.

"*Excusez-moi.* I woke up too early. How much is that?"

I paid him in ten-franc notes, a pile of them out of the kitchen pot. He counted, and smiled.

"Have you far to go, Mademoiselle?"

"Bordeaux. What's that, a couple of hundred kilometres?"

"Two-fifty, three hundred. *Bon, bonne journée, Madame.* Perhaps I see you again?"

"Perhaps."

He watched me go, standing there with the sun in his eyes, a young man with oil on his face and hands and his hair on end, just another young person like me. I wasn't a married woman to him, or a mother, or the depressed patient of a psychotherapist. Just a woman with a car, going on into the blue. I knew he'd remember me, that was the trouble, if anybody asked. I'd better drive for a bit, before I stopped for my coffee. I'd better get out of the Lot valley as fast and as far as I could.

Belinda asks me, "Why Bordeaux? Any particular reason?"

"I don't remember. I suppose, because of the sea. And it was more or less due west."

"You just wanted to go west? Did you know what you were going to do when you got there?"

I tried to remember. Most of my young life was recorded in diaries—I was a maniacal diary-writer—but somehow in all those hoarded volumes I can rarely find reasons for doing things or plans about what to do. Most of my diary-writing was about feelings. I poured out onto the page all the feelings that even my shrink would disapprove of. The feelings that went with my trip westward that time are not hard to remember, but the thoughts are. Did I have any thoughts about what I would actually do, once I had left?

It's funny, though, how quickly you can leave feelings behind, at least temporarily. Geographically, they take a while to catch up with you. So as I drove, I sang. I felt light-hearted, happy, and free. I sang *"La Vie En Rose"* and *"Non, Je Ne Regrette Rien."* I sang some scurrilous early Brassens about *jupons* and *baisers.* Then I switched to "Moon River" and "Blue Moon" and "Singing the Blues" and "Hot Diggety" and "Ma, He's Making Eyes at Me." I'd been going for nearly an hour when I switched to *Oklahoma* and sang my way through that. Then, a selection from *West Side Story.* At last, I relapsed into hymns. At the

school I went to, we sang a hymn every single morning for my five years' incarceration there, with extra on Sundays, so I knew a hell of a lot of hymns. They always came in handy on extra-long car journeys, like old stores of chocolate.

I drove, and sang. It seemed to be a very long time since I'd done either. With Robin, I drove when he was tired and I had to do it very carefully, with him wincing beside me and asking me if I hadn't seen that truck and had I noticed the speed limit sign back there. He winced in a very audible way, with breath sucked in between his teeth, and the movement that went with it was jamming down his foot on the floor as if there were an invisible brake there. So I never sang when I drove with him. Come to think of it, I had more or less stopped singing altogether. He was a very quiet man, and with him around my singing had come to sound raucous. Also, he couldn't sing himself, or so he said, so it seemed unfair to be reminding him of it. And singing in French, pretending to be Piaf or Georges Brassens, rolling my r's and my eyes and gesticulating over the wheel, would to him I think be showing off or dangerous or both.

I had plenty of time, on this trip, to think about my situation; but I don't think I began thinking about anything until I'd put at least a hundred kilometers on the clock. What had been happening had been my life accelerating since the age of about eighteen, without my having the least idea how it had happened. In the last brief space of time, I'd left school, gone to University, fallen in love with a long list of people, read hundreds of books, seen hundreds of films, heard hundreds of songs, met Robin, married him out of fatigue, or something like it, had three brief jobs, got pregnant, had Belinda, moved house and gone mad. Now here I was, all alone in the middle of France.

All the books, films, ideas, jobs, lovers, had been left behind. Robin and Belinda had been left behind. All that remained were the songs, and those I thought would be with me to my dying day. I could quite see myself on my deathbed, only whether it would be *"Non, Je Ne Regrette Rien"* or *"The Surry with the Fringe on Top"* would be up for grabs. I wondered if I had gone mad because I had too much in my head. It was possible. Some things in life you could let go of, empty out, but not all the songs you had learned. The Top

Twenties of 1956 and all the Beatles songs seemed particularly stubborn. And as for those hymns…

I realized all at once that I hadn't stopped for that delicious cup of coffee and cigarette at the unknown café where I would sit looking like Jeanne Moreau, sexy and mysterious and all alone, puffing at my Gauloises. Well, I'd do it at lunch time instead. Order a *verre de rouge* and some wonderful little dish.

God, this was fun. I wanted to telephone Robin and tell him how much fun I was having, only I remembered that this was not the point. After a couple of years of marriage, it was strange to be doing something without him. We had the habit of referring things to each other endlessly, in the way couples do. He was always telling stories about things we'd done, telling them to other people, I mean; and he always got them slightly wrong, then stopped in the middle and asked me, that was how it was, wasn't it, so that I was torn between my attachment to the absolute truth and a wish not to put him down. The fact was, he was a hopeless storyteller. So I sort of took over the narrative part of our marriage. I wondered now how he was managing without me, not so much at the level of practicalities as at this other level, of knowing what came next. A marriage has to have a plot, doesn't it? Beginning, middle and end? This was the first time I'd ever thought of it having an end. But maybe this, this journey of mine was the end? I was without him, in a place he couldn't imagine, he didn't know what was happening, so in a sense I had derailed our plot by the simple act of starting up the car.

Car. This was when I noticed that we were veering to one side and bumping along and that turning the steering wheel didn't do anything to right us. The car bumped onto the grass verge and I braked. A big black DS went screaming by, a man glaring out of the window. I'd turned off without signaling, just in front of him. I turned off the engine. The silence of the countryside around me absolute. The car ticked slightly, cooling down. There was no baby yelling on the back seat, no voice beside me saying, "Now what's the matter." Nobody in sight. No help at hand. Oh, hell, I was truly alone now.

I opened the door out on to the grass verge. I stood looking at my lopsided car and the squashy black shape of the tire. Not even a slow puncture that could have got me to a garage in time. I opened the boot

and heaved out the spare wheel and the metal box of tools and found the jack under the seat. It was one of those jacks that you wind up slowly, like a corkscrew, not the fast kind you get today. It was painted blue, like the car, which I thought was rather smart but not essentially helpful. I sat down on the grass and looked at it and cast my mind back to a shaming scene from the late fifties when my father had shown me how to change a wheel on the car. He'd sounded unfairly astonished that I hadn't been born knowing how to do this. I'd also come into the world knowing no algebra or historical dates and without any knowledge of chess, and all that annoyed him quite a bit. But to not know how to change a wheel on a car! Boys, I gathered, were all born with this knowledge rolled up tight inside them just waiting to get out, the way girls had eggs. Anyway, the shameful scene had taken place in our drive and by the time it was over, my father was silent with scorn and I was in tears, but I did know how to change a wheel on a Morris Minor, the only thing humble enough for me to operate on. He wasn't having me near his Jaguar or whatever it was then. The only trouble with knowledge acquired like this is that you are apt to forget it, out of self-defense, or if you do remember it, it comes with feeling sick, wanting to cry, or shaking from head to toe. So I sat and shook on the grass for a bit before I inserted the part of the jack that went under the car's belly and began winding it up. It was a surprise that it worked. I thought it might not, like when I tried to change a plug after a lesson of the same sort and mixed up all the wires. Still, there aren't too many bits to mix up on a car jack, so soon my car was hanging in the air, like a horse with one hoof lifted to be shod.

Then I fished out the spanner and began loosening the bolts on the wheel. This wasn't too hard. After a few tugs, I got them all free, stored them in a row beside me, and lifted off the wheel. Then, on with the spare. God, was I pleased with myself. If I'd been with Robin and Belinda I'd be looking after a squalling Belinda while Robin swore and hit himself on the knuckles and then I would have had to admire him for what he had done. What a con. Stopping screaming babies from crawling into the road or the tool box is a whole lot harder than changing a wheel. But you never get admired for it, or told how well you are doing. While the simplest job that demands a tool box—well, that's got to be heroic. Men's work. Ho hum.

I was just tightening up the nuts on the spare and thinking these revelatory thoughts when I noticed that a car had pulled up beside mine. There was a man in it. He opened his car door and got out. He stood looking down at me, hands on hips. All I really saw was a pair of dirty jeans and some scuffed boots, but I felt the stare.

*"Qu'est-ce que tu fais?"*

"What d'you think I'm bloody doing? Changing my bloody wheel." In French I said more politely, *"J'ai eu une panne. Ça va maintenant."*

He squatted beside me. Oh, my God, black eyes. A long dangling lock of black hair. But then you see these all over France, Imogen, nothing to get worked up about. He pushed his face quite close to mine to gaze at my hand still tightening nuts with the spanner. He looked at the tool box, the jack which I began to unwind.

*"Dis donc, tu te débrouilles, hein?"*

*"Bien sûr."* Of course I manage, of course, and who are you to turn up and start calling me *tu* like that, anyway?

"You are not lost?"

"Certainly not. I am driving to Bordeaux."

"You will need to go through Tonneins and Marmande."

"I know. I have a map."

"Excuse me, but it is easy for tourists to get lost round here. Excuse me if I have been impolite."

I forgave him for having assumed that I didn't know where I was going. Then I stood up and rubbed my hands on an oily rag that was in the tool box. The door of his car hung open and he'd left the engine running. It was a 2CV, the old gray sort with no pretensions to being trendy.

"Well, thank you for stopping."

"Where did you come from?"

"England. Oh, you mean today? From the Lot Valley. The other side of Villeneuve."

*"Ah, la vallée du Lot.* I know it, of course. *Connais bien.* You like it? You are on vacation?"

"Yes, I'm on vacation and no, I don't like it very much. I don't know why."

I was thinking, there must be the material for another Lot joke

somewhere in this conversation. *La vallée du Lot.* What could you do with that?

"Why is it *le Lot* not *la Lot*, since it's a river? It ought to be feminine. Like *la Garonne.*"

"In French, *une lotte* is a fish."

"Ah." We were nearly at the next Lot joke, then. How do you like your Lotte? I thought that I would never be able to explain this concept in French. Jokes are what divide one nationality from another, anyway.

"So *la Lotte*, you eat, *le Lot* you swim in. *Voilà la différence.*"

He'd nearly got it. But what was I doing standing by the roadside trying to swap jokes with a totally unknown man? I said, "I must get on my way." I tried looking at my watch but found I didn't have it on.

"You have an appointment in Bordeaux?"

"Yes. An important appointment."

"Ah. *Dommage.* That's a pity. *Bon voyage.* I hope your tire is good."

When he said the word *"pneu"* he blew out with his lips, like a little explosion. I held out my hand and we said a formal goodbye. I started my car and turned off the grass verge, aware of him watching me to see if I did it right, the way men do. As I set off towards Tonneins, I saw him in the driving mirror, waving and the *deux-chevaux* with its door still hanging open, parked lopsidedly half on the verge. It was slightly disappointing, leaving him behind. I wasn't sure why I'd done that. It wasn't fear, or dislike. It was probably because I was so used to being a wife.

I tried to regain my sense of free and effortless traveling. It felt good to have changed the wheel myself, and to be up and running again, but I still had to have the other one fixed and hunger was beginning to growl in my stomach. In the next town, Tonneins, I spied a restaurant with a menu outside being held up by a little man in a chef's hat, and though it wasn't the kind of place Maria and Paul would have stopped in, I did. There was a garage just down the street, so I pulled in and gave my wheel to a man in bright blue overalls who looked me over and said he would be pleased to *"me depanner"* or sort me out. I left the car with him and walked back to the restaurant. The menu was written in bad typing with an "a"

that jumped about. I stood reading it. My chance to be Jeanne Moreau had come, but I had the feeling she wouldn't have spent her morning changing a wheel on a car and wouldn't now be wondering what to do with her oily hands. In the toilet I looked at my face in the mirror, short hair standing on end, no make-up, no jewelry, no look of a femme fatale at all. Maybe I would go and have a facial, spend my afternoon in one of those mysterious beauty parlors the French have so many of, even in towns this size. Maybe I'd get my ears pierced. Maybe I'd transform myself so thoroughly that Robin wouldn't even recognize me when I went back. It was the first time I'd thought about going back to Robin, and what he might say. If I went back transformed into the ultimate in French chic, would it be better or worse? I sat down at a little table outside the restaurant and crossed my legs in their rumpled little skirt and tried to look relaxed. I read the menu several times over. The waiter came out, looked surprised to see me.

"Would mademoiselle not be more comfortable inside?" No, I wanted to stay outside. Somehow it seemed easier eating alone if you were outside; it was less like lunching and more like a picnic.

*"Un verre de rouge, s'il vous plaît."*

*"Oui, mademoiselle."*

The wine when it came was purplish, in a thick little glass. I sipped and it stung its familiar pathway right through my body, transforming everything. Wonderful. I began to feel different at once. It didn't matter what I looked like, it was what I felt like that mattered. It was about enjoying myself, this was, not impressing other people. Anyway, it was that magic hour in French provincial towns when everybody has gone home for lunch and a siesta and there isn't a soul in the street.

Except. Oh-oh, as the Americans say.

"I know," Belinda says, "the man in the *deux-chevaux.*"

"How did you guess?"

"Because that's what happens in all your stories. A sexy Frenchman turns up, and bingo."

"But this story's true."

"Weren't the others?"

I feel slightly annoyed, as I had when I saw the *deux-chevaux* turning in the empty square. "Well, it wasn't quite like that."

"What was it?"

"Well, those are novels."

"Everything else in your novels is autobiographical."

"But I'm trying to tell you what actually happened. There's a difference."

"Is there?" My daughter can't see it. Perhaps nobody can. Robin certainly couldn't, or didn't want to, even though I explained to him that you have to have a certain amount of sexual activity in novels these days.

Anyway, the *deux-chevaux* was parked under the plane trees in the empty little square, and its owner came strolling across to where I sat.

"*Rebonjour.* You didn't get very far."

"I was hungry."

"Ah. You won't eat here."

"No?"

"No. The best is Chez Gilberte, the other side of the church. You want me to show you?"

"No, I'm fine here, thank you."

"It is a pity, not to eat well." I felt the same sort of irritation I sometimes felt with Maria and Paul, who always knew the place to go, the dish to choose, the right way through every menu.

"Well, I am here now." I waved my glass of wine.

"You want me to join you?" He sat down, without waiting. "I tell you who I am. My name is Jacques." He stuck out his hand and I put my still dirty one in his. He squeezed it and put it down on the table.

"I am on my way from Paris. I am a student. My family lives near here, I am going home. Excuse me, I am not dangerous. I just like to talk with people. I am going to eat at home. My mother is a good cook. You could come, if you want."

I hadn't actually ordered any food. But hell, everything was happening much too fast. I was beginning to imagine an alternative life for myself, in which I lived in rural France with a man called Jacques and ran up to Paris to do a little light shopping and go to the Louvre, midweek.

"What about my car?"

"We get it on the way back. Then you go on, to Bordeaux. You will have time. To get to your appointment, I mean."

"Ah, yes, my appointment." I looked for my watch and found I still didn't have it on.

"Your appointment is at what time?"

"Ummm, five o'clock."

"*Bon.* You have the time. The road to Bordeaux is better after this, it follows the Garonne, it is easy. After lunch I bring you back here and we take your car."

"Okay. I'll just pay for my wine." He slapped down a couple of francs on the plastic table cloth, as if wine that color couldn't possibly cost any more, and we left.

"You mean, you just went off with him, just like that?"

"Mm-hm. People seemed a lot less dangerous in those days. Or we didn't have to be so suspicious. I used to hitchhike all the time when I was a student, and nothing ever happened."

"So, what happened with what's his name, Jack?" My daughter, I realize, also reminds me of Maria from time to time. It's as if there is a race of people who just always know what to do, who are rooted in a kind of common sense so obvious that you can't imagine how you didn't think of it first. But you didn't, and that was that.

"We had lunch at his parents' house. It was fantastic. It was probably the best lunch I ever had in my entire life. It was what they had every day, I suppose. Or maybe it was a bit special because their long-lost son had turned up. We had, let me see, soup, with a taste of chestnuts in it, and rabbit terrine, then a sort of stew, with wild boar marinated in red wine—"

"You mean, you can actually remember what you ate, all these years later? How come you forget so many other things?"

"The memory is selective."

"Okay, go on."

I remember the lunch because it was, in a way, what I had come to France to find. So, I suppose, was Jacques. Oh, and his parents, his fat mother and his lean father and the way they sat around the table and

slurped their wonderful food and eyed me as they tore up their bread. On the way to the house, as we lolloped along in the *deux-chevaux*, he told me about his life in Paris.

"You know about what happened last year? The revolution? *Eh bien*, I was there. It is not finished, oh no. We will not give in. Whatever this government does, it is finished. The students and the workers, they are together, still. You know about the strikes in the Renault factory? You know about what happened in the Sorbonne?"

"Well, yes. I read about it. I was having a baby at the time."

Damn, I hadn't meant to mention a baby, or a husband for that matter. I'd even put my wedding ring on a different finger on my way to his car, though I think they wear it on a different finger in France anyway.

"You were having a baby?"

Of course, he'd pick that up. He looked at me sideways, his arms wrapped across the top of the steering wheel. His eyes were narrowed like they are in romantic novels, and his black hair flopped forward.

"Well, yes. But I don't want to talk about it." I turned my face away, as if the whole thing were far too painful, and let him guess at some tragic romantic involvement resulting in my shame and a possible adoption. "Go on. Tell me about—Paris. The whole thing. Exactly what happened. Where were you? Were you involved in the street fighting? Did you throw cobblestones? Did you hear Sartre speaking? Were you in the occupation of the Sorbonne? Are you an anarchist? Or a socialist? What do you study, are you in political science?"

It was enough to make him drop the subject of babies.

Belinda looks indignant when I tell her this. "I wish you didn't have to spend so much time pretending I didn't exist."

"Look, it was just in the story I was telling him, you didn't exist. Or maybe I'd give you up for adoption. Really, you were perfectly well and safe with your dad. So, do you want to hear the rest of this, or not?"

"Yes, I do. Even if you'd left me with a bunch of drunken lunatics and you gallivanted off with a strange Frenchman when I was only one year old. Sorry. Go on."

"Well, I didn't gallivant very hard, as I'm telling you. But what he

was telling me was absolutely thrilling. He'd actually been there, in it, taking part."

As he talked, I thought how envious Robin would be, and what a lot I'd have to tell him. It seemed odd to be thinking this, but then I was so used to thinking about him, it was hard to stop. I imagined sitting over a bottle of wine with him and telling him all the details of Jacques' revolutionary activities and those of the miraculous lunch.

"You really think the government will fall?"

"Of course. They are ridiculous. They are also paranoid. They should have fallen after the Algerian war. De Gaulle is an anachronism. But do not say this to my father, he will be angry."

"Oh, no, of course I won't. You mean, he's actually Gaullist?"

"Like most of La France Profonde. We don't talk about it anymore. But only last week, I received a hit on the head, from the police. I was coming around the corner of les Jardins du Luxembourg and we ran into them. I couldn't resist shouting out at them, and one of them came after me. My friends got me out of there. But, feel—" He took my hand and placed it on the back of his head, in among the thick black hair. I felt a bump the size of a small egg. My first real evidence of government oppression and the truth of anarchist theory. I left my hand there a moment, impressed. "Does it hurt?"

"No, not now. But what hurts is the state of corruption, the police presence, the racism, the whole totalitarian enterprise. That is what hurts."

I was silent, out of respect for all that. I was a million miles away from the house in the Lot Valley, with its ineffectual English people drinking too much and pretending to be anarchists too. Here was the real thing. I thought, it wouldn't take much to fall in love with Jacques, and then the entire course of my life would be changed. It would become real, overnight. I'd have to go and get my baby, of course. I'd have to come clean over that.

Jacques' family lived in the sort of low, rambling red-tiled ancient house that is these days often advertised for sale in English and American papers, because French farmers simply can't afford to farm anymore. But in the sixties, tucked into the fold of a small hill between

Agen and Tonneins, in that quiet corner of southwestern France where tourists hardly went, they were doing nicely. They had a lot of plum trees and specialized in making prunes. If you're Anglo-Saxon, prunes conjure up quite a different image, I realized, than they do to the French. Forget constipation remedies and focus on wonderful little black mouthfuls soaked in brandy. You see what you can do about changing the raw materials of things. It's all in the imagination, always was. *Les Pruneaux d'Agen* were what kept Jacques' family going, and that continued I expect until the Common Market and the Global Village had something to say about their means of production. We ate them as an aperitif, surprisingly, and I licked brandy and prune juice from my fingers as I listened to his mother telling Jacques how bad he was for not coming sooner, and asking who was this *charmante jeune fille*, and were we fiancés yet?

"No, we are not fiancés," Jacques told his *maman* but she carried on looking at me as if she thought we might be one day soon. I'd put my wedding ring right away, in my purse. I felt bad about this, but thought that in this position Robin might have done the same. No, he wouldn't, I take that back. He would never even have thought of it. As Jacques' mother was going on at him about various members of his family, various cousins and brothers and aunts, I was off into a daydream of my alternative life. I hadn't yet noticed that some things happen to you that are not possible to erase. They are like your first wrinkles. They are here to stay, but you still carry on under the illusion that with the right moisturizer or enough sleep they will disappear. In my early twenties, everything I had done had been reversible. No effects were permanent. Or so it seemed. Now, what had changed? I was a mother and wife, but I was still only twenty-six years old, and I felt like the kid I had always been.

The most famous statement about the alternative life is surely Robert Frost's one. "Two roads diverged in a yellow wood." Since he wrote it, people have made a meal out of this idea, the "road less taken" and so on. But the trouble is, you never really stand at the point where the roads divide. Or I don't. I, and surely many other people, are usually well down one of the roads when it occurs to them quite suddenly that this isn't the right one, and it's damn hard, not to say unpopular, to go back and take the other one instead.

If I'd really had this alternative life idea going for me, I might by now be married to a *professeur* in *Sciences-Po*, live in an apartment in Paris, and be visiting my aging in-laws down in the valley of the Garonne. I would probably have read Lacan all through the seventies, been pals with Barthes and Derrida, and published some arid little *textes* in which the author did not exist, far less show her face, and I'd be able to deconstruct everything in sight. Belinda would have been at a *lycée* and I might have some other well-dressed French children with good haircuts and scooters and poor old Ben wouldn't even have been born. I probably wouldn't have divorced, but would have been on terribly good terms with my husband's mistress, and my own love affairs would have been discreet, civilized non-marriage-breakers, and right now I wouldn't have sold my house and moved to America. It would all have been mighty different. Would I still be the same person? Hard to say. If language creates reality, no. If it is the other way round, yes. If there is no author, I would have been just *texte*, just the creation of circumstance. If there is an author (as I think now), then I would have still been it.

Anyway, I sat and sipped and smoked a cigarette, because that was what Jacques was doing, and then I helped Madame Duclos bring all the plates in from the kitchen, just like a good future *belle-fille* and Jacques himself didn't budge, just like a future *mari français*.

But the division in the road, the place where Robert Frost stood and contemplated, was long since past. It wasn't a true choice. The two roads had diverged long ago, and I had not noticed. I had simply gone careering down one of them without even looking, as I am sure most people do.

After lunch, Jacques tried to kiss me in the barn, and that was when I told him I was married and put an end to the fiction of my alternative life.

The barn was incredibly ancient, probably Romanesque, he told me, I had to see it. I didn't say then that he had got the wrong person, that it was my husband who was nuts about Romanesque barns, but it nearly came out. We were in among the old stones and sagging beams and I was being knowledgeable about them, when he put his

arm around me and aimed a kiss. I wasn't expecting it, so it landed near my ear. It was his arm, suddenly tense around my shoulders that felt constricting. I wriggled away.

*"Je suis mariée."*

It probably sounded like a poor excuse to a real revolutionary. He tossed back his black hair and looked at me scornfully. *"Et alors?* Marriage is a bourgeois institution."

"I know. Sorry. I just can't kiss you."

"Why not?"

"I just can't, that's all. I'm not used to it."

*"Le mariage,* we will abolish it," he said with a sniff, and turned away to light a cigarette. "Why are you married?"

"Why? Well, I suppose, it's because I wanted to be."

"Do you love your husband?"

I thought about it. There seemed to be no other reason for my behavior. "Yes," I said.

"I think it is stupid, to say you will love only one man."

"Yes, well, I didn't say I would only ever love one man, it's just that I do at the moment." I got my subjunctives a bit tangled as I tried this complicated thought on him.

"So. You don't want to go to Paris with me? To make the revolution? You are married, instead?"

"Yes," I said, "Sorry. I mean, I'd love to, otherwise. But I can't. Not now. I have a baby, too."

He blew Gauloise smoke all over me and I felt like crying. I felt young and stupid and probably wrong about everything, but one thing I knew, I was way past that turn in the road, if it had ever existed. The one down which I would have gone with a French lover, to Paris, to make the revolution.

"So, you want me to take you back to your car?"

"Yes, please."

"We'll go, now. You are really going to Bordeaux?"

"I don't know."

"You don't know? You don't have an appointment there?"

"No. I just said I had, because I needed a reason to go there."

"Now you don't?"

"No."

"You are bizarre," he said. "I don't understand you. What are you doing here?"

"Deciding, I suppose."

"About what?"

"Oh, about the rest of my life."

We went back in to say goodbye to his parents. If they were anxious about a future daughter-in-law vanishing so soon, they didn't show it. I thanked them. I said truthfully that I would never forget their lunch, or their kindness. Madame kissed me on both cheeks and gave me a little pot of prune jam, and Monsieur shook my hand and said several times over, *"Enchanté, mademoiselle, enchanté."*

Jacques and I got into his *deux-chevaux*, banged the volatile doors several times to make them shut, and he started it up so that it leapt on the spot. He let out the clutch and we jumped away over the rough ground of the yard.

I said, "It was very kind of them to give me lunch."

"It's normal."

"Are you angry with me?"

"No, of course not."

"Thank you for asking me to go to Paris, anyway. Are you going back straight away?"

"Probably not. I will stay for a day or so."

"Then you'll go back to the revolution?"

"Of course."

"Do you still want to kiss me?"

"You are English, you are married, that means you can't kiss anybody. Full stop, new paragraph."

"No, it just means I can't go with you. I have commitments elsewhere. My life is elsewhere. But I can still kiss you."

"Back there you said you couldn't."

"Well, I can now. I just had to make it clear that it wouldn't be going anywhere. If you see what I mean."

He stopped the car, on the grass verge. Tonneins was in front of us, a line of buildings against the sky. He braked and turned off the engine. The car shook a little, then subsided into silence.

"Life is not about where we are going," he said, looking straight ahead. "It's where we are now. The present does not implicate either

past or future. If I kiss you it will be an act without consequence. *D'accord?*"

"*D'accord.*"

He looked at me with his head slightly on one side, his dark eyes narrowed and a little line running up from the corners of each one, a line which in middle age would be permanent, I thought. I looked back. It did feel as if time had stopped. Perhaps it did stop. Perhaps the present was in a little fold in time, a tuck taken in the fabric of our lives. I reached forward towards him and we kissed and kept on kissing for a long time, our tongues having that intimate languageless conversation on their own until they knew each other thoroughly, and then withdrew. By the time we had finished, my body was raging for more. But he withdrew, turned on the ignition again, and drove the car forward into future gear, so that there was no going back. My car was parked all alone on the town square, where the *garagiste* had left it, with the wheel in the back. He parked beside it. Neither of us spoke. I wanted so much to go on touching him that I dared not move at all. I took my hand and just briefly laid it over his blue denim crotch so that I could feel his erection. There was nowhere else to go now, but on together or clean away. But I knew, at the same time, that this wasn't anything to do with the rest of my life. He was my dream, my fantasy, if you like; and the thing about fantasies is, that as soon as you come really close to them, they turn out to have nothing to do with you at all.

So we said goodbye, with a brief kiss on the lips, and then I got into my car and turned it around so that it was facing in the direction I'd come from, and drove away. Thank God it started first time, or I might have wavered. Thank God I didn't have to ask him for help. He waved to me, just a little wave, more like a salute. He hadn't even turned off the engine of the *deux-chevaux*. In my mirror I saw the little car, like a bug, turn around in the square. He left just the way he had appeared. Then I was alone.

Belinda says, "What did you do then? Just come back to us?"

"I did a few weird things. I stopped and went into a jeweler's and had my ears pierced. The man said it was the first time he had *"percé une anglaise."* It hurt like hell. I'd always thought having your ears pierced didn't hurt, but it's not true."

"It didn't hurt when I had mine done."

"Well, perhaps things have improved, then."

"What happened next?"

"Well, with my ears hurting like hell, I went into a church and sort of—well—prayed."

"I didn't think you did that sort of thing."

"I didn't. Or rather, I hadn't for ages. It wasn't the sort of thing you did in the sixties. But I needed something, something I just wasn't going to get from anywhere else."

My daughter looks astonished. She used to have that look of astonishment as a baby, and it has grown with her.

My ears hurting like hell, and the darkness of a church towards the end of a long summer afternoon. Yes. And what was the praying for, if not for help? Getting away and sex with a stranger were not what I wanted. This particular day, I'd had to grow up. I'd had to realize that I didn't have an alternative life, that was it. So I needed some help with the one I did have, the road with no turnings off it that I saw running straight ahead of me now, possibly going on forever. With the burning pain in my ears and the two new little knobs of gold set in their crusts of blood, I kneeled down in the darkness of a church and waited for help. I was not exactly *en panne* any more than I had been in my car. I could manage the jack and the spare wheel myself, and I could make the decision myself and turn my car round and point it back facing east. But the general sensation of breakdown had been there for a much longer time. It was what you were not supposed to admit, in that era of freedom and cheap psychiatry, the need for something deeper and older and more powerful than anything around you, because you could not make sense of your life on your own. I don't know how long I stayed there, or really what happened. When I came out it was nearly dusk. The day seemed to have slipped on into a long golden twilight and everything in the outside world had slowed down. I got back into my car and sat there. It was, incredibly, only the end of the day whose beginning had seen me off on my blindfold adventure, going west. I felt very tired. I spat on my fingers and massaged my sore ears with spit. The man in the jewelry shop had crunched through the flesh of my ears with a sound I could still hear. He'd held a cork behind each ear

to bury his needle in. Afterwards he'd given me a thimble-sized glass of brandy and the singing sound in my head had stopped. In the church I still had the taste of brandy and the pain and the smell of the alcohol he'd rubbed my ears with and the feeling of the bulge in Jacques' jeans arching into my left hand. I was a bundle of physical sensations, nothing else. I was skin and bones, pain and pleasure, taste and touch and smell. I was twenty-six. Twenty-six years of physical sensation, pleasure and pain and taste and touch and smell. Hot and cold, near and far. Hunger, desire: food, sex, the comforting fullness of pregnancy, the tearing of birth. What else? What else was I? I'd grown up without even noticing. I'd rushed into adulthood, doing all the things that adults are supposed to do, and I'd never paused.

I stayed in the pew until I was cold and the candle I had lit burned low. When I came out the world looked different. It was different. I'd made the journey I needed and I could go home.

When I approached the village in the Lot Valley, the road seemed shorter, as if it were rushing me back. The black trees went shushing past and the moon hung upside down, a shining eyebrow, low in the sky. I still hadn't found my watch, so I had no idea what time it was. Perhaps it didn't matter. I swerved around the curves of the narrow road, flooding the way ahead with yellow light from the headlamps. A rabbit ran across the road, turned, skidded away on to the verge. The night was a kind of limbo, halfway between an old life and a new one, in which I felt at ease. I didn't think about what awaited me, or what would be going on in the house. I felt impervious to it all. I'd come back for Robin and Belinda and the recognition in their eyes that I knew awaited me.

"So that's how I came back to you, darling, and that's how Ben was born, and that was the way things were for the next twenty years."

"Not forever, though."

"No, not forever. The forks in the road come back; it isn't just a single track going straight ahead, but when you're having children, the thing is, you need to believe that it is. You need not to see the other roads. That's what I think now."

"So the straight road picture was an illusion. It wasn't really like that."

"You make it up, honey. You make it up as you go along. There aren't any roads ahead, not really."

"So what happened when you got back? What did Dad say? Did you ever tell him about Jacques?"

I drove up to the house and parked and noticed that there weren't any other cars in the street. In the house there was one light burning. As I stepped out of the car, I heard the toads croaking. I heard the rushing roar of the river. I heard the silence that surrounded us, always had. Robin opened the door. He had Belinda in his arms, with her look of astonishment that she had after she'd been crying. He looked at me.

"Oh, so you're back?"

"Yes. I decided to come back." I thought, at that moment, that I had made the wrong decision. I'd let the other story go, the one with romance and revolution in it; would I ever get it back? Robin was looking at me so guardedly that I knew that this day had made everything change for him, too, and that was a fact I hadn't thought about till now.

He pushed the door wider open, the heavy wooden door that made the front of this house look like a castle in miniature.

"Where did you go?"

"Nowhere, really. I just drove. Hey, where is everybody?" For the silence and emptiness of the house was all around us, making our voices loud.

"They've gone."

"Gone?"

"I sent them away."

"You sent them away? All of them? Just like that? Your parents? Everybody?"

"Mum and Dad were the most understanding. They could see it had all been too much for you. Everybody was so worried, though. They all thought the best thing was to leave quickly, so they did."

I couldn't believe it. He'd sent them all away, and they'd gone willingly. He had waved a magic wand and everyone had vanished, and so had all their cars, belongings, bottles of wine, preoccupations, jokes, and demands.

"So there's just you?"

"Me and Belinda."

"Robin, I just can't—I mean, it's just astonishing. Why? Why did you tell them to go?"

"Well, it was all too much for you. Wasn't it? Wasn't that why you ran away?"

"I don't know," I said. "I honestly don't know."

The house was nothing more than just a house, a container, a shell. It had nothing to do with me, with us, with Robin and Belinda and me. Did it? Everything in my absence had been robbed of meaning. The signs no longer signified.

Robin said, "I thought we might as well go home. What do you think? We could leave tomorrow and drive back. Taking our time, I mean. We don't want to stay here, do we? I mean, it's over, wouldn't you say?"

I looked at him and at Belinda, who waved and cooed at me as if I'd never been gone. They looked so self-sufficient, the two of them. Did they need me? Or was it me who needed them?

"Robin," I said, "what about the fiftieth Lot joke?"

"What?"

"Did they get there?"

"Oh, that. No, they didn't. But I'll tell you something. D'you want to know?"

"Yes, what?"

"We're going to be a lot happier from now on. Will that do?"

Belinda says, "I don't get the bit about the joke. Why did you need the joke?"

I try for a moment to remember the flavor of those times, when jokes seemed to be essential. People told jokes and were photographed leaping in the air and they put on funny voices for a lot of the things they said. Being serious, it seemed, was out of the question. You made up the best jokes you could think of and hoped that they would do, to cover up the gulf of what otherwise might be. It was the language of that era.

"We just told a lot of jokes. Being jokey was sort of essential," I tell her.

"Sounds pathetic to me," she says. "Well, what are you going to do with all these? Are you keeping them all, or do we chuck them out?"

"I guess you don't want them?"

"Well, I'll just take a few." She picks out one of me and Robin standing in front of a tree, he with the baby who was herself in his arms. "You look almost normal in this one. Oh, and this." Herself crawling naked towards a wine bottle across an expanse of sharp-looking grass. "Just so as I can remember my youth." She grins at me. "What about all the rest?"

The urge to keep these fragments of the past is so strong; we go through life trailing memory like snails their slime. But I've come to that fork in the road again, the one Robert Frost was so ambiguous about and so misquoted. I am already well on my way down the other road, the new one, that has stretched out bright and fascinating and new and brought me west all the way across the Atlantic to a new world, the New World as it used to be called, where a man waited for me, and I was free to come.

I scoop up all the other photographs and tip them into a black plastic bag to put out for the garbage. Ruthless, I know; but sometimes you just have to be, and it has to be at the right time, not before.

# Chloe's Pool

FROM THE cool place up north where Chloe spends her summers, she sent me in a packet a small golden key. It was Scotch-taped to a handwritten note, telling me to enjoy myself. The key was the key to her leafy yard, where the pool was. Not actually golden, an ordinary Yale key really; but in the light of a Florida summer, with everything turning limp and sweatsoaked around me, it appeared like gold.

All through these summer months, since Chloe sent her key, I've been down there, as if to a secret rendezvous. As the waters off Key West turned soup-warm and were found to be so full of fecal matter that no one dared swim in them, I began biking down daily to Chloe's place, letting myself into her secret garden with the small key that fitted a lock in her white-painted gate and opened to me: blue water, a perfect rectangle, areca palms dropping over it to give shade, the white flowers of frangipani floating on its surface, a single leaf drawing its patterns upon the bottom, light on shade on light. I arrive, let myself in, I put the key back in my purse once I've locked the door behind me, I lean my bike up against the side of the house, I go barefoot over hot dry wood to the pool's edge; I look down into its blueness. I take off my T-shirt and shorts and step down into the water. I do it slowly, no diving, no jumping in, the quiet of the place precludes it. I feel cool water hold my ankles, then my calves, my thighs. I lean into its embrace, push it with my hands and arms, move in a single long stroke as far as I can, my nose only just above the

water, like an alligator under the bending arecas, invisible in their shade. I do laps, or float, looking up at the sky. I tell nobody, nobody knows I come here except the guardians of the place, Anne-Marie and Justin, who live in a small cottage at the back and are the caretakers. Sometimes they come and chat, but mostly they just wave and leave me alone, as people do in art galleries or in church, not wanting to disturb whatever meditation, whatever musing, or prayer, or private grief or joy has brought the person there. For it is a ritual, this swimming, this ploughing up and down the blue rectangle, the one before my eyes and in my imagination, that soothes and assuages me when I am not even here, that is before me like a mirage, informing my days.

When I am grinding paint off the back of the house, when I am stroking on the brushfulls of new aquamarine paint to the porch ceiling, when my husband is hammering at the foundations, when the day is too hot to move, when we can't speak to each other unless to snap, or groan: Chloe's pool is in my mind like a promise of salvation. It lures me. Just another hour, I say, and then I will come. I will wash and put down my brush, I will wheel my bicycle out and in five minutes I will be there. When my neighbors yell on the street and all the dogs begin barking one after the other and the chainsaws and leaf blowers and Harleys and boomboxes of Key West all tune up to their usual cacophony and one more plane goes over, one more than I can bear, I will bring Chloe's pool to mind, the cool blue of its water, its one floating leaf, its frangipani blossoms, and it will chill my brain as I imagine cocaine does, an image of order into which I may plunge, in my mind and then in reality, the rush of water past my eyes and ears shutting everything else out.

Sometimes, the voices and bodies of the writers are there, the other ones, who only come here like migrating birds in winter; who wait for the right drop of temperature, the right deep blue of winter sky. They aren't here in summer, but their ghosts are: famous names dropped with their clothes at the pool's edge, nicknames all that keep them bobbing there, nearly naked, nearly anonymous. I won't blow their cover. They need Chloe's pool as much as I do, in order to be their true, unfamous selves. Sometimes I hear them still, and glimpse

northern-white bodies, glimmering like Blake's naked souls, under-water, where they can't hear the noise of their fame. Other times, I'm simply alone here. I feel someone stirring in the house behind me, locked and shuttered until Chloe and her famous husband arrive and open it all up again, doors open to the air, a pad of wet feet in and out, a clink of ice in glasses, a murmur of talk. There's no one there but in memory, the house's memory, mine, the memories of those who have been here, swum, had iced drinks, eaten delicious dishes from Chloe's kitchen, plopped back into the pool.

It's still summer. Elsewhere in the world it's the beginning of win-ter, but here the heat's still on and the sky, that impossible blue, paint-ed in dark between the ashy branches of the frangipani, its fat fingers, its flowers of wax. I lie on the warm wood of the deck, not scalding now, not burning, and I look down into the pool. Light plays in its depths like fish. There's a twig floating, its shadow a paintbrush drawn across rippled surface. A yellow leaf, a brown blossom: seasons changing, the way we notice them here, so slight, so subtle the change that strangers think there is none. I've swum my laps, forgetting to count, each stroke moving my body through the water like the dip of an oar, the push of a boat and the dazzle in my eyes made me close them, I moved through a blind world, red on black, a flitter of light, a flash of something descending. When I open my eyes again, rings of gold loop across the bottom, chains form, the ripples are like the rip-ples on aging flesh, that tentative sketch of change, that strange beau-ty: necks, the insides of thighs. I stagger up the shallow steps to lie and burn in the sun.

This last week, in Key West, a young man hanged himself in the Monroe County Jail, that square pink building on the shores of Stock Island that faces into the sunset, although I imagine none of its occu-pants is allowed to do so. He was Hispanic, his name was Jose Delga-do, I read it in the papers. Three weeks ago he killed a young wom-an. He shot her as they sat in his van at the roadside, just a little way up US 1, on Rockland Key, or just where the bridge goes over to Rockland Key. He killed her, was arrested, then killed himself. He managed to hang himself with a knotted sheet, it said in the papers. The prison governor was interviewed. Too many people hang

themselves in jail. They were moving the shower heads. Would they take away the sheets? People who were going to be executed for murder should not be allowed to break their own necks.

Why do I think of this as I lie out on the warm deck beside Chloe's pool? I'm thinking of what this pool has meant to me, all summer. Its refuge, its beauty: the cool silence of its depths. Its absolute symmetry. The way people arrive to clean it when I am not here, so that each time I come it is pristine, renewed. I'm thinking of the gap it creates between me and extreme heat, me and irritation, me and the paint job on the back of the house, me and everybody else on this overheated island in the long summer months. It places its blue rectangle— there—between me and noise, me and dust, me and sweat, me and work, me and all argument. It exists, and I have the key to it. I let myself in like someone in a fairy tale or dream, to immerse myself in something other than what is. In another country, it might be a cathedral, cool, dark, holy. Or a cave, hollowed secretly into a hill. Or a shrine. Or a place in the desert where oasis means rest.

What I'm thinking is that Jose Delgado killed himself because in his life there wasn't that gap. Nothing could be placed between him and the immediate hell of his life. He was in that truck, she was next to him, he was angry, or drunk, the pure fire of rage was in his belly, he had a gun beside him, it was easy, he reached for it, shot her, saw her fall dead. No gap between feeling and action. Just a fluid line, running on, feeling, movement, act. A decision can be made that has no thought behind it, simply because the cool blue place where thought happens does not exist, it has been lost, its source is gone.

I swim a couple more lengths, the water so beautifully cold on my skin warmed by the sun. I think about Jose Delgado, who ended someone else's life, and then his own. In the paper, it said he hanged himself from a shower head. The governor said, it's the geographical position of this island, people run here, unstable people, desperate people, that is why there are so many suicides in this jail.

And the sky blue as a dream, as imagination. The water, waiting. Cleaned daily, new every day, a glitter on its surfaces, how the ocean used to be, renewable, renewed.

\*    \*    \*

Jose Delgado sat in his truck with the engine running near the bridge at Rockland Key and shot his lover. Something streamed from his gut to his hand, and his brain was just a flashpoint on the way, an electrical fizz. No circuit breaker, no stopping it. A couple of days later I biked through the cemetery and a crowd was there around an opened grave. A little green canopy had been set up against the sun, and young people in black were walking towards it, holding each other up, in tears. The young woman, whose name was Amanda, was the daughter of an old family in this town. Beaches, buildings have been named for her ancestors; they lie in an ancestral plot in the cemetery in the middle of Old Town. She was named Amanda: fit to be loved. Who knows what she was doing with a transient worker, Hispanic, poor, no family plot for him, just an incinerator somewhere, disgrace. Maybe she loved him, or he her. Love can make you that angry, blind you, muzzle your doubts, create jealousy, drive you up a narrow road in the dark to the place where your only option is to kill. What we call love, that lack of perspective. What we still call, love.

Imagine it, her parents, her siblings, her friends. In black, heads lowered, they stand around an open grave. The island earth is shallow, you can't go down far; here the dead often lie above ground, in stone houses built to hide them. I wheeled my bike, out of respect. Just outside the cemetery gates people in fancy dress, wearing strings of beads and masks for the carnival, were whooping and taking photos of each other. A young man and a woman both wore pants cut away to show their butts, four trembling globes, not even tan. Four egg-halves, gleaming in black.

The funeral party contracted and expanded like a bee-swarm. The long cars were black, parked among the crumbling graves. The sun was high overhead still, its furnace at midday only just beginning to sink. Outside the cemetery gates, the carnival, Fantasy Fest. Inside, a young woman's coffin lowered only just as far as sea level would allow.

I turned my bike around and made for Chloe's pool. To put it between this and that, to make its blue order central, set its geometrical exactness there, where chaos wanted to be. To swim up and down, blinded and wrapped by water to feel it hold me, carry my weight, place distance between desire, fear, anger and any action I might ever take.

# Nothing Works in Homestead

**A**T THE EDGE of the green and gold Everglades, you can see where the wind snapped tall trees in half like pencils. Snap. You can almost hear the sharp sound of it still. We hitch a ride in from the west, where we've been hanging out, Flamingo, looking for work. He said there'd be work there, in winter, cleaning up rooms, waiting tables, something in construction for him. Well, there wasn't, in fact the place seemed pretty much deserted, just a few boats in the marina and the motel part looking cracked and run down, though they did have water in the pool, so I jumped in when no one was looking. I had a towel with me from the restrooms, in case anyone thought I wasn't a guest and bawled me out. I was getting sick of people bawling me out. Anyway, it was Casey who was pissed, said I shouldn't be in the pool, said someone'd throw us out if they saw me; and I knew he was pissed because we weren't getting any work, were running out of money, and because he felt responsible.

We've only been together a few weeks. I thought he liked me then, when we met down in Key West. Now, I'm not so sure.

The next town, the nearest town, is Homestead, where the hurricane came through in the fall. If you can call it a town, because to me it looks like the set of a disaster movie. The two Filipino tourists in their clean car going to New Jersey drop us at a crossroads knee-deep in blowing garbage. Everything seems to have slipped. But there's a fruit stall on the corner with a painted sign on the roof, with a sign up, "Robert's Here." It looks kind of reassuring, like somebody's still

at home. There's no fruit that I can see, only broken pictures of it on splintered wood. We're in a world that's been wrecked. It's a warm day. Casey won't let me say "hot." He says you have to keep that word for the summer, when it's really hot. So, it's warm, really warm. We have a small bag with our stuff in it, a banana, sixty bucks, and a credit card that may not work, because I took it from Hank when I left and he may have stopped it. We walk to a gas station where they sell coffee, or brown water called coffee that dribbles out into a paper cup like slow pee. It's twenty-five cents a cup. We get a sticky donut which we divide between us; one divides, the other chooses. I will say this for Casey, he tries to be fair. I can't remember at this point why I'm with him, only that I found him attractive a few weeks ago, and when he told me there was a fortune to be made after a hurricane—rich pickings, he called it—I believed him and went along. We smoke cigarettes in the sun and lean against a wall and flip through thumbed telephone directories that are still hanging on their chains like relics of another time. Nobody much answers. He gets to talk to a man whose number he has, a contractor. The guy says they're full, try back in a couple of weeks. Everybody else must have gotten here first, seems like. Though to look at the place, you wouldn't think business was booming. When we've tried everything on the one phone that works, we kind of droop. He looks meanly at me, as if it were my fault. A black woman seizes the telephone and starts shouting into it as we move away. I suggest we hitch a ride with someone going north, so we can get into what used to be the center of town, because we aren't there yet, but Casey says everyone I point out is either gay or stupid or both. He won't take rides with anyone he thinks is gay or stupid, though I think when I was very young and used to get rides from men, even when I was traveling with a guy, all you had to do was stick out your thumb and look sexy while your guy hid in a ditch. Nothing bad happened, at least, not to me. Now, hitching is illegal here; you can get picked up by the police for even trying.

So, we get a ride up several blocks north because free transportation has been laid on since the hurricane and these little buses scoot around taking people from A to B the way they should in towns anyway. Casey sits wedged on the back seat between two young black men and one white, the three who told us about the bus. They are all

young and stringy. The tall black one plays with an orange, passing it back and forth in his long fingers as if he really wants to juggle. He stares at me staring at him, then we both look away. I sit on a side seat across from a woman wearing several skirts. We hop off at a car rental place. Casey has this notion that we can rent a car, using Hank's plastic, and cruise around in it looking for work; you can get hired easier, he says, if you look like you've got money. I don't think we look like we've got money, not after these days and nights on the road, though I am cleaner after my dip in the Flamingo blue pool. But I go along with him, because what else would I do? It's still like that; if you've got a guy, you have to go along with him, and frankly, I'd have no idea what to do in this godforsaken place on my own.

"Sammy," he says, "the plastic." He's been filling in this form, all excited about the thought of a sixty-dollar car and getting behind the wheel again, which will make him back into a real man and, I think, will make him less mean to be with. I'm thinking, thank God, maybe we can get out of here, this place God wrecked for a reason maybe, when the man comes back with the card from his little machine, with that look on his face, and says happily that the card has been refused. Okay, I knew. I just knew. That nothing would work, not with us, not in Homestead. And it sounds like such a homey place, it makes you think of apple trees and brown and white cows looking over a picket fence, and it's not like that, oh, not at all.

"Why?" says Casey, and his mouth's tight under his mustache.

"We aren't allowed to ask," the man says. He sounds prim and pleased, like some auntie.

"But I want to know. There's no reason. Why's it not working?"

"You should know that."

"But I don't. Sammy, why's this goddamn thing not working?"

I shake my head. It worked for us once, in that restaurant on the Tamiami trail when he was looking for work at the 'gator wrestling place, and then Hank must've found out, and stopped it. I think of Hank, stoned and happy on his boat just drifting at anchor in Cow Key channel, back in Key West, and for a moment I miss him, just because he never gave me any hassle—or much of anything else, come to think of it. But this man, this car hire man, not Casey, is just like a schoolteacher. You should know, and if you don't, I can't

tell you. End of story. It makes me feel even a bit sorry for Casey, because everyone gets talked to like that in school, and I'm sure he remembers.

He fumes out of the place, and I follow. I'm doing a lot of following these days. The car rental dream is a wreck behind us, one more piece of debris in this fantasy of freedom and the road that we had, and the love that went with it.

Casey says, "There you go. I knew it. You can't trust credit." I say nothing because nothing is all there is to say. We wander off across waste ground, not talking. We don't see any sign of construction, or people lining up to work, or of the federal money that's supposed to be pouring into this place like a river, right now.

Then, "I don't get it," he says, and a few minutes later, "Guess we might as well go on back to Key West." He starts looking in the garbage heaps for a piece of cardboard to write a sign saying "KEY WEST" so that we can hitch there. One thing there is plenty of in Homestead is cardboard. We go from dump to Dumpster looking for the right piece fingering through the wreckage. I think how much time people all over spend taking out their garbage, clearing their yards, making their small areas of neatness and order. But when the hand of God reaches in and actually wrecks everything, it only takes a minute, and there's nothing nowhere to clear it so there's no "away" to throw it. The whole idea of throwing things away doesn't mean a thing. One day, the whole world could look like this. I guess a lot of it already does. I search in my mind for the blue water of the day before yesterday, the clean sand, the pink bellies and fluttering wings of the roseate spoonbills on their flight paths over our heads, the bald eagle sitting in a tree. Because I need them, these things, I need them like cool water to drink, and the touch of love.

Homestead looks like "away," the away where things get thrown. Nobody knows what to do with it. Poor Homestead. There are sprayed signs on collapsed buildings: "The Keys Motel" scrawled on a roofless wreck, "Looters Will Be Shot," and even "Looters Will Be Castrated." The land of chaos, is what I think, the place of bad dreams. And yet, "Robert is here." Roadside signs sprout saying "Reconstruction Work Undertaken," "Tree Work," "Garbage Cleared"; but nobody seems to be doing it. It's as if they've given up.

So we find our piece of cardboard and I watch him making this sign, and it is one of the most surprising things about this day in my life. He picks through cardboard till he finds the right piece, careful as a man trying on hats, to get the right shape and size. Amazing. I watch him inking in the words "KEY WEST" so they fill the center of the cardboard, all level and regular, and putting little heads and feet on the tops and bottoms of the letters. It is not a thing I would ever have thought of doing. It is like being with someone from a different planet, I think. While he is doing it he is absorbed, like a kid crayoning a picture, coloring right up to the edges. This is just one of the things I notice, this day in Homestead.

Then we go by the bus station on the way to the highway, just to see if we can afford the bus. There's a young man from California at the counter, grinning, lounging, slowly planning his long trip home. A woman is going to Minneapolis with stops along the way. I count out our remaining money. After the coffee and the donut and Casey's cigarettes and the phone calls, we have forty-nine dollars left. Two tickets one-way to Key West come out at fifty-three. The bus goes in two hours and may be late.

We hike down to the highway with our sign saying "KEY WEST" and position ourselves at a left turn where people may stop. We stand at the hot edge of the highway, and nothing stops for us, in spite of the pretty sign. The glossy cars go by with just one person in each of them, the trucks with huge men in them also pass. Everybody is going for lunch. It's already past noon, on this day which started in Flamingo at seven and has been creeping along ever since. I feel old. Hunger is making hollows in us and cigarettes won't fill that gap or fool us into feeling less hungry. I have this old-fashioned feeling, that he is supposed to be looking after me. We ate the banana hours ago, dividing half and half, as we do everything we have. After an hour on the highway, we trudge up the shoulder to a convenience store which is actually open, and buy a bag of donuts and a pint of milk. We walk all the way back to sit in the bus station. We now have even less money, but at least we won't starve, and I must say that hunger's been making me feel something like hatred for Casey, and I guess from the way he's been looking it's the same for him with me. I rip open the donut bag and he says, sharp as a slap. "Don't open it like that!"

I can't believe it. I say, "Do it yourself, then." But it's too late, I've already ripped it open and made one more mess in Homestead, which perhaps he finds he can't stand, like that last straw that's supposed to break the camel's back. He takes the donut bag, opens it again the proper way. We glare at each other and munch in silence. I think about being told to not do things in that tone of voice, and what it reminds me of. I sit on the uncomfortable plastic chair, not shaped like any human butt I've ever seen, in the waiting room of the bus station in Homestead and think about all this. I feel like I'm stuck in the middle of my life, no way to go back or forward—just here.

A young man, about twenty, begins talking out loud to no one in particular and then homes in on Casey. He's very skinny, with large pale blue eyes and black hair, and his arms move wildly like a puppet's. He has a plastic ticket fastened to his wrist and to start with I don't understand a word he's saying. He's from Georgia, I hear at last. His voice skids around like a car on oil. All the sounds which usually end words seem to be missing. No brakes. I notice how Casey's listening to him, like he's the most interesting person in the world. The young guy comes and puts himself at Casey's feet. He's on the ground, talking about drugs and madness.

He says, "I'm hyper, I'm too full of energy, all my family's like that, even if I have a Coke, I get high."

Casey asks him slow questions. "Why d'you come down here from Georgia? What's better about being here?"

The young guy rubs skinny fingers together. "Greenbacks, of course. Hurricane pickings. And all the rest. Nearly got knifed last night."

He's telling about people, names run off his tongue, people we don't know, have never heard of, will never hear of; it all trips off of him, water off an oiled duck, it pours from him like sweat. He pulls out details, here, there, a room, a car, a girl, a hospital visit, money, wads of it, thousands of bucks, then nothing, emptiness, the blue eyes staring, the skinny hands coming out to beg for help. Casey sits and hears him for an hour. I don't know if he's really listening, or what. I catch words and pictures and drink my milk like a good girl and pick at the sickly donut crumbs with my fingers. As soon as you're part of a couple you begin to do things you'd never, ever, do on your own. I

sit back and watch what's happening. To him, to us, to me. At least in a place where so few things work, you do get a chance to do that.

Casey says, "Why don't you go and find out what time the bus is coming?"

Why don't I? Any good reason? I tell him, "We haven't got the money for it," and he waves me away.

I go to the counter just for something to do and because I've been told to. I fit in a joke with the man at the counter. The blue-eyed raving young man is beginning to tell Casey about women. Across the room I can hear the noises that go with this kind of talk. It always seems to liven men up, like an electrical charge. The young man throws his arms about and wears a boastful look. Casey smokes cigarettes and listens to him like one of those psychiatrists on TV who probably get paid a hundred bucks a minute to do just that. The bus comes in with a tired exhaling sound and people begin picking up their bags and moving towards it. I look at the man at the counter and I have to shrug and then look away. He clears his throat. I see he's pointing at something on the floor, then I see a single note fluttering towards me on the draft that the bus brought in, and I bend in one easy movement to pick it up. It's a twenty. The man behind the counter grins at me and begins making out our tickets for Key West. I yell to Casey and wave my arms, like I can suddenly move again, and he looks up and in a couple of minutes everything's changed.

The mad-eyed skinny boy shoulders his small bag and heads back home to Atlanta, or so I imagine. Casey and I, with our half-drunk milk and a few donuts left for the journey, get on our bus that will eventually set off for the Keys, an hour or so late, with stops along the way for the driver to munch and slurp chocolate milk, for the Burger Kings to get their slice. The bus is chilly with air-conditioning. We sit on sagging seats with the springs coming through.

"I can't believe you just found that money."

"It was blowing towards me, across the floor."

"Well, I'll be darned."

We begin to make up a poem together, with rhymes, but it won't last the whole way. We talk about the collapse of capitalism, or rather, Casey does. It's something he often likes to talk about when there's nothing else to do; and the fact that he talks makes me happy now, as

the fluttering greenback with my name on it did. And the grin of the man behind the counter and the whole movement forward and away that suddenly happened once the bill was in my hand.

Just outside of Homestead there's a mile-long traffic jam where giant trucks are out to rebuild the power cables, which involves building little platforms first, all along the edge of the swamp, for the trucks to sit on while they do this. On the bridge, traffic is stationary. But we're going somewhere, back where we came from, but never mind, somewhere, beyond the blockage.

I think about the people of Homestead and what it does to you to live among wrecked houses, collapsed roofs, dead power cables, businesses gone bust, dead phones, heaps of old metal trash and wood and cardboard and torn-up trees. What it does to the human heart. You'd give up trying, is what I think. Even with the free buses and the shelters and centers and government aid putting trailers everywhere; if you couldn't recognize your own landscape or remember your street or walk back to your house, what would collapse inside you, what would the damage in there be?

We head south, towards the blue-green water of the Keys and places which haven't been destroyed. The bus swings out along the Seven Mile Bridge and heads straight for the sunset. I put my hand in Casey's and our hands rub together a little as if they agreed with each other. I'm thinking, as soon as you recognize that nothing much works, but sometimes you get exactly what you need, you are curiously free.

# Cuba Run

**W**HEN LAURIE called me on that Tuesday night in October, 1993, and asked me if I wanted to go to Cuba on Thursday morning, I said yes. Sure, I said. We made plans. She'd come by and pick me up at six and we'd be in Stock Island by six-thirty, waiting for the boat that would come down from Marathon to pick up the supplies that would be waiting on the dock. Medical supplies, that was. There'd been boats going out of here that year, before the rafters started coming in, boats that took medical supplies out to deliver to the Cuban hospitals. Back in May, these boats had been stopped from running. A group of angry Cuban Americans in Miami had threatened to shoot at them if they went on, so the Cuban government had refused to let them come in. It was October. The three boats going out this week would be the first three to cross since May.

The guy who was organizing this particular trip gave me a call late that night. He went on about how well he knew Havana and how he could take us around. Maybe I should have smelled a rat then, but all I noticed was how he seemed to want me to know what an interesting person he was. I listened to some of this and then hung up. See you on Thursday. It was only after I'd hung up that I realized I didn't have the name of the boat or the name of the dock in Cuba we were heading for. I didn't know the captain's name either. And I didn't have a number to call him back.

"I'm going to Cuba," I told my sweetheart on Wednesday when he came back from sea.

"Ha, turning the tables on me, are you?"

I'd spent a lot of nights awake and listening for his step, the key in the lock, a phone call, his ship to come in. When you live with a sailor you don't get used to these things. Absence is still a dark turbulent void, like the Gulf Stream or outer space. You don't get used to them, but you do get to know them, every one of the fears about somebody disappearing at sea. The houses of this town have walkways around them and first-story balconies that are known as widows' walks. They were built for the women who paced the night, waiting for their sea-going men, dreaming of the Gulf Stream and of love and desire being sucked back into it like matter into a black hole or life being turned backwards, so that men were drawn back helplessly into the salt belly of the world. I knew what it was like. It was better to be the one going. There was the triumph of sailing out of port towards the open sea. There was going somewhere, facing into wind and spray. There was not being one of the generations of waiting women. There was the chance to do otherwise.

We were on the dock at Robbie's Marina by six-thirty. It was pitch dark still, with only a couple of lit boats. One was the anti-whaling ship *Whales For Ever*, which had put in here recently after its battles with the Norwegian government. It was a great shapeless hulk of a boat, massive and covered with murals of whales. There was a man asleep on a folding chair by the gangplank with a mug beside him. He opened an eye and looked at us. "Hi," he said.

"Hi."

The boats in the boatyard were high and dark, their hulls exposed like the bellies of beached seals. Shrouds at the masts rattled a little in the slight breeze before dawn. The sky was lightening and the no-see-ums were biting. We slapped our legs, feeling the burning pin-prick sensation of hundreds of tiny bites. The water was still and whitish under the sky and there was no sign of the *Guinevere*. A guy in a singlet and a ponytail came by and told us no boat had docked recently as far as he knew. He told us where to go for coffee. We drove through puddles and potholes to get to Dickie's, the only store open, which sold coffee in plastic cups and half-and-half milk in tiny containers. Dawn came up. A flight of egrets went over, heading south. We

slapped our bites with anti-insect cream and sat in the car reading the paper.

The *Guinevere*, when it came in, came in fast. Its wake spread and churned behind it, a long wishbone. There were two men on board. By now there were also two men with us on the dock. There was Maury, who was slow and fat and Jewish, with a shy smile and long thick wavy black hair, and there was Vanni, who was lean and lithe and impatient. Vanni strode up and down, his hands on his hips, and stared out to sea as if willing the boat into sight. When it arrived he stared at his watch. He was like a man at a train station waiting for a train. He timed the arrival, hating lateness. If Maury was a comfortable inflated mattress of a man, I thought, Vanni was a coiled spring. Perhaps they went together. Perhaps you had to have both. The men in the boat were the captain, Raoul, and the man who talked to me on the phone about Havana nightclubs. His name was Wally, which turned out to be short for William Wallace IV. He had aristocratic forbears, he said. He was the one tying up the boat while Raoul at the wheel was lighting a cigar. The boat was a thirty-foot diving vessel with a 450 horsepower diesel inboard engine.

The truck that had come from California with all the goods on board was standing open on the dock. It was well into the morning, and the sun was already hot. Everything and everyone was in place. I looked at Laurie. We hadn't known each other long, either; I just knew her as a good journalist who seemed to have her life worked out. She was reading the paper still, leaning against her car. Nobody moved. For a long moment nobody moved. Nobody greeted anybody and nobody moved to begin unpacking the goods and the opened truck was there like a cargo of Christmas gifts that nobody wanted to unwrap until the signal was given. The seabirds screamed up overhead and somebody moved off the *Whales For Ever* in the distance to go for coffee. The boat just rocked gently on the water close to the dock. Something had to begin. I walked towards the big red open truck and there was a young man inside, behind all the parcels.

"D'you want us to unload?"

"Well," he said, smiling gently, "somebody might as well start do-

ing something. Hey!" he called to Maury and Vanni. "Hey, you catch these, will you? We'll pass them down to you."

I joined him on the tailgate and we began passing parcels, beginning a long human chain that we hoped would stretch to a dock in Cuba, and far beyond.

"Why you going to Cuba, you got a Cuban boyfriend?" Vanni called up from the ground.

I threw down a box for him to catch. He was slow and in between boxes I had to shout to him to attend to what he was doing. My legs and back ached with bending and lifting. Behind me the load of cardboard boxes slowly shrank. Tom, who had driven them here from California, passed them out carefully to me and I threw or passed them down to Vanni according to whether they were marked "Fragile" or not. He passed them to Maury who passed them to Wally who stood on the quay. The pile of boxes down there grew. We added piles of crutches, used ones not in pairs but oddly assorted, as if a lot of one-legged people in California had suddenly thrown away their single crutches, after some miracle had occurred. I thought that if you were to go through the pile playing a sort of game—elbow crutch, short leg, full crutch, long leg and so on—you could end by matching them up.

"That's enough, stop, I can't take any more," the boat's captain suddenly shouted, refusing a box.

"But there's room!" Tom shouted back. "Hey, this stuff came all the way from LA. You sure you can't fit more on board?"

I jumped down off the tailgate. The stack of cardboard boxes down here looked small beside what was left in the truck. A white car arrived and parked next to Laurie's two-seater. A blonde woman in uniform got out. She was very neat and gave us a tight lipstick smile as we shook hands in turn. She began going through the boxes, opening some and then sealing them up again with green government tape and "U.S. Customs" written on it. We all stood around as if we were guilty. We tried to get a look at the list on her clipboard but she held it close to her firm chest. It's funny how any official inspecting anything you are involved with can automatically make you feel guilty. I looked across at Laurie. What if we were refused permission now?

The woman asked for passports, examined the photos in them, looked at us and handed them back one after the other like a teacher handing out books.

"Three of the people on this list can't go. They don't have authorization."

"What do you mean? We're all on the Treasury Department's list. We've all got clearance."

Wally came up and stood close to her. He wanted her to know he was the boss here.

She looked at the list. She was very cool. She had neat brown legs going down into polished loafers and her hair was all in place. Beside her, tired already and slapping our mosquito bites in the raw early morning sun, we already looked disheveled.

"I have authorization for three people who are not here. Three other people are on the list. Not these three."

We shifted and looked at each other. Who had drawn the short straw? I thought suddenly that I hoped neither Laurie nor I would be left behind. Four unknown men on a boat seemed alarming, now that we were here.

At last she relented enough to call her office and check whether a fax had come in from the Treasury that morning to give us clearance. She spoke on a white mobile phone out of the back of her car. She wrote in small neat writing on her clipboard.

"You can all go."

Charlie had said to me earlier, if she asks if you are going to Cuba, say no. I was relieved not to have to do this. Lying always scares me, and it shows. Lying to officials, either here or in Cuba, did not seem to me a good idea.

"Get on board!" Raoul yelled out to us all. It was nearly midday and he'd suddenly noticed. He and Vanni had been off in Vanni's truck to get the Loran fixed and to get a new fuel cap for the gas tank. He'd watched the loading of the boxes, smoking his cigar. Now he suddenly wanted to go.

"I said, get on board! Somebody cast us off. Tom, untie that rope."

I said "But Laurie's not here. Somebody just told her to go move her car."

Tom said, "I'll go get her. Wait just a minute." He ran off between the trucks and the boats up on trailers, towards the office.

"I said, untie that rope! It's midday already. She can catch us at the marina. I'm going in for gas." He stood at the wheel, his short legs spread in bluejeans, his belt sagging and his captain's hat pushed back on his head. He revved the engine. The boat strained at the painter like a tied horse.

"Will somebody untie that fucking painter? Wally—"

I said "You can wait five minutes, surely. We've already waited five hours."

I didn't want to leave without Laurie. I stood by the boxes in the stern, looking out for her. He would never think of leaving a man behind. And I wasn't going to Cuba with a bunch of men, leaving Laurie on the quay.

She and Tom ran up. She scrambled over the dock and into the stern. I just had time to clasp Tom's hand. He was a good guy, a young college kid from California. In the truck we'd talked about Che Guevara and Latin American cinema. Now I saw his face as we gripped each other's hands and my hand slid out of his as the boat moved out.

"Take care of it all, won't you? I hope you get there in one piece."

I hoped so too. Laurie clambered past the boxes and up into the body of the boat. "Were they really going to go without me?"

"They were," I said. "They said they would pick you up at the next marina, wherever that is."

"I don't believe it."

We came into the marina on the other side of the island and Raoul put in eighty gallons of gas. He collected a hundred dollars from each of us to pay for it. Then he turned the boat and went out through the channel markers towards the open sea.

We were still within the channel when Raoul left the automatic pilot on and went down into the hold for something. Wally stood at the wheel and played with it as if he were driving a car on hairpin-bend roads. The boat swerved and our wake swished out behind us like a fan. Vanni came leaping down the ladder from the flying bridge in a minute. "What the fuck's going on?" He took the wheel from Wally just in time to swerve past a red marker.

"What the fuck are you doing?"

"Oh, I guess the automatic pilot wasn't working."

"Too right it wasn't. Hey, Raoul, whyn't you slow down a bit this side of the reef?"

Raoul took the wheel back. The flashlight and a can of peanuts had already hit the deck. The blue tarp that wrapped the cargo flew up and flapped in the air.

"Somebody tie down that tarp! And make a passage there, I need to get to the bilges."

Laurie and I began shifting boxes. Vanni found a rope and lashed the tarp down. We tucked the ends of the tarp under the bottom boxes.

"That's not enough of a gangway. I said I need to get through."

We shifted boxes again. With a gangway made, only half of them could be properly covered by the tarp. I straightened and looked out over the stern, past the fanned-out churning wake we made, to see Key West grow smaller on the horizon. There was the line of Australian pines at Fort Zachary beach. There were the tour boats going out. It was the last sight of anything familiar, that thin spit of island on which we lived. Raoul took a direction on the Loran and we charged out towards the reef, heading southwest. I thought of everything I had left behind and felt scared for a moment of what I had undertaken. It's like a fist closing round your heart, this sudden fear. And then when you think what you're scared of, it's only the unknown.

On our wall in the apartment where we live, there's a big sea chart. It shows the triangle of water in between southern Florida, Cuba, and the Bahamas. It's where the Gulf Stream sweeps through, north of the Cay Sal Bank. The ocean is marked in depths and shown in blue and white for shallow and deep water. It's a crossroads, a turning point, a place where the bloodstream of the world runs fast. For five hundred years, ships have gone down there. It was the hunting ground of the old wreckers of Key West, the licensed scavengers of the last century; before that it was the domain of pirates of all sorts. It's where the galleons went down, weighted with gold and silver, in the seventeenth century. It's where the ships set out to cross the Atlantic, bringing treasure to Spain from the New World. It's where Columbus sailed.

And this summer, it was where a new migration took place as Cubans scrabbled out on their little boats and rafts to reach Florida.

We went out past the reef at twenty knots or so and came into the Gulf Stream. It was flat calm, with only a slight rising swell like breathing. The water was a dark deep blue. It rocked us gently, with no threat. We passed a shrimp boat going out and then there were no other vessels in sight. We settled down to a long day. I stretched out on the icebox to read my Spanish phrasebook. Laurie, Vanni and Maury were up on the flying bridge, out of sight. Raoul stood at the wheel with a cigar between his teeth. Wally asked me to get up every few minutes so he could get another beer out of the cooler. The Budweisers lay in there floating among the ice. He cracked them open and handed one now and again to Raoul. The cans lay about on the floor. Wally smoked Marlboros one after the other and he and Raoul teased each other in the competitive way men have.

Once I heard Raoul explode, "You've got a fucking nerve!" He turned and explained to me, "We always fight a lot."

"How long have you known each other?"

"Fifteen years. We go back. He's an asshole, but he's all right."

Wally explained, "Raoul's Algerian. He's a millionaire. He came here with nothing, now he owns a marina."

He looked at Raoul with boyish admiration. Then he said, "And I've got three businesses. I haven't done too badly, have I, Raoul?"

Raoul said, "I am French, actually. *Je suis pied noir. Vous parlez français?*"

"*Bien sur.*"

"*Eh bien, je suis né en Algérie, j'suis parti en '57.*"

"*Où ça?*"

"*J'suis né a Oran.*"

"I knew some people from Oran in the sixties." I thought of the young guys, my age, who had told me about the Algerian war. That was thirty years ago now, and here was one of them, turning up again. He said to me, "Ha, that was a time."

Wally said, "I don't know what you're talking about."

"That is because you are an American. You have no experience of the world."

"Sure I have experience. I've been to Cuba God knows how many

times. I know Havana like the back of my hand. I can show you things you've never even thought of, Raoul."

Raoul smiled at me. He had sea-green eyes and a nose like the Renaissance dukes in Italy and a crooked, fleshy mouth. He shrugged his shoulders and went back to studying the instruments. The green radar screen showed a boat as a little blob within its radius.

"Cuban boat. Very small one."

I looked at the Loran calculator. We were within thirty miles of the coast now, with seventy miles of water behind us.

Wally said "Look, I can see land."

There was a small lump on the horizon.

"Those are mountains. They're really big. Or you wouldn't see them this far out."

We watched the mountain grow and become part of a range. The land was vague and gray and if you stared too hard it seemed to disappear. I thought how even with all these instruments we had, the feeling of approaching an unknown coastline must be close to what the early sailors felt. In theory and on the maps, Cuba was there. But it was outside our experience and imagination as surely as it was for Columbus when he sailed there. When you don't know what is in front of you, you are always on the edge. The Loran tells you your direction and how far you have come and the radar tells you what is in your way. But the voice going out on the radio to speak to the Cuban coastguard and maybe get an answer is like a voice going out into space.

Wally began radioing the Coastguard and got no reply. We heard some garbled Spanish, but it was coming from a fishing boat. There were no boats in sight, only the growing line of the shore rimming the water, and the dark blue ocean. Laurie was asleep curled up on the deck now, and Vanni was handing out subs with tuna and sausage in them, brought from Key West. Wally had the binoculars and was peering through them at the shore.

"I know where we are; there's the match factory at Matanzas; we'll be coming in to Matanzas."

I looked at the compass, which was showing SSW, and the Loran, which was at 210°. There was a long line of beach showing now and two lumps sticking up.

Raoul said "See any harbor markings?"

I took the glasses and peered. With the movement of the boat, it was hard to focus. I saw a patch where there seemed to be no beach. It could be a harbor entrance. But there were no buoys or markers in sight. We turned southwest and headed downwind. The two lumps got bigger and turned into buildings with letters standing up on them. The gap in the sandy beach was an opening, but a narrow one. Then a boat appeared fast from down the coast, chugging towards us, a gray battered-looking little boat with two guys standing up on board. It came alongside and the two young men, one black, one brown, stared at us. They were holding guns.

"*Medicina!*" shouted Wally. "*Para hospitale.*"

The young men lowered their guns and waved instead. They had very smooth faces and little mustaches and the black one flashed a smile full of wonderful teeth. They gestured with big sweeps of their arms. We were to follow them. Their boat turned and they set off at a fast rate towards the gap. Close, I could see the red and green posts marking the entrance to the harbor, their paint so faded that they were only faintly red and green. We followed the gray boat at full speed up a canal with people standing and staring on its banks. Some waved. The gray boat slowed suddenly so that Raoul had to cut our speed in seconds. We still had this huge wake behind us, filling the canal to its concrete edges. The boat turned and went in bow first where the men pointed. Raoul did it well, turning in a tight space. Wally threw the rope onto the dock and missed so that it fell in the water. Vanni seized it from him, leapt off and made us fast. On the dock there was a tall black man in white shirt and shorts. He watched us come in, watched Vanni leap onto the dock, watched Wally with his beer can in one hand and his cigarette in the other, watched two women staring back at him, watched the American flag flutter and droop at the masthead, watched everything.

"Hey!" Wally called out, "Have a beer! Don't worry, we're bringing medicine, we're a humanitarian mission, we're your friends!"

The man in white grinned at us. He was slightly above us on the dock, sitting with one knee up and his arm resting on it, his hand curving down. Wally waved his arms, tottering where he stood. He

was very skinny with thin arms and legs and with his thinning hair on end in the breeze he looked like a puppet with a coconut for a head. His face was red and windblown.

"Hey, someone pass me a couple of beers. Imo, get some out of the cooler."

I lifted the styrofoam lid and in among the soup of floating sandwiches and candy bars there were a few Budweisers left. I reckoned he must have drunk eight at least since we left. The Cuban on the dock leaned and shook hands with each of us in turn.

"Have a beer," Wally insisted.

"What sort of beer?"

"Budweiser. The best. American beer."

"Okay. I'll try it."

"Have a cigarette. American cigarette."

The man in white took both and sat there on the dock sipping his beer and smoking.

Wally waved a file at him that had the ship's name on the cover and all the papers inside.

"Here's everything you need. We've got all our papers in order. It may mention 'Basta' in there, but we aren't directly connected with 'Basta.' I now there was some trouble earlier this year with Alpha 66. Oh, well, perhaps you didn't hear..... These are medical supplies that we're delivering to a doctor from the hospital on Saturday afternoon. The Matanzas hospital."

"You stay on the boat," the man in white said. "Customs and immigration will come. Till then you stay on the boat."

"Okay, okay, we understand. Red tape. We have that too."

"Red tape?"

"Bureaucracy. Officialdom. Bullshit. You know. But we're all above board, you just have to look at the file. We've all got clearance from the State Department."

"You stay on the boat."

"No, no, we want to go to Havana. See the city. Well, I know Havana, I've been there several times, I have lots of friends in the Bahamas, you see, so I can operate here easily. Here, have another beer."

The man in white took another can and set it down on the dock unopened.

"You bring medicine?"

"Yes, all this has been collected from all over the United States. From many hospitals. People give it for free. They want to help your people. They know how terrible things are here."

The man in white looked down, smoking.

Raoul said under his breath, "Jesus, how many beers has he had. Wally, less is more. Get it?"

Two more men came down the dock. One was small and black, in khaki, the other tall and light haired in a plaid shirt. They shook hands and jumped on board.

"Passports?" We handed over our passports. A little crowd of watchers was gathered on the dock. Looking beyond them I noticed that the other boat, *Morning Cloud*, which had left Stock Island before us that morning, was tied up a few yards down the dock and its crew were still on board. We waved and they waved back.

"They're still on their boat."

"They have to wait for you," said the man in white. "They wait until you come. Then customs and immigration do all at once."

"What time did they get in?" Vanni asked. He stood with his legs braced on the deck and slightly apart, looking alert and irritable. He threw a cigarette butt into the water.

"Three, four o'clock."

It was now after six. We sat in dock and watched the sun sink, while men in various uniforms went to and fro, looking at us. Our passports did not come back to us. The man in white, who said his name was Alexi, sat on. He seemed in no hurry to go anywhere. He cracked open the other beer and drank with Wally. Raoul had one too. Vanni looked at his watch.

"How long's it take to get to Havana from here? How far is it?"

"One hundred thirty-two kilometers."

"Can we get a cab?"

"Is very expensive, a cab. There is a bus. But it is slow. You will get there very late. It is better you stay here. There is a good hotel here in Varadero."

Wally said "Varadero? I thought we were in Matanzas."

"Fifty miles out," said Raoul, his teeth clenched on a cigar.

"I will telephone. Make reservation. Yes?"

"How much is it?"

"Thirty, thirty-five dollars. Nice room, two beds, hot water."

"Restaurant?" asked Maury, who had not spoken since we got here. "I'm starving."

"Good for you," said Vanni, waving a thin brown hand towards Maury's belly which hung out over his trousers. "Good for you to diet, get in shape. Cuban diet, Maury, get it?"

Maury, when Vanni got at him, drooped as if he were going to cry.

"Cheer up, Maury," said Vanni. "Soon be in Havana. I'll find you a nice big black man there."

"I telephone the hotel," said the man on the dock. "You want?"

"No, we want to go to Havana."

"To Havana? Tonight? Tonight, to Havana?"

"Yes."

"Is better you stay here. More safe. You wait here to take the things off your boat. Havana is in other province. This is Matanzas province. If something bad happens in Havana, you will have problems. Not here."

Vanni said, "We're going to Havana. We'll get a cab. Will you call us a cab?"

The man shook his head slowly from side to side. The sun was sinking behind the masts of the moored boats. He said nothing. Then the tall fair-haired young man came back with our passports, clambered down on board. Just behind him was another uniformed man, very young, with *"Ministerio del Interior"* embroidered on his shirt. He sat down among the beer cans and remains of our picnic and spread out some papers.

"Your professions please."

Wally said at once, "Well, I'm a businessman. I have businesses in the Keys and the Bahamas. I've been here a lot of times before. I told you we are not here with Basta, didn't I? I'm a member of Basta, but this is not a Basta expedition. They had to stop coming back in May, because of threats by Alpha 66. Maybe you haven't heard of Alpha 66. They're a bunch of Cuban terrorists in Miami. They threatened to blow us up."

"Hmmm. What was your orientation to come here?"

"Oh I've been here often before, I love Cuba. I've been a member

of Basta for some time, not that this trip has anything to do with Basta, we're independent, but I really support the Cuban people in what they're trying to do. I know my way around here, I'm telling you."

Raoul said, "Idiot. He means our orientation, not your life history. One-eighty-five to two-ten degrees," he said to the official.

"Have a beer," said Wally. "Why don't we all have a beer? Like some beer, you guys? It's American beer."

Both Cubans on the boat shook their heads. The one in uniform got out thin sheets of yellow paper and began filling in the details from our passports.

"Your professions," he said again. "Please."

Raoul said, "I'm the captain. This is my boat."

"Ah, you are the captain." The young man shook hands with him again. Raoul squinted down his cigar.

"And you?"

Maury said, "I'm a jeweler."

*"Joyero,"* said Vanni.

"You too?"

"No, just him. He doesn't speak Spanish."

"I've come to steal treasure," Maury said, and giggled. The immigration man looked at him.

"Just a joke," Maury said. "Vanni, explain, what's a joke in Spanish?"

"You?" The young man looked at Vanni.

"Fisherman."

"You were born in Italy."

"Yes."

"And you?" He looked at Laurie and me. Laurie was looking serious. We'd been told not to say we were journalists.

"Writer," she said. "We are both writers."

"What do you write?"

"Fiction. Poetry."

"Ah. That is good."

He handed back all the passports with yellow slips of paper tucked inside them that were our visas, saying we could stay fifteen days in Cuba. I felt relieved to have my passport, my old solid dark-blue British passport with its lion and unicorn and its apparent guarantee of safety for the bearer, back in my bag.

"Good," said the immigration man.

"Now, can we go?"

The masts of boats cast long shadows over the marina. The sun was as low as it could be without disappearing.

"No, you wait. On the boat."

"What for?" Vanni asked. He was looking at his watch and frowning. "It'll take us a good two hours to get to Havana. Won't it?"

The man in white frowned too. He said "Too far to go to Havana tonight. You want to go to Havana? Go in the morning. There is a bus. Tonight there is nothing to go to Havana."

Vanni muttered, "We'll get a cab. I'm going to Havana tonight. How about you, Maury?"

"Sure. I just want to get something to eat."

"Eat, sleep, here," said the man in white. "I telephone." And he got up to go.

"How long do we have to stay here?" Raoul asked. "What are we waiting for now?"

"Permission."

"For what?"

"You want to go to Havana, you have to get permission. Havana is in other province."

Wally said to us all, "It's not like arriving by plane. When you arrive by plane, you just walk through the airport, clear customs and there you are. No bullshit. I've done it often. It's very different if you come in by plane."

I said, "I'm sure it is. It's always different. But we're on a boat."

Wally burst out with his long braying laugh.

"I said, it's very different if you come in by plane," he told the man in white. "Different story altogether. I'm coming by plane next time. I can fly in from Nassau any time I want. Don't get any bullshit then. Here, let's have another beer."

The man on the dock stood up. He said, "You are drunk."

"I've only had a few beers. Celebrate being here. *Viva Cuba!* Go on, have another, we've got plenty. Plenty of beer in America. *Salud!*"

"For God's sake, shut up," said Raoul.

"What's the matter with you? Just because I said it's better to come in by plane and we're stuck on your fucking boat?"

The man in white walked away. His dark face and arms and legs disappeared first, and we saw his white clothes glimmer in the dusk all the way to the office. I climbed out of the boat and went after him. It felt good to be on the solid wood of the dock after six hours at sea.

I said to him, "Hey, can I go to the bathroom?"

"Yes."

He turned, motioned to a young man who was one of the watchers on the dock. He too was in uniform and had a scarcely grown mustache.

"*Los baños,*" he said.

"*Si, si.*" The young man plucked at my arm and pointed. We walked together down the dock, took two right-angle turns, and arrived in the office building. The young man walked alongside me without speaking. He pointed down a corridor to the toilet, which was at the end. I went ahead and found a toilet with no lid close to the floor. My guard stood with his back to me in the corridor while I peed. There was no toilet paper and the plug would not pull, but at least I would arrive in Cuba relieved of an urgent need. He smiled a bit shyly as I came out and we walked together in silence back to the boat.

When we had stacked all the boxes inside the boat rather than in the stern, and covered the ones on the outside with the blue tarp, we got off one by one and walked towards the exit of the Marina. Alexi met us there with the fair-haired man in the plaid shirt whose name was Pablo. Pablo was on a small old moped. He said, "Do you have any of your work with you?"

I handed him a book of my poems from inside the flap of my black knapsack. He sat astride his moped in the dark, reading by the faint light from inside the building. I sat down on the curb and smoked a cigarette. Laurie had gone to find the toilets. Wally was pacing up and down looking for something to organize. Raoul was sitting against a pillar, his legs bunched under him, waiting. He was used to Arab countries where waiting is what goes on most of the time. He too was in waiting mode. You just hunch up your legs under you and squat or perch and let time go by and empty your mind and maybe smoke something and the stress from waiting diminishes. Vanni was doing the opposite. He was smoking and throwing his

butts off like fireflies into the darkness and looking at his watch. Maury, with a fat man's calm, seemed to have subsided into himself. Every now and then he said, "I just want some lobster. Anywhere'll do as long as I can get hold of some lobster."

"You'll get your lobster Maury," Vanni said. "We're gonna get some goddamn lobster if it kills us."

The man on the bike gave me back my poems.

"Good," he said. "I like poetry."

"Do you write it?"

"I try. Sometimes. Not very much."

Wally stood quivering close to him in the dusk, "Where's your boss gone? I mean that Alexi guy? Or are you his boss? I gotta get this straight."

"I am not his boss, he is not my boss. We are colleagues."

"Oh. Well, where's he gone? He was here a minute ago. You guys keep appearing and disappearing...."

"He is telephoning. For you. You say you want taxi to go to Havana, no?"

"Ah. Well, can you give me ride while we're waiting? Is there a store round here?"

"Not far." The man on the bike waved his hand into the darkness. "Maybe one kilometer." The palm trees waved in the dark and on the road a horse pulling a cart went clopping past. Several dogs sat immobile at the edge of the curb and under the trees. The moon was shining half-full.

"You want to go?"

"How long will the taxi be?"

"Four minutes."

"Okay, if we've got time."

Wally climbed on behind Pablo and the moped puttered off into the night.

"Where's Wally gone?" asked Raoul from his North African silence.

"Shopping."

"Hunh."

A small bus drew up. All the lights seemed dim after American street lights.

"Where's this going? *Donde?*" Vanni bounced up to it.

"Varadero." The driver leaned out.

*"La ciudad?"*

*"Sí."*

"Okay, Maury, let's go. You want your lobster? Well, this is going to be the only way we get to eat tonight. You heard him, taxi in four minutes, well, we've been here four hours already. Four minutes. God knows what time they'll get outa here."

Maury hesitated. The driver ran the engine.

"Come on, Maury, are we going to eat or what?" Vanni ran round to the other side of the little bus; Maury followed him more slowly, dragging his bag after him, and the doors slammed and they were gone.

Raoul said, "I thought they wanted to go to Havana."

"Hunger got the better of them. They're off after lobster. D'you want a granola bar?"

"No. Where's that fucking alcoholic gone now?"

As he spoke, Pablo and Wally reappeared on the moped. Wally held a six-pack of Cerveza Hatvey, each can with the ferocious-looking Indian head on it. He handed them out. "Twice the strength of American beer," he said with pleasure.

"No thanks."

Alexi came out of the office.

"Taxi is coming. He did not want to go to Havana, it is late, but I ask him. So he will go to Havana. Eighty dollars for six people. Where are your friends?"

"They took off in a bus," Raoul said. "They were looking for lobster."

"For lobster? Why lobster?"

"They hear lobster is good in Cuba," Wally said. "It is the best. Here, you give your lobster something that will make them mate all the time, don't you? So they are very tender."

"Mate all the time?"

"That's just what he wants to do," said Raoul, opening a can of Hatvey. "Don't take any notice of him. Where's our taxi?"

"I told him six people. Now, only four."

"Well, we four will pay him. Twenty dollars each."

"Very expensive to go to Havana at this time," said Alexi. "Better to stay here. I told you, I telephoned for you to the hotel in Varadero. Very nice hotel, clean, hot water, modern, two beds. But you must go to Havana. So, I find you a taxi. You go to Havana."

He shrugged, letting go of us.

"I go now. I had enough of this. Saturday, when you come back, I will not be here. I cannot work this way. He will be here, Pablo. Pablo is a patient man." He took a bicycle from the shadowed side of the wall and biked off slowly, his white uniform glowing in the moonlight.

Pablo said, "Here is your taxi."

It was a Nissan, with bashed paintwork and sagging back seats. The driver was an old man who did not turn his head or greet us. We piled our few bags in the trunk and got in, Laurie and Wally and I in the back, Raoul in the front.

Pablo slapped the taxi on the closed trunk as if it were a horse he wanted to get rid of.

"Havana," he said, and we went.

The countryside was dark and quiet. There were hardly any cars on the road and the road itself seemed to have no verges, so that it merged with the surrounding dark scrub. It was hard to see what was growing. There were the outlines of tall palm trees and the shapes of hills. There were little houses built close to the road with people sitting out on their porches and the lights were dim with a blueish glow. There were long stretches of country where we saw nothing but darkness, the half moon riding alongside us to our left. I opened the window in the back and breathed in the smell of Cuba. It was kerosene and charcoal and cooler air than Florida, it was unique the way the smell of a person is.

Raoul sat and puffed his cigar in front so that the smell of that wafted into the back and it was good to have clean cool air rushing in through the open windows. Raoul spoke to the driver in Spanish. The old man answered in monosyllables. Perhaps nobody here was ever crazy enough or rich enough to hire a cab to go to Havana in the middle of the night. He was a good driver. He paused before overtaking a slowly straining truck; he flashed his lights into the thick dark-

ness. There were bonfires lit on the road from time to time to slow drivers down, instead of traffic lights. There were the leaping tongues of yellow flame in the darkness above the oilfields, which ran along beside the coast and stifled us suddenly with their stink. Without the refineries being visible, these disconnected balls of fire were all we saw, blazing like meteors in midair. But the air was thick with fumes and you could not breathe. Then it was past and the gulps of air we took were clean and fresh again, with the taste of damp country, earth and charcoal.

It was a hundred and thirty kilometers to Havana, the man had said. We stopped once on the way, for Wally to buy more beer, at a roadside stall on the other side of the Matanzas bridge. The rest of us had sodas, warm from the can, and I went to the cabinet marked with a figure in pants, as the one with the skirt was locked. Wally and Raoul started up a bored-sounding bantering session about how much money each of them had. Laurie and I were silent. She sat in the middle, between Wally and me, and we all slid about on the bumpy seat, and then Wally fell asleep with his head tipped back and his Adam's apple like an ostrich's pointing upward. When we reached the edge of Havana he woke up and began telling us that we were nearly there. He told the driver to take us to the Plaza Hotel, near Central Park. There are not really any suburbs to the city of Havana and we were suddenly there, parked outside the big hotel with its lights beaming out like a lighthouse. We fumbled with dollars and bags. The old man put out a hand for the money, standing as if he were begging. His face was still. We laid twenty-dollar bills in his hand and he took them patiently, said nothing, and prepared to drive away.

It was after midnight. We leaned on the clean counter, filled in forms, and paid in advance for our two rooms, men in one, women in the other. The Plaza was high-ceilinged and spacious and full of pre-Revolutionary gilt and mirrors, fountains, and tiled walls. We walked down the hall with our bags and three people passed us; two very young women wearing short skirts, high heels, and a lot of make-up, hanging on the arms of the man in the middle, who was pale and thin-haired and about twenty years older than they were. The two girls grinned, their lipsticked mouths showing fine teeth.

They looked pretty pleased with themselves. The man in the middle tripped, as if he were exhausted, or drunk.

Laurie and I stood in the elevator together. In the sudden light she looked pale and drawn, and I suppose so did I.

"Well," she said.

"Well."

"I certainly don't feel like seeing Havana with any of that bunch, do you?"

"I do not."

"First thing tomorrow, we escape, okay?"

The elevator reached the third floor. We dragged our shabby bags marked with seawater down a tiled corridor with white walls and overhead lights. She had the key. Our room was tall and rectangular, taller than it was wide, so that it was like being in a decorated box. There were very tall windows with louvred shutters. There was a shower and a toilet. There were two beds with clean sheets. We sighed and sank down on the beds.

"Did you notice those two in the foyer?"

"With the guy? Yeah. Teenagers, I'd guess."

"That's why a lot of guys come to Havana. It's cheap."

"I wonder if that's why our guys came?"

"Not pure humanitarian zeal, anyway."

One after the other, we took a long time in the shower. There was soap and there were little bottles of shampoo and clean towels, the way there are for tourists in hotels all over the world, whatever the local population is doing without. We stood under jets of hot water and then rubbed ourselves dry with the small towels, and then lay on our beds eating granola bars from our store. In the midst of peace and silence, there was a knock at the door. I stood up and pulled my shirt back on to answer it. Outside, standing side by side in the corridor, scrubbed and shaved and wearing clean shirts and ties, stood Wally and Raoul. They looked like high-school dates and should have been clasping flowers.

"My," I said, "you do look clean."

"Better than before, eh?" said Raoul. Shaved, he had lost his piratical look and looked younger.

"Definitely."

"We wondered if you want to go out to eat," Wally said. "We thought we'd go to the Floridita. It's about the best."

I said, "We're just going to bed. We're tired. Have a good time."

"You're not going to sleep, are you, in Havana?"

"Yeah," called Laurie. "We're going to sleep. It's about the best thing we can think of right now."

"Okay, see you in the morning. I can show you around if you want. The Cathedral, the University, the museums—"

"Thanks. Maybe."

Laurie called from her bed, "We're pretty keen on looking round on our own."

Wally looked disappointed.

I closed the door, "I guess he's trying to be nice."

Laurie said, "Well, after today, I can do without it."

"Yeah, I know what you mean."

"I mean, guys. I mean, it really makes me glad I'm single."

"Well, luckily they're not all like that."

"No, I guess not. But Christ, the ones that aren't are pretty damn rare."

In the dark, she said, "Imo?"

"Yeah?" I was falling down a long soft tunnel and enjoying it.

"All the stuff on the boat. We just left it. D'you think it'll be okay?"

"I dunno. Hope so."

"Nobody seemed to care about just leaving it."

The future, even tomorrow, was beyond my reach. I hit sleep, and sank. Whatever was happening to the *Guinevere* with its cargo, I could think no more.

In the morning we had showers again just for the fun of it, dressed in clean clothes, and went up to the roof terrace to have breakfast. There was coffee with hot milk, there were peeled rounds of grapefruit, there was a huge tray of cold fried eggs that looked like eyes, and there were several sorts of little dried cakes and buns and some dark stewed preserve that turned out to be quince. We parked our trays and sat down at a white table in the sun. Beside us the rooftops of Havana were spread out, and beyond that the glittering line of the ocean. It was a

beautiful morning, blue and fresh with high white cirrus clouds, and we had both slept well. At the next table were Raoul and Wally.

Laurie whispered, "God, they look terrible, what can they have been doing?"

"Hi."

"Hi, how are you?"

"Terrible."

"Have too good a time last night?"

"We didn't sleep."

Raoul's red-rimmed eyes were half open. His face was pale and unshaven again.

"I can see that."

"You women are so damn superior." Wally moaned, his head in his hands.

"Well, we got some sleep. And it's amazing what a little make-up will do. You ought to try it sometime."

"This coffee's not good," Raoul complained.

"It's the canned milk," Wally said. "So what are you doing today?"

"We have an expedition planned."

I could see why Laurie had had this good position on the *Washington Post*. She had her ducks in a row, as they say.

"You ought to come to the Tropicana tonight," Wally said. "You shouldn't miss the Tropicana. It's amazing."

He passed his hands across his eyes. "Anybody bring any headache pills?"

"They're on the boat. Boxes and boxes of headache pills, all the way from California. Have you forgotten?"

"Oh, god, hasn't anybody got any here? By the way, we have to be back there by two tomorrow. There's a ceremony, for handing over the stuff. So we gotta be there in time. No getting lost, okay?"

"You're one to talk," said Raoul. He added, "He's fallen in love. Already, can you beat that? How can you fall in love in six hours?"

Laurie and I walked out of the hotel, past the Central Park and down the street towards the Granma Memorial. Then we headed for Batista's old palace. Outside, there was a small group of schoolchildren dressed in red and white, who sat cross-legged on the ground while

their teacher told them about the former dictator. We stood and listened to some of what the teacher said. The children grinned at us and waved and fidgeted. A young man came towards us.

"You speak English? Great Britain?"

"She's American. I'm English."

"American? Forgive me, how did you get here?"

"In a boat."

He grinned and lit a cigarette. "I thought all people in boats were going the other way."

"We brought medicine. Things for hospitals. They were given free by the people in the United States."

"You are my first American," he said to Laurie. She blushed slightly. We all shook hands. He offered me a close-packed dark Cuban cigarette and I took it. We all stood in the middle of the vast space in front of Batista's house and faced towards the harbor and the sea. The day was fine and hot, the sky windy. The city was quiet. There was little traffic, just occasional old cars going slowly and people on bicycles. We all three walked down towards the Malecon, which is the long street that runs alongside the ocean.

"You like Havana?"

"Yes, I like it very much. It is beautiful. You have a beautiful country."

"Yes. There must be changes. We have a beautiful country, and we have nothing."

His name was Pedro Chavez. We found a hotel along the Malecon where Pedro said we could get coffee. We went in and stood on a clean marble floor.

The woman at the desk said to Pedro Chavez, "You cannot come in, you have no shoes."

He looked down at his flip-flops. I said "I have the same shoes as him." I pointed to mine.

"Oh, then you can come in."

We sat at a table laid with a white cloth and heavy silverware. Pedro said, "It's a hotel for tourists."

"That means you can't come in here?"

"That's right. That is why she said about the shoes. She wanted to be polite."

"But you can come in here with us."

"Yes, but she tries to find a reason, you understand? She tries—
*como se dice?*—to not insult me."

"I thought it was quite insulting. After all, everybody wears flip-
flops."

"No," he said, "she tries to make it—okay for you."

I said, "I don't understand."

"It doesn't matter. You want coffee? *Con leche?*"

"Yes, what about you?"

"I never drink it. Not anymore. Water."

The young waitress came over and wrote down what we asked for
on a small pad.

"Two coffees. One glass of water."

The coffee was half canned milk and tasted of salt and was cold.
Laurie and I sipped it and Pedro sipped his water.

"Is it good, your coffee?"

"Fine."

He laughed, "Now you do it too, I see. The same as the woman.
You try not to insult, eh?"

Laurie said, "Well, it is a little strange-tasting."

We all laughed, and Pedro smoked. When we paid for the coffee,
it was two dollars, the same as his wage for a month, Pedro said.

"I am a nurse. I work in the hospital. It's good work, but I have
not worked this year. I have been sick. The doctor told me not to
work, but to rest."

"What was the matter with you? What sickness?"

*"Hepatite."*

"Hepatitis? How did you get that?"

He shrugged. "Hygiene is not good. We have no disinfectants,
things like that. Nothing is clean. Okay, shall we go?"

We walked out and along the Malecon, where the sidewalks were
pitted and holed and the street too. A sea breeze came in from the
north and the only clouds were high and white, like clean laundry
hung over the city.

Late in the afternoon, Laurie and I said goodbye to Pedro Chavez
outside our hotel.

"I will see you again?" he asked us before leaving.

"Tomorrow we must leave at ten o'clock."

"Then I come at nine o'clock. Here? You will wait for me here, outside the hotel? I cannot come inside."

"Okay. Tomorrow at nine."

"I will bring my poems and the address of my brother." He blew us a kiss, and strode off, his pants flapping against his thin legs. He walked off down a side street, met a friend, clapped him on the back and they walked in tandem. We saw him go, in his loose Bermudas, his tank top and flip-flops, picking his way through potholes and mud, one hand on his friend's shoulder, the other waving a cigarette.

As we went into the hotel foyer, we met Vanni and Maury.

"Hi. Where did you get to? Have you only just got to Havana?"

"We came this morning."

"How was last night? Did you get a lobster?"

Vanni said, "Hmmm, the dinner was okay, the hotel was okay. We just had to get away from the moron."

Maury said, "They don't give you very big servings, is all."

He looked tired, and black bristles protruded all over his lower face. Vanni took off his dark glasses and rubbed his eyes. The downward-drawn lines around his eyes were pronounced today.

"God, you look awful."

"Thanks."

"Didn't you get any sleep, either?"

"Not much. Oh, hell, there's the moron."

"Who?"

He gestured towards the bar, where Wally was sitting at a table with two Cubans, a stack of beer cans in front of them.

"At it again."

"Apparently he fell in love last night."

"He would." Vanni groaned. "The man's a moron. Where's our noble captain today?"

"We saw him this morning, looking about as bad as you do. I don't think he fell in love, though."

"Some people only come here to get laid," Vanni said. "Isn't that right, Maury? We didn't find the big black Cuban for him yet, did we, Maury?"

"Shut it, Vanni, will you. Everybody's going to think I'm gay."

"He isn't gay," Vanni informed us. "He's got a girlfriend at home who hates him, isn't that right, Maury? In fact, she may not be there anymore when he gets back."

"I kinda hope she won't," said Maury. "She hates me."

"Why does she hate you?" I asked.

"Dunno. She just thinks I can't do anything right. Maybe I can't."

"But he's a genius in the sack. A genius. Aren't you, Maury? So she ought to be grateful."

"Shut it, Vanni, will you?"

"So what are you girls doing tonight?"

Laurie and I looked at each other.

"Wally wanted us all to go to the Tropicana. D'you want to go to the Tropicana?"

"With the moron? What time are you going? I guess we might. What is it, girls and tits and that sort of thing?"

"Cuban culture," said Laurie. "Music. Folklore. I don't know. I'll go and ask him, shall I?"

She walked across to where Wally sat, at a table near the bar, tucked away behind a fountain. I saw her bend and speak to him, saw none of the men move, watched her walk back to us with her face red and her head held higher than usual.

"He's changed his mind," she said. "He's drunk."

"What did he say?"

"He said, go there yourselves, there's a bus, find out at the Hotel Inglaterra when it goes. So I guess he and Raoul have set themselves up some hotter dates for tonight."

I said, "Well, as far as they're concerned, nobody could be less hot than us, could they?"

Vanni said, "You're well out of anything he organizes. The man's an asshole."

Maury said, "We could always go and get something to eat."

"I've got to find you a hot date, Maury," Vanni said. "We can't have you going home all frustrated."

"No, really, Vanni, I don't want to. I just get embarrassed. What can you say to a woman you can't even talk to?"

"You don't say things, Maury, you do things. Haven't you ever done things with a woman without talking?"

"It's all right for you, you're a bloody Italian, we all know what they're like."

"Maury, I'm a married man. Have a little respect. My wife doesn't even know there are any women on this trip. She'd murder me. Coming all the way to Cuba with two ladies on board?"

"I'll take a photo," Maury said. "One on each side of you. Get me free fishing trips for a year, eh, Vanni, would that be worth it."

"Okay, girls, see you later. Let's boogie. See you tomorrow, back in Varadero. Or we could share a cab? Yeah, let's do that. Come on Maury, let's hit the town."

The two of them went out the door, still bickering.

"I think they're in love," said Laurie.

"I think they're married," I said.

We went and sat on a bench under the dark leaves, out in the Central Park. The moon was coming up. The park was full of people sitting and talking or sitting and not talking. It was as if they were waiting for something, only they were not, because there was nothing to wait for. A woman was feeding a small boy out of a paper cup. He stood still and opened his mouth like a bird. The streets grew darker and there was a safety in sitting there just doing nothing, in among the crowds of people doing the same.

"D'you want to go to the Tropicana?" asked Laurie.

"No. Do you?"

"No."

We went to the Floridita, which was just down the street from the hotel. All the way down the street little boys asked us for pens. We'd given away our ballpoints and our water bottle by the time we arrived and an unsmiling man in a red coat shut the children out and allowed us in. I saw him glance at my flip-flops and thought of Pedro. We perched on high stools and ordered daiquiris, the way you are supposed to in Havana. They had the consistency of snow that piles up on street corners the day after a snowfall. We ate all the plantain chips on the bar. The place was empty except for all the men in red coats and a couple who sat gazing at each other across a little table, talking German.

"Not very friendly, is it?"

"No. Let's go."

On the way back to our hotel we went into a store that sold prints and heads made of coconuts and maruccas and leather belts to tourists. The shopkeeper, whose name was Larisa, was somewhere between Laurie's age and mine, I guessed. She was solid, round-faced, and smiling, with curly cropped hair and a way of lifting the corners of her mouth as she spoke.

"Excuse me, I know it is embarrassing, but I wonder, do you have any tampons?"

"Yeah. At the hotel."

"It is bad to ask. I feel ashamed. But it is so bad to have to do without. We feel like we are going back in time. You understand?"

"Sure," Laurie said.

"I'll go back and get them," I said.

"Now? You can do this? It is not inconvenient?"

"No, we were just going somewhere to eat. We were in Floridita's."

"Floridita's?" She pulled a face. "But that is for capitalists. Are you capitalists?"

Laurie said, "No, we didn't like it, so we left."

"We'll come back," I said. "Will you be here?"

"Till eight. Oh," she said, "thank you, thank you. And have you anything for pain?" She clutched her lower stomach, "Pain, you know?"

"Period pains?"

"Yes, that is it. Oh, if women could live without them. In our country we have enough, we do not need that too!"

Laurie and I walked back to the hotel. We emptied our bags of tampons, cotton wool, face cream, mascara and shampoo, found painkillers and pills for diarrhea, and took all the little bottles of body lotion and shampoo and all the little squares of green soap that the hotel provided. We scooped them all into one bag and walked back to the store on the corner. We took some more granola bars for the little boys on the street, and the rest of our pens except for one each to write with. In the store we gave the bag to Larisa who clasped us each by the hand and had tears in her eyes.

"Oh, you cannot imagine. This is like Christmas. You are like Father Christmas, you know that?"

She poured the contents of our bag into hers, behind the counter, and went off to the restroom with the tampons and painkillers like somebody with a new outfit to try on.

"We're going to eat dinner," Laurie said when she came out smiling widely. "Do you want to join us?"

"Yes! Of course! Where will you go? Where will I find you? I have to finish work here and call my mother. My mother is old, she will worry if I am late. When I tell her I will eat dinner with Americans, she will not believe me. You eat dinner with our enemy, Larisa?" And she burst out laughing. "You are sure you are Americans? You can't be Americans, really!"

"Well, she's not, but I am," said Laurie. "And we both came from America. She's married to an American."

"Married? Really? I am not married. I do everything I can, but it doesn't work. And you, are you married?"

"No," Laurie said, "I'm single."

"And are you a virgin?"

"No!" Laurie blushed a little.

"Me neither. But it is so long since I make love that I am afraid that I become virgin again. Perhaps that can happen? But with all that you give me, the creams, the *maquillage*, that is for making love, no? So I will make love again! Wonderful." She smoothed her body with her hands in the gesture of a long caress. "Mmm! Wonderful! But I will not be long, I will come on my bicycle and join you. Where will you be?"

"The Hotel Inglaterra."

"*Buen!* But you must wait for me at the door, yes? Otherwise they will not let me in."

"Sure. See you soon, Larisa. *Hasta la vista!*"

She laughed at our Spanish, and perhaps at the thought of making love again.

Outside the door at the Inglaterra I stood and watched people being turned away. The two young men on the door held up their hands like closed doors. A tall thin black man was protesting that he had a friend who was expecting him, but the doormen shook their heads and held up their hands. Out on the street, very young women

walked past in twos and threes, their hair stiff and fixed, their lips scarlet, their breasts and buttocks jutting on account of the high heels they strutted on. They hung on to each other's arms, like kids trying on heels for the first time. The cops on the street corners watched them go.

"Yes," said Larisa, after locking up her bicycle and embracing me, "that is terrible, no? Once, this did not happen in our country. But now. Tourists come. They are hungry. What can they do?"

We went into the restaurant to find Laurie, who was sitting at a table reading the menu.

"Science fiction," said Larisa, reading her menu. "This is science fiction."

"What is?"

"Lobster. Chicken. Shrimp. Bread, even!" She picked up one of the little rolls that was sitting on a white napkin with a pat of butter beside it.

"We never have bread like this. I will take it for my mother, for her breakfast, may I?" She put the little white rolls and the wrapped butter pats in her bag, wrapped in a paper, and we signed to the waitress to bring more.

The waitress smiled at us. "You are very hungry tonight."

"Yes," I said. "Very hungry."

Larisa winked at the waitress. We ordered our food. Little pots of sliced lobster came, the slices sitting on slices of pineapple. Larisa asked for beer, and I had fizzy mineral water. After the lobster came chicken, very skinny pieces of chicken with small mounds of rice beside them, for Larisa and me. Laurie had what was described on the menu as "viands." "What kind of meat?" she asked the waitress.

"Meat."

"Oh, okay, I'll have that."

When it came, it was in long tough strips, dark brown, with a lot of sauce.

"I'm really mostly vegetarian," Laurie explained, pushing it to one side.

"You don't eat?"

"I never eat much. Mostly vegetables."

"I take it for my mother," said Larisa, and signed to the waitress

for more paper napkins. "You don't mind I eat chicken with my fingers? I try with a knife and fork. But it's impossible, you miss too much."

"It's the best way to eat chicken." I copied her, picking up the chicken bone and gnawing the strips of meat off it.

Two musicians came by, old tired-looking men with guitars. They began to play *"La Vie en Rose."* We sang along. Larisa had tears in her eyes again. We toasted each other in beer and mineral water and our greasy fingers went in among the chicken bones again. We gnawed and smiled and sang. Everyone in the dining room was listening now. We sang well together; the musicians nodded at us and changed into "As Time Goes By." We sang on. Larisa knew all the words, in French and English.

"Where did you learn French?"

"In the French school here."

"You've never been to France?"

"Of course not. I have only been to Cuba! From here you do not go to other places. Only to Florida like a *balsero*. But tell me, how did you get here? You did not swim?"

"On a boat. We were allowed to come because we brought hospital supplies. Medicine, syringes, rubber gloves, books, medical ones, crutches, bandages, all that. It's all in Varadero. We have to go tomorrow to give it to the people in the hospital."

"Tomorrow? You go already tomorrow? But I have only just met you. Oh, life is hard."

"We'll be back."

"You will? Your country will allow it? You are sure? You will bring more medicine? Oh, that is good, oh, thank you for doing that. We need everything. As you see. My mother will cry when I take her rolls for breakfast. There is nothing here. That is what shames me. I can give you—nothing."

"Friendship isn't nothing."

"No, *claro*, that is true. Next time you come you stay at my house. So, America sends us medicine? I think we need strong medicine," she laughed. "Medicine that makes you shit, you know? That sort. Excuse me. This is not talk for dinnertime. I forget where I am. I am of the people, you know. I forget I am in a dining room, with a

*capitalista.*" She laughed and stretched her arms. "You have a ciga-
rette, now? I think I will have everything. Beer, chicken, cigarette,
everything. Oh, it is good. You cannot imagine. I think, Larisa, are
you dreaming? Is this a dream?"

"It's real."

"There is one thing I must ask you. About what is real. You know,
one thing we hear about America. We hear," she giggled and put her
hand up to her mouth, "we hear that there are contraceptives for men
that have the taste of fruit and different things."

"It's true. There are."

"It's true? It's really true? Oh, that is amazing. You say it's really
true?" She laughed until her eyes shone with tears.

When we said goodnight to Larisa that night, she said, "Now, I will
cry. It is too short. You are going already. Ah, life is so hard."

We hugged on the quiet sidewalk outside her mother's apartment.
There were big dark trees and silent facades of buildings. There was
no one on the street but us. She unhooked her bicycle from the back
of the cab that had brought us out along the Malecon and up to the
street where she lived. It was a grand, spacious part of the city, with
houses that must once have been bourgeois family homes, set well
back from the street.

"You will not come up to see my mother? Then she will see I did
not invent these Americans?"

"No. It's late, and we have to leave early tomorrow. But say greet-
ings to her from us, Larisa. We will meet again."

"Promise?"

"Promise."

"Yes, this is meant to happen. I can tell that. *Adios,* my friends."

She wheeled her bike up the dark alleyway beside the house. A
faint light came on at an upper window. We got back into the wait-
ing cab and sat behind the driver as he took us back into the center
of town.

Early in the morning, on the roof terrace, we met Raoul. He was
selecting his breakfast from the rows of fried eggs and little cakes and
pots of preserves and then he came and sat beside us.

"Good morning. How are you?"

"Good. How are you?"

"Terrible. I did not sleep."

"Again? What were you up to?" Laurie asked.

"We went to a nightclub. Very expensive. Then I come back here about dawn and I find Wally asleep in my bed. We have to wake him. We have to leave soon. Do you want to help me wake him? Three of us should do it."

We swallowed our coffee and went down in the elevator with him to wake Wally. The room smelled stale and stuffy when Raoul opened the door.

"Hey, Wally, time to get up!"

Laurie and I stood and watched as Raoul shook him by the shoulder. Wally's head came out from under the sheet and he sat up looking surprisingly young, naked to the sheet that was around his waist. He blinked at us.

"The girls came to wake you too. I thought you might need several of us. It's eight o'clock already, we have to leave in an hour."

"Okay," said Wally. His thin hair stood on end and his eyes kept on blinking. He looked at Laurie and me and then at Raoul, who stood close to the bed.

"Okay," said Raoul, "he's awake now." He ushered us out. "I told you he thinks he's in love, didn't I? He has some romantic idea about trying to get his girlfriend to Florida. The trouble with him is, he thinks he can do anything."

Pedro Chavez came to the hotel and we all embraced in the foyer. He brought his brother's address and some of his own poems written in pencil on scraps of paper, and a copy of *Macbeth*, which he inscribed for us in Spanish. Then we all embraced again and he walked out, his long shorts flapping against his legs, his flip-flops quiet on the clean tiled floor. We saw his dark cropped head go down the street, going home.

We left with Maury and Vanni that morning, in a cab which suddenly appeared and stood outside the hotel with all its doors open. Vanni was in his urgency mode. He strode around waving his hands, telling everyone what to do. He looked at his watch. He jerked back

his chin with impatience. I was reminded of what the whole of Italy is like, with people waving their hands and jerking back their chins and tutting and clicking their tongues. He stood with his legs apart checking the bags as they went into the trunk. He leapt into the front and then changed his mind. "Maury, you go in front, you're the fattest. I'll go in the back with the girls. Here, can I put my knee here? You don't mind? There is so little room. We might as well be comfortable."

Laurie patted his knee. He patted hers. "Is this my knee or yours? What does it matter? Just, you have to be a little careful with me. I get excited at very little, you see. Sometimes, a touch will do."

Laurie put the magazine she had been reading opened out across his crotch. "There, now no one will see. I can't stand men getting embarrassed."

Maury said, "Vanni, I will tell your wife. I will take a photo. Then you can give me free fishing trips for a year."

"My wife is a jealous woman. She knows me. Maury, if you do that I will kill you. I am serious."

"She is right to be jealous."

"So what, I am Italian. I cannot help it." He settled Laurie's magazine about outer space more securely over his crotch and kept his knee against hers. That was how we left Havana behind and headed northeast again, out of town. I rolled down the window and looked out. In daylight, the countryside was green and fresh, with big palm trees. In among the wild scrub and flowering bushes, little areas had been carved out for cultivation here and there, but I could not see what was growing. We passed people walking, people on bikes, a few horses grazing, a bus that had broken down across the road with all the passengers waiting outside it, and a big old military truck crammed with people going the other way. The sky was a calm blue and there was a slight wind that moved the palm leaves about. When we stopped for a soda at a roadside booth, there was a big hawk cruising down the empty blue of the sky. We all stood and watched it. I took a photograph of the other three, Vanni and Maury and Laurie, standing at the edge of a parapet above the Matanzas bridge. There is an intimacy in this photograph; it was like being friends or relations, it was there and then gone. The three of them look very small and

stand close together, at the edge of the void. The hawk is a black blob, high up. The depth of the drop beneath them doesn't show.

At Varadero, Raoul and Wally were waiting for us outside the customs office at the entry to the marina. There was no sign of any official reception. They were both smoking and frowning and stood a little way away from their bags.

"What's happening?"

"They're refusing all the stuff. They say we've got to take it back."

"No! Why? What's going on?" I asked Wally.

He shrugged. Raoul said to me, "It's because he mentioned Basta when we first arrived. He handed all the goddamn papers over to the Cuban government in that yellow file with the ship's name on it, without even looking to see what was inside. Because he was drunk. That's what happened. And now we're in this shit."

He dropped the butt of his cigarette and ground it out with the heel of his boot.

Wally said, "Something else happened. I'm telling you. My friend, the doctor, the one who came here from Matanzas, he told me. He said, something has happened that we couldn't foresee. Something inside the government. But we'll probably get clearance. He's seeing to it. He says it'll only take a call to Havana and everything'll be okay."

Raoul grunted and raised his eyebrows at us.

Vanni said, "What the hell has been going on? What haven't you told us, you bunch of assholes? What the fuck is going on here?" He dropped his bags to the ground and paced up and down a bit and then asked Maury for a cigarette.

Raoul said, "Well, we all have to go and wait on the boat."

"Till when?" asked Vanni.

"Till immigration and customs have seen us. That's all I know."

"Or till the permissions come," said Wally.

"But when's that gonna be? We've run out of money. We haven't a cent left, you know that. We were going to deliver the stuff and then get out of here, and that's what we should do."

Raoul said, "We can't deliver the stuff. They won't take it, are you deaf? But we can get out of here, as soon as we've cleared customs, that's what I'm gonna do."

Laurie said, "But we can't just leave without delivering it! That was the whole point of coming here! What are you talking about?" She sounded on the edge of tears.

Raoul said, "Sweetheart, that's what I'm telling you, we don't have any choice. It's been fucked up. This guy here is the one that screwed the whole thing. So shout at him, not me."

Wally said, "I don't see how you can say it's my fault."

"Well, you're the fucking alcoholic that gave the whole thing away in the first place."

"I only had a few beers."

"Tell that to the Cuban government, they're going to be impressed."

Vanni said, "She's right, we can't just take the whole damn lot back home again. We should see it through."

"I thought you were the one who'd spent every last cent, didn't you just say that?"

"Well, we could stay on the boat."

"For three days, four days, however long it takes? With no food, while they take their time sorting it all out? No, I tell you, I'm leaving."

Raoul set off through the swing doors of the building and strode down the steps and along the dockside to where his boat was moored. We all followed him. We were all silent until we got there. Then we saw that all the boxes had been moved out from under cover and pushed back into the stern. About a quarter of them were missing. We all stared at the remaining ones, with their damp corners and their sticky tape coming undone, their printed notices—"Rubber gloves," "Made in the Republic of China," "Fragile," "This Way Up," "Sutures," "Syringes," "Handle with Care." There were the names of hospitals in California and medical schools in Texas and there were all the careful instructions that Tom had given us and all the plans that after all had gone astray. I sat down on the cool box, next to Raoul.

"You're really going to leave?"

"I told you. I have no choice. Here is the immigration man. He will get our papers back and as soon as we're cleared, I'm gonna go. It's my boat and it's my responsibility to get this boat and these people back safely. The rest can go to the bottom, as far as I'm concerned. I'll throw

the whole lot overboard if I need to. Look, the wind's getting up, it's coming in from the north, that's about the worst goddamn wind we could have. I'm telling you, if it's rough out there, we'll need all the speed we can get, and I'm not letting this stuff stand in my way."

Vanni said, "I still think we should try to deliver it here."

Raoul said, "Well you can think what you goddamn like, I'm the captain of this boat."

He chewed on one of his cigars. Vanni frowned. "Maury, what do you think?"

"I don't know really," Maury said. "I think we ought to try and deliver the stuff."

"You're a goddamn idiot, then," said Raoul. "I knew you were another idiot from the start. Jesus, what a crew. I tell you, and I'm never taking such a bunch of idiots on board again. Jesus."

The small black official in khaki arrived then and the two immigration officers were not far behind. They all squatted on the dock and peered down at us.

Then the two immigration officials climbed carefully on board. We made a space for them to sit down and once again they examined the passports, turning the pages with careful fingers and examining the photos and stamps. One of the officers, who was young with short hair and a mustache, spread out the yellow immigration forms.

"So, you are leaving today?"

"Yes," said Raoul.

Wally said, "Can't we just leave the boxes on the dock?"

"You can leave nothing on the dock. But you wait, please. I will give you passports. Customs will count boxes. You will wait, okay?"

Vanni said, "I don't see why we don't just put them out and leave them. Somebody'd take them. Hell, somebody's taken some already."

Raoul said, "Will you just shut up?" To the official he said, "Yes, I am the captain. That is me." He pointed to the photo in his passport and the official stared back at him.

"Born in—Africa?"

"That's right."

The official sighed, closed the passports and gave them all to Raoul, who dealt them like cards back to us.

"Now what?"

"Now you wait. Someone will come."

"But the sun's going down. We won't get out of here until sunset at this rate and I don't like the way the wind's coming up. It may get rough out there." He repeated all this in Spanish. The immigration man pursed his lips and said, "The sea is not bad. You can go. But first you wait."

"Wait, wait, wait," said Raoul, "doesn't anyone know anything about the goddamn ocean?" He put up a finger. The wind was blowing more strongly now from the north and all the masts in the marina were rattling. Little slaps of water sounded against the hull. The sun was sinking already into a mass of cloud, above the harbor entrance. In another twenty minutes, it would be down.

That was when the tall American in a baseball cap came and squatted on the dock where the immigration men had been. He had a broad freckled face and bony freckled knees and he spoke slowly, as if to foreigners or morons.

"Hi. My name is David Hinds. I'm with the other boat. We've just had a wire to say that Tom and Charlie are coming over on the sailboat in the morning and will have all the necessary papers on board. So if you can hang in till then, guys, it'll be okay."

Raoul said, "I'm leaving. As soon as we get clearance, I'm outa here." He stood up, his cigar between his teeth. The tall man looked back at him.

"I don't understand. I just said, they're on their way across."

"It's easy," Raoul said. "I'm leaving. I'm getting out of here."

The tall man narrowed his eyes. "In that case, why did you come?"

"I thought I was on an organized humanitarian mission. I offered my boat. That's about it. I didn't know I was going to be involved with a bunch of cretins."

The tall man bowed his head.

"In that case, there's nothing more I can say, is there? I can't ask you to reconsider?"

"No," said Raoul.

The tall man unfolded himself from his squatting position and walked away down the dock, back to his boat. We all looked at each other. We'd turned into a rebellious crew, and nobody knew what to do or say.

\*   \*   \*

Raoul started the engine and shouted to Wally to cast off. The ropes slid off the dock fast. There was a little group of people staring at us as we left. The wake spread behind us, hard, and we were off. We went fast out the way we had come, down the canal with the men fishing at its edges, heading for the setting sun. It was minutes still above the water. We went into the wind and hit the incoming waves at an angle. Raoul accelerated.

"Hold it!" Vanni shouted. "Go slow while we cover the stuff up, at least!" Our cargo was still out in the open part of the boat. He threw the blue tarp over it and flicked an edge of it to me, an edge to Maury.

Raoul shouted back to him, "Leave the bilges clear! I have to be able to get down there."

We all heaved and tugged at the boxes. The flying spray had come in and wet them already. We piled them in the center under the blue tarp and fastened that down with rope and duct tape.

"Okay!"

Raoul turned up the engine again and headed north. The wind was in from the north so we were going straight into it. The water was dark and slapped up in four-foot waves.

"Could get rough out there!" Raoul called. The flashlight and a box of nuts hit the deck. The duct tape shot across the wet floor and fell among floating beer cans. I picked up as many beer cans as I could reach and chucked them into the ocean. The water hit the bow with a regular slap and the boat bounced up and plunged again. I wedged myself in on the cooler box, my feet against the center piece, one hand gripping the side. Laurie was still up on the flying bridge and I could not see her. I peered up.

Maury said, "You'd see her flying past if she fell off, don't worry."

He and Vanni stretched out on the blue cushions, smoking. Wally stood beside Raoul, deprived of beer, navigating. Raoul stood with his short legs braced apart, the wheel flying between his hands and a cigar in his mouth. We traveled on, back the way we had come. Nobody spoke, except to ask for water or a light. Nobody joked, or boasted, or talked about money or sex, nobody teased each other, nobody drank. I watched the after-colors of the sunset, across the Gulf Stream. The boat hit the water, *bam! Bam! Bam!* A first star

appeared, which was perhaps Jupiter. The moon was approaching full and lit our way from the port side, unclouded all the way.

Laurie climbed down from the flying bridge and clambered over the boxes. She gestured to me across the bodies of the men, and fitted herself onto the other cold box on the port side. The radar showed green and the lights of the boat showed us the water, and the moon accompanied us on that stretch of water where there was not a single other boat to be seen.

We docked in Marathon six hours later.

"Twenty to twenty-two knots all the way," Raoul said, "Not bad, eh?"

Nobody had spoken to him for the entire six hours. Now he sat on the dock of his own marina, hunkered down on the concrete, leaning against a post. He tipped a can of soda to his mouth. Wally went off to call customs and report our return. Maury and Vanni went to the men's restroom and Laurie and I went to the women's, as none of us had been able to move on the return journey, let alone get down the hatchway.

I walked back and sat down beside Raoul. I lit a cigarette, the last one from the crumpled pack of dense black Cuban cigarettes that I had.

"How are you?" Raoul asked. "Are you okay?"

"Sure."

"It can get a bit wild out there."

"It doesn't bother me. I don't get seasick. How are you?"

He put down the can on the dock. "I don't know if I did the right thing or not. You all thought I did the wrong thing, hunh?"

"You're the captain. Somebody had to make a decision, and you made one. You don't have to justify it."

"Tell me, what would you have done in my place?"

"I would have done what you did."

"Really?"

"Really."

He was silent for a moment, looking back down into the boat where the wrapped boxes still were and the water was draining out of the hull.

Then he said, "I was scared. I was scared they would take my boat. It happened to a friend of mine. His boat was impounded over there."

"I understand."

"I had to think about our safety, and the safety of the boat."

"Yes. You are the captain."

He held out his right hand to me then and grasped mine briefly.

"Well," he said, "we must unload the boat."

Vanni and Maury stood there. Laurie was already on board, hauling bags up out of the hold. I went to join her and we began shifting boxes.

"You guys," said Raoul, "are you going to let a woman show you what to do? Come on!" he roared. "Let's get on with it. We don't want to be here all night!"

We went back and forth with a little trolley and with boxes in our arms, to stow them in a trailer at the edge of the marina. One o'clock in the morning, and nearly all the boxes we had taken across the Gulf Stream were back here again, once more needing to be stacked. We lifted and carried and set them down in a long line without speaking.

Then we all went our separate ways, home.

# At the Reef

THE SCHOONER was to go out on the morning tide. I sat on a piece of timber on the dock in the early sun and drank hot coffee from a styrofoam cup. On deck, two crew members moved slowly among the shining ship's timbers and polished brass, their brown torsos bare. A third strummed on his guitar on the dockside. The captain, blond as a Scandinavian and with a white mustache that made his face a shy brown animal's, came up through the hatchway. The great sails were still furled.

Everybody came on board, all wearing white. White shorts and T-shirts, white sneakers. It would be a safe journey, a controlled encounter with the sea.

A man sat down next to me in his white perfect shorts, giving me the old opening phrase from teenage dances, when to say something was crucial, to break the ice as they say, as if ice were normal between humans.

"Have you been out before?"

"No, but I've wanted to. Oh, for a couple of years now."

"Then it's quite a day for you."

"Yes, really." The woman next to him wore gold rings and had the smooth well-kept look of a wife. She leaned across to talk to me, slipped her white top off tanned shoulders and her molded one-piece red swimsuit.

"Got to get as much sun as I can," she said. "We've only got a week."

The man said, "What would I give, just to keep on sailing this boat, what a job, imagine, got to go and sail that goddamn boat again. Boy."

Then there was silence for a moment, because the ugly couple came and settled themselves across the deck from us, in full view of where we sat. Well, perhaps you can't have an ugly couple as such, but two ugly people who were obviously together. Not ugly as a couple, not at all. For they gazed at each other in open adoration and that made you wonder what ugly was, after all, what it might mean. Everybody stopped talking, just before the boat moved out. They had this effect.

The woman took off her T-shirt and baggy shorts and revealed a white and pink body sprinkled with black hair in a bikini that left her enormous belly hanging between its two parts. She smiled with a face like a little pug's and folded up her clothes, got out her suntan lotion, and began smoothing it on her flesh with the same happy absorption that my bronzed, slim, shaved neighbor in her red swimsuit was showing. The man peeled off his own shirt and was white, knock-kneed, and pigeon-chested. He emerged like a lizard blinking into the sun, his head pushing forward as he groped his way out of his clothes. An intake of breath all over the boat, a little shock occurred, as if this were the Victorian era and an ankle had been exposed in a drawing room. We were all used to nudity; the shock was for ugliness in a culture whose Puritanism demanded beauty, refused all else.

These two people did not seem to know that, or mind. They came from somewhere else, where perhaps it did not matter, or would be forgiven. The woman slid an arm around the dead whiteness, the hairlessness, and squeezed. The backs of her thick thighs were marked with long black single hairs. The man flattened his body for a moment against hers, then turned with her arm still around him so that both could gaze outward, out to sea.

They spoke to each other in another language, rapidly. The shocked audience began putting on dark glasses, pulled out books to read, checked their own faces in little hand mirrors pulled from vanity bags.

The man next to me might be a lawyer, New York, Washington, perhaps Philadelphia; he had that serious look, from trying to be fair.

The arrangement of lines that in ten years' time would be the map of his life.

He said, "What wouldn't I give, to live in the sun?" His wife smoothed suntan cream all down her long brown legs and rubbed it in little gentle movements, satisfied with the creation of her body. She showed none of his slight signs of wear.

The huge sails hung and billowed when the men in blue shorts hauled them. They were like bleached laundry in the sun. They unfurled completely and climbed to the mastheads. The brown men in blue were very small, hauling away on the deck.

The captain called out, "Watch out for the boom, get your heads down. Everybody stay aft, okay?"

Several people laughed, like children. It was about being told what to do. They sat back on the seats at the rail and leaned back as if they did not need to be told anything. The unfurling and climbing of the three sails was like a ballet. The men tucked the ropes in around the dark wooden cleats and pulled the knots tight afterwards. The man who might be a lawyer went to help and came back with a broad blister on his palm, his skin raw, as sudden as that. His wife wanted to hold, it, examine it, but he tucked it out of sight.

With full sail and engine, the ship turned and headed right out of port. It was like a moment to clap or cheer, but nobody did. The sails tightened against a slight northeast breeze, the sky was blue and empty of cloud, the water aquamarine, turquoise, lapis, indigo, jade—all the jewels and adjectives you could think of to approximate the living colors of the sea as it moved over sand, grass, stone, and changed colors all the time. It would be like trying to describe the exact color of skin.

The captain said, "If you smoke, don't throw cigarette butts into the sea. Sea turtles live here and they eat cigarette butts but they can't digest them."

We were all quiet and obedient as a kindergarten class this time, understanding why. Nobody smoked. In our clean white clothes on a clean blue ocean, we wanted it kept that way. We headed out on a clear course east, past the islands and the moored boats, towards the reef. The colors of everything were such to make you want to paint,

or cry. This is what the world is like, it is this beautiful. We faced for-
ward, stared windward, looked about us silenced to whispers. Then
people began making their little camps, staking out territory, and
couples embraced each other vaguely and the mate dragged out the
icebox full of sodas. The creak of the ship's timbers and the sound of
heavy wings. Like being in a wood, it was, or a cathedral; like a place
where you might get touched by a wingtip, a feather, and imagine
angels passing.

"Huh? Oh yeah, thanks. I'll have a Diet Pepsi, thanks." At last you
had to make it more ordinary somehow and then settle down.

Up in the bows, the ugly couple had evidently not understood the
captain's asking everyone to stay aft. Their world, they had it with
them; in it, her big brown eyes and his little pale blue ones turned
endlessly upon each other as if there alone was where perfection could
be found. The ship sailed on. The boat's sails everywhere were like
folded wings. It was so beautiful, you could hardly bear it, even I,
who see it every day. If beauty can cause you sometimes this sharp
pain, then should not ugliness be reassuring?

"We're coming up to the reef, guys. Be there in a few minutes. See
where the water changes color over there?"

The captain stretched his brown arm, finger pointing. The only
living coral reef in North America, the place where the warm breath
of the Gulf Stream creates a tropical world where none should be.

"*Wie schön,*" the ugly couple were exclaiming to each other. Their
language was German, not the German I had learned at school but a
rougher, edgy version that slid about more. They were holding each
other by the hand, standing up now. They breathed out on "*schön,*" in
perfect accord. The man turned the woman's hand over in his and
then brought it to his lips. Her hand wore a gold ring but surely it
was the wrong hand for a wedding ring? The man's gesture was too
much for the woman in red. She ran her hands through her dark
smooth hair, seized a tissue and scrubbed at her own perfect lips be-
fore applying more lipstick. Her eyes were behind big dark glasses.
She rummaged in her bag so that her frown might not be seen. Her
husband looked mildly surprised, pulled his belly in and turned to
face out to sea, leaning on the rail like an officer in a war movie. The

German woman pulled down the front of her bikini top and rear-ranged her breasts. Her belly was striped with the purple and silver marks of childbirth. The hairs on her thighs lay smooth with a coating of oil. She smiled around her like a delighted child, her pug-face sniffing up the fresh air. Behind them and coming closer lay the creamy translucence of the water above the reef. Her husband took a photo of her there, leaning, smiling, sniffing, loving him, just as if she were a beauty. Everyone else on the boat seemed to be looking away.

When the great anchor had ground its way down to the bottom and the sails sagged right down, the crew came round handing out snorkeling equipment—masks, frog feet, life vests. Soon everybody looked the same, rubber masks in place, bodies and feet encased. The captain gave a brief talk about going out to the reef. Some of the men were so eager to be out there that they did not stop to listen.

"And remember to relax. It's only tension that can make anything go wrong. Just enjoy it. Breathe regularly and just lie on the surface of the water. If there are any problems, come back here and we'll try to fix them. You won't be able to get back up the ladder with flippers on, so take them off in the water and pass them up, and we'll have lunch for you when you come back in."

"D'you get sharks out here?"

"Yeah, sometimes. They won't bother you if you don't bother them."

"Stingrays?"

"Yeah, best keep away from them."

Some people laughed nervously at what the captain had said. The frog feet paddled on the deck and somebody groaned. A young woman from Georgia sat neatly apart wearing a sunhat, opting out. Her young husband was flexing his muscles as if for a fight. The first one in the water was the German man, unrecognizable except for his white skinny thighs. He went down the ladder quickly and for a minute the dark water closed over his head. The woman, fat and trembling but not far behind, lowered herself. Her face looked up at us all for a moment before she put her mask on. In the water she looked like a seal, broad, trusting, round-eyed. We saw her follow him more clumsily off towards the reef.

\*　　\*　　\*

Once I was in the water, I entered another world. We were all in it, but silent in the submarine silence, vaguely moving figures at the edge of each other's vision from time to time. The blue world of the reef, deep channels like canyons over which we flew in a slow dreamtime, mountains of coral, ballets of colored fish; it was enchantment. It claimed us like a shared sleep. I don't know how long I lay poised above it all. Moving my body slightly among shoals of yellowtails, or hung above a motionless turtle, or what the blue fish was that slid suddenly out between my outstretched arms, or whether the barracuda far down at the bottom of the channel, not moving, had noticed me or not. I came up at last, snatched off my mask and tube to breathe, saw a rocking dark blue sea between me and the ship. The ship seemed small and too far away. I set off swimming a fast breast stroke, kicking myself along. There were other heads dotted on the surface of the sea. The world was all dark blue splashing water with a small three-masted schooner at the edge of it. Relax, the captain had said. I choked on sea water and coughed, slowed my stroke. The others were getting closer. The ship was no longer at the very edge of the world. Soon I was on the ladder, frog feet in one hand and the other hauling me up. I shook and my teeth chattered and I arrived on deck hardly able to stand. Others were shivering around me. Only seventy-three degrees, someone was saying, not warm enough to stay in too long. In summer it's different, you can stay in all day.

"Is everybody up now?"

The captain was counting heads. Wet rubber was stripped off and flung on the deck. The deck timbers were warm underfoot. The last person on board was the German, larval white and pimpled with gooseflesh as he stripped off his life vest. He grinned around him happily and then his expression changed.

"My wife, where is my wife? *Meine Frau...?*"

There's a moment as he gazes around searching for her when I know the program is no longer working. The smooth day out, the sunshine, the perfection, the ease; a gear has slipped and we are out of control. The German woman is not with us but is down in that sea, lost. The safe excursion has turned a corner. We've slipped into another reality that none of us can cope with.

*"Meine Frau? Wo ist meine Frau?"* He runs to and fro, a pathetic human being reduced to simple fear. She is not on deck. There are no more heads in the sea. This can happen. He knows it, it's in him, life carries death close inside it, it can never be far away. He looks at the captain. The captain sees what has happened. They will dive and dive for her and never find her. And there's a cloud growing fast out there at the edge of the ocean, a hard-edged cloud like a wall that will engulf them. What you expect is never what happens. The captain knows this, that anything can happen, anything; and the German man knows it, but for a different reason.

"Have you seen her? Please, have you seen her? We must wait, *wir mussen—*"

He and the captain face each other, only feet apart. It's like seeing the same film develop slowly on their faces. It's about responsibility, for the life of another. There is only one decision to make and it develops fast upon the features of each of them. They are like men twinned in understanding. Everybody else hangs back as if unable to move. There is no command yet. Everything is still for a second: the ship hangs between one curved wave and the next, at the center of the world.

And then the program rights itself. There's smooth progression after all. With a look of surprise she ambles out from behind the slack heap of sail up in the bows. She's taken off her mask but is wearing frog feet still, so that she looks like a reptile slowly turning human, as her body, bluish with the cold, begins to warm to pink.

He stretches out his hands to her. He feels foolish, frightened, and relieved. Everybody has seen him as he is. Everybody has seen, in that moment when time stopped, that without her he would be a dead man, that he is even a dead man already. He has been seen while he contemplated the impossible, the unthinkable yet familiar daily terror that knocks at the doors of his brain. They have all witnessed it, these sleek and playful Americans, the fear that never really lets him go.

The captain rubs a tanned hand across his face, riffles his white mustache.

"Hey, you had us scared for a moment there, ma'am."

"I am so sorry. I was cold, I looked for a place in the sun. *Liebchen, was ist los?*"

She takes his cold hand and they move together, trying for warmth. They are so naked, standing there, their reptile skins stripped from them. The others, all of us, look away, open cans of beer, and go for lunch.

# The Knowledge

**D**AN SITS at the top of the long flight of steps and looks down. There's no way they're going to get down there even with Matthew heaving. It's just the same as jumping off a fucking cliff. They'll have to go back to Victoria and find a lift. Or give up on the whole idea. Matthew's gone to the kiosk for fags. Outside it's raining slightly like it always is this summer, but it's warm, he's sweating inside his biker's jacket; but the trouble is that with this kind of jacket, you put it down anywhere, it gets nicked. Now it's mended, it's better than ever; where the elbows were worn out from pushing the wheels round, it's now got studs and black cowhide stapled on. It'll last him years now. Have to, unless the Social Security get it together. Or the two of them rob a bank

Matt comes back with ten Regal, disgusting fags but it's what they can afford, better than rolling tobacco and the way that comes apart in your mouth, anyway. He pockets the fags, leaves Matt the change.

"Shall we go up Victoria?"

"Might as well."

"Hang about a minute."

He's seen the girl, sitting where she was last week.

She's about fifteen, not more, she looks as thin as a rake, and she's got this big black Alsatian sitting next to her with his head on his paws. Nice-looking dog, friendly face; you can tell a dog's nature like a person's straight off. She was there when his mother was here, only

the two of them had been so busy saying all those things—look after yourself, keep in touch, those useless sort of things you say when you are trying to leave and really trying not to feel anything—and after she'd gone, away down the same stairs, he'd noticed the girl with the dog. He thinks, how can you be on your own with a dog and not have anywhere to live? And then perhaps she has somewhere to live and just comes here to beg.

He rolls himself towards her. The wheelchair's so completely fucked, he's nearly over the edge and down the stairs, but he stops himself in time.

"Watch it," says Matt.

The dog and the girl both look up. The girl has a man's cap beside her on the step and there are only a few coins in it. He feels about in his pocket for the rest of the money his mother gave him. She must have plenty to spare, he thinks. Himself, he likes to keep money moving; easy come easy go people say, but surely that's the point. That way, if you run out you can be reasonably sure there'll be some more on its way. If you're tight-fisted, you just stop up the flow, and in the end you stop it coming back to yourself. At least that's how it seems to work.

He holds out the note to the girl. It's been in the bottom of his pocket all week, like a miracle, and he hasn't known what to spend it on but has known it was for something.

"No," says the girl, "you need it more than me. Go on."

"No, I don't, go on, you've got your dog to feed."

Funny, he thinks, how people will always have somebody with them that needs more than they do. You can't explain to a dog that there's no more dog food even if you're not eating yourself.

"Anyway," he says, "there's always more where that came from. I get it off the Social, don't I? They can't not give it me, it'd make them look terrible. Go on, have it. Buy yourself a meal."

The dog looks up and trembles. Dan thinks the dog shows feeling for the girl, perhaps. The girl has such a little pinched face it'd be hard for her to show things. But she pockets the fiver, doesn't put it in her hat. Dan thinks he'd like to get more for her, lead her away from here to a house somewhere, open the doors for her and say this is yours. Then she and the dog would live happily, roaming through all the

rooms and he would visit sometimes and give them money. But this is daft, he knows, because money doesn't buy happiness, houses certainly don't, and all the space around you you can long for can turn as suddenly into loneliness as milk in a bottle can go off. This he knows from his mother and father. Always bloody well worrying about something. If it wasn't something else it was the mortgage. At least when you've got nothing, when you're at the bottom of the pile, there's nothing much left to worry about, and you might as well give it away as keep it, he thinks. Living in the present, that's what counts. Starting things over again. Not thinking beyond the end of this particular day.

Matt says, "Shall we go then?"

He teeters above Dan, rocks the wheelchair up on end. Sometimes he runs through the rush-hour crowds, hands on the handles, feet up on the back like on a skateboard, hurling Dan along at knee-level, and the two of them yell for people to get out of the way. They take the backs of people's shins and batter their way through and don't apologize. It is like being an army, cutting a swath through people's ordinariness like that, through their helplessness.

Sometimes it makes him giddy, the power there is, when people look back in fury at them and dare not protest, because it's a kid in a wheelchair and his kind friend, and you're supposed to be sorry for the disabled. He imagines it's like being black and always in the right. He thinks of asking Rosie: does she feel like an army, when she's out there with her brothers and they're walking down the street? Probably not, because people are still allowed to be angry at black people; they're ashamed of looking angry with the disabled.

Yeah, he says sometimes to people in pubs. What, you're drinking, and you in a wheelchair? Yeah, we're supposed to be saints, aren't we? No vices. Pure as driven shit. But it's okay for me, you see I can't get legless.... And enjoys their discomfort, as he sails away with Matt, and the two of them are outlaws that no one dares stop.

He'll come back and see her, this girl with the dog.

He says "See you. Look after yourself."

And with Matt behind and above him, he hurtles away up the street. They might look in at the pub on the way. Matt wants to see if there are any women. The people Matt calls women are all in short

skirts with long legs, painted brown, and they go in twos and hang about phone booths. He has suddenly gotten very interested in them, but only wants to look in, just to check up, just to see if they are there. They are there. They seem to hang about in the afternoons, and for all they look at you, you might as well be invisible. Dan thinks they are probably a lot older than Matt thinks they are, and a lot less brown than they look. They have gold chains about their ankles and wrists and necks, very fine chains like gold hair, just enough for you to notice. And their knees are bony and they move like racehorses out for exercise.

"What about going on? I thought we were going up the East End?"

"Yeah, just a minute."

The pub's an Irish pub with a friendly woman—a real woman, not one of the racehorses—behind the bar. She has a big soft bosom though the rest of her tapers away, but anyway that's all you need to see across a bar. Matt thinks she might make them a cup of coffee. He leans on his thin brown arms which he tries to thicken with muscle-building in the bedroom, and talks with an Irish accent. His grand-dad was Irish, so it sounds okay. The woman makes them two mugs of coffee for free and Matt says something that makes her giggle, and she brings them across.

"Next time we'll buy something, only this mental idiot's just given away all his money."

"Ah well, next time you do such a thing, think of me—"

"I will," says Dan, "oh I will."

Sometimes his own accent slips all over the place and comes out Irish too. Mostly, he is flattening it out into proper London. It has been Newcastle, with a touch of Scouse. It tends to move about with him, giving him cover. It does now.

"You're good lads," says the real woman.

Dan thinks they aren't good, but they are convincing. It's as if they have practiced for years and it has come out right. He doesn't have to explain much to Matt. But sometimes when they fight in the bed-room because there's nothing else to do and Matt backs off and he sees the alarm in his eyes—Oh, God, now I've really hurt you—he knows that there's something Matt's scared of, and it may be hurting

people, and it may be something that they're both holding in check.

"Shall we see if Rosie wants to come?"

"Yeah. We'll have to get this thing down the escalators so she can give us a hand."

"This *thing*? My valuable spaz-wagon?"

"Heap of old iron. Come on, or are you going to leave that coffee till next week?"

"See yez," says the real woman.

The others, the skinny ones with the knees and the short skirts, the ones Matt wants to watch, are all outside clustered round a phone box as if one of them's won a prize in a raffle and they all want to know. They give them a wide berth. No point in what Matt's saving up to say to them, thinks Dan.

Rosie's sitting lolled on the clapped-out sofa back at the B and B. She's got her long black legs sticking out from under her skirt like open blades of scissors and her arms crossed over her chest. But Rosie does it for a laugh, egging them on. Dan likes her extreme blackness, the way it's matte and not polished, thinks she's the blackest person he's ever seen, and it's kind of soothing, the way a very dark night is.

"Hey, Rosie," he says. "Coming down the East End?"

"All the way," she says. "What for?"

"Makes a change. Better than this stuck-up tight-arsed part of town."

"Okay maybe. I'll ask my Mum."

"That's a good girl," says Matt, annoying. Rosie sticks her tongue out at him and Dan thinks, oh, beautiful.

He says, "Rosie, that's my favorite name."

"Well," she says, "in that case we must be made for each other. 'Cept of course I wouldn't look at a stupid honky kid in a wheelchair, would I?"

Dan says, "Don't call me stupid honky or I'll call you a stupid black—"

"Okay," she says, and places a soft hand over his mouth, smelling of soap and herself. He smiles beneath the hand and bears it. There are all these moments when you feel you might be overflowing your

edges and turning into a bit of somebody else, when everything begins to flow so fast that there aren't any edges and you don't know who the hell you are or where you end. It happens now, with Rosie holding her warm hand over his mouth. He wants to bite her. He thinks of the girl with dog at the tube station and the way the dog trembled, feeling things for the girl. He would like to rub alongside Rosie's legs now like a tall furred dog, an Alsatian. He would like to *be hers* in the way the dog was the girl's. But all this is daft, it is loony, it is up the creek.

"Come on," says Matt and flexes his little muscles in his arms under his T-shirt the way he often does. Matt wants to be stronger than he is, bigger, older. Dan knows so much of the time what it feels like to be Matt, what he wants. He feels how language traps him, so that he can only say short things, how there is so much locked up inside. Once, people thought Matt was a criminal, though he was only a boy. He's been through things that make him whimper in his sleep, dreams he won't talk about, memories he won't have. Dan thinks, I'll have them for him, it's easy for me, water off a duck, everything that was ever going to happen to me, everything scary, everything of that sort's already happened, and here I am, I've survived.

"Yeah, come on."

And the three of them, Dan, Matt, and Rosie the tall black girl with the legs like scissors, go off together up the street. Together, they'll manage, they'll make out. It's as if they've been practicing all along.

Matt spins in through the swinging door to where Dan sits on the bed smoking. The room the three of them share is so full of their stuff you can hardly move; there's shirts and trousers spilling over the beds and suitcases sticking out that belong to someone else, tripping you up with their sharp corners, and the air's stale with smoke and the smell of them all, even after the outside summer fumes.

Matt says, "I tried the hospital. They've got them all fucking chained up. Or I'd have nicked one. They told me to go to the Red Cross. So the thing outside's all I could get. Still, we can go out now."

"What about the council?"

"Westminister council said we weren't their responsibility. Said

we'd signed on down in Bethnal Green so they couldn't do nothing. Useless. And I had to pay a fiver to the Red Cross."

"Where d'you get it?"

"Changed a wheel on a BMW, didn't I. Saw this geezer sitting there with a flat, said I'll change it for you, he handed over the dosh, just like that. So you owe me."

Dan says, "We could do a bit of that, I could do the flats, use my pocket knife, you could change them. Anyways, where's this wagon you got me?"

"'s outside. Won't get in through the door."

"That's a fat lot of use. How'm I going to get in and out?"

"It'll do the outside door, 's just the one in here, it's too wide for it. It'd take a ten ton granny. You'll have to crawl."

"Done enough fucking crawling to last me a lifetime. Where we going, anyway?"

"Up West?"

"Lot of bloody yuppies up there."

"Yeah, but there's nothing down here. I'm pissed off with looking at the trains."

"Why don't we just get on the Orient Express?"

"And pay at the other end?"

"Anyway, let's get out of here," says Dan. "It's like solitary confinement."

"Only you got company."

The two of them double up laughing and Matt heaves Dan up off the bed and lowers him to the floor and suddenly there he is among all the dust and shoes and the sharp edges of suitcases. He crawls round the edge of the door and out into the passage and it's like life has been nothing but this, yards of dusty carpet, everything up above you, a fucking great effort just to move an inch. Then there are suddenly Rosie's beautiful legs right above him, a mile high over him, flashing black all the way up to her white knickers under her skirt.

"Hi, Dan. What you doing down there, man?"

"Hi Rosie. What's it look like? Wheelchair's knackered, isn't it, can't get hold of a new one."

Rosie says, "What a fucking nerve. Here, I'll give you a hand."

He feels them one each side, Matt tense and bony and with

muscles just like hard apples and his stale breath of fags sharpened with chewing gum, Rosie soft and firm and somehow dense. The feeling at his cheek must be her breast.

"Christ, what've you got me? You call that a wheelchair? Looks more like a tank."

"Best the Red Cross could do. Reckon they must think we're still back in World War Two. Wheeling round the chaps that got sliced up by the Jerries."

Matt collapses into the wheelchair and sticks a leg out straight and mops his brow.

"Move out, you nerd, I've got to sit down."

Jesus, he thinks, and I can't even reach the wheels on this one, he's brought me a fucking tank. And he thinks, we can't do much more of this, living nowhere, having nothing. We're getting up to the edge of it. But somehow it's all there is, because all the rest, back there, just isn't real. I can't go back. But Jesus, what would I give for a few things that work, a bit of space.

In the tube there's a sign up that says "THIS CITY IS FULL." They have to go down on the escalator, Dan up on his back wheels, Matt with his whole body tense to hold him. You can't trust the brakes. They go down into the smells of metal and hot air. There's a wind blowing like straight out of hell. Then there's a guy who comes up and says, you can't come down here, you're a fire risk, you'll have to go back up.

"You mean I can't use the tube?"

"Only if you give us prior warning."

"How much fucking notice d'you need? A week? A month? I don't believe this. Matt did you hear what the man said?"

Matt says, "We're down here now, we're going on the bloody tube, same as everyone else. That's our right."

"Well, you can, sir, but I'm afraid your friend can't."

"How'm I supposed to go? In a bleeding taxi?"

"You just have to give us prior warning."

"I just don't believe it."

Sweet Jesus, he thinks, I *cannot* take much more. He thinks of Matt and Euan and their Mum and the man they have all chosen for a father and of Rosie who lives with her Mum and her three younger

brothers and how they've all been dumped, how they've all got stuck, and how being with them is the only thing that matters because it is all that is left that is real, and he looks up at the man who stands over him, he tries to sit up straight in the wheelchair that is far too big and he says, "Fuck you."

"Now there's no need to be abusive."

No, there's just a mountain to go back up, the one they just came down, and then there's steps and then there's the claggy outside air that you can hardly breathe, where the car exhausts blast you in the face and the horns scream at you as you cross the road.

And the notice: THIS CITY IS FULL.

That just about says it, that just about wraps it up. But where else can you go?

Back at the B and B, the others are waiting for news. You can spend your whole day and night waiting for news. Joe is smoking and leaning by the telephone. Somewhere, there's a possibility—a house, a job. But where?

The man turns. He's still got his piratical look, he won't give up, he holds a fiver.

"Go down the chippy for us, will you, boys? I may be on to something here."

Dan thinks, he's a fighter, that's why I'm with him; but for the first time he thinks underneath this thought, but is there really anything to fight for? Is there anything left? He thinks, somewhere, there isn't a connection. He's standing there holding that phone, putting coins in as if there is. As if he can stand there like an old pirate and make anything happen. But the line's gone dead. Nothing's working. It's just not connected up.

And when Joe hangs up at last, there's a line of Pakistani women waiting for the phone. It's as if everybody's waiting to be told something by someone who isn't there.

So this is what it looks like, the rest of my life?

And yet, he made a choice, he knows it, it was to be with them whatever happened, however hard things got, that was why he had left his father's house, because of what was real and what wasn't because of what was and wasn't connected up. You couldn't go back on

that, once you had seen it. But Christ, he thinks, I hadn't realized it was going to be quite this fucking hard.

Joe says, "Well, you win some and you lose some."

Beth's in her room. She cries sometimes in the room in the afternoons and then she comes out sniffing and doing her make-up again and nobody quite knows what to say to her. She's showing it, what's getting to all of them. She's letting it out, and it makes them feel uncomfortable because it's what's there and what may be dangerous to show. You have to hold things in, thinks Dan, or they'll spill everywhere, and then people begin to walk all over you, because they don't know where the edges are.

He thinks, if I could walk, I might walk away from all this. But then, I don't want to, not really, however hard it gets. So maybe it's just as well I can't walk anyway.

Matt comes in with the chips then, and they're all together for a moment around the steaming greasy packages and he holds the paper with the grease coming through, burning holes in his legs if he doesn't watch out, and they eat them off his knees as if they were all birds swooping. He takes the last one, the last little chip. He licks his fingers, wipes them on his trousers. You just have to take it one thing at a time, one minute at a time, and then it's all right. You can handle it like this, one minute at a time. It's the only way through. And there's no going back.

The summer warms to a gray London haze. Dan wonders how long it's going on, this being here, waiting, living day to day. In the shared bedroom with Matt and Euan he lolls upon the bed and the three of them watch TV in the midafternoon. There are adverts of men with fast cars and new wrist watches and cool waterfalls of drinks crashing over ice; there are kids' programs that they all used to watch years ago, and they fight and giggle and punch each other when these come on; and then there are programs with smart women in lipstick and suits asking other, hopeless, messy women about their lives. It's hot outside and the streets are fuller with foreigners and foreign cars and girls in short shorts and halters that make Matt whistle and gasp as if for more air. Sometimes they sit out on the step and watch them go by. Other times, most times, they stay in the room. There are three beds

and in between not enough room, Matt says, to swing a cat, though Dan always wonders why you might want to. There's a bath, in which Dan wallows like a dolphin, passing the time, flooding the floor. He goes under and holds his breath. His hair floats out like a weed and the patch at his thighs like weed too. His legs come up and are light and his head goes under, he dreams of underwater, he makes them all afraid.

"Dan, what you doing down there, come up. You'll burst, one of these days."

If he stays there long enough he'll float entire and light to the surface. He lets the air out in slow bubbles, comes up. His hair plasters his skull, flattens its curtain against his eyes. For a moment he floats liberated in a liberated world. The water scummily reaches the top of the bath and slops over, slaps the floor.

"Watch out," cries Matt, "you're flooding!"

Once out and sitting dripping in his chair, he flips a towel across his lap and Matt with a practiced hand slicks back his hair. Euan chucks his jeans, T-shirt. When he's done, Matt comes back with the gel and sticks it on. Dan's hair springs back from his forehead, the gel's cold as some jelly pudding, he leans back, cranes to the mirror to see. Euan's on the floor, putting on his shoes and socks, does the knot with his tongue sticking out, twice. They dress him like people decorating, pinning on medals, and then stand back to see. They don't complain, Matt and Euan, just tease him; it's like they want to, like it's even fun. They scold him gently, chivvy him along. And thank God for it, thinks Dan. It's new to him, feels loving, the way it ought to be.

"Quick," he says, "I got to get down the Social."

"Let's get going then," says Matt.

"I'll go on my own, if you want."

"No way. I'll come down with you. It could take all day."

"That's what I mean."

"Well, I'm not doing anything else, am I?"

They bump out down the steps, into the heat. Euan's left smoking a fag and watching TV and looking out for messages. If there's a message, he'll dash down with it, if there's a hint, a clue. Sometimes he just sits on the steps and waits for things to happen, sometimes he

makes them up, and he could be there hours, just totting up everyone that came past and the ones that didn't too; it's like he's in training for a detective or a spy.

There are things to be seen to every day; mostly, money to be got. And Joe's on the phone to people; he asks questions and as far as Dan can see there are never any answers, because what should work doesn't anymore. Because something's gone dead. Joe sucks on one fag after another and sighs. Beth's up in the room with her rage, it's like she doesn't dare come down these days in case she lets it out and it goes up whoosh like a blowtorch, a flamethrower, and frizzles everything up. When she comes down she's sort of contained, like she's left it in there, locked up.

Dan thinks, it shouldn't be like this, but it is. If you want to be with people you stick by them no matter what happens, but it shouldn't have to be like this.

Sometimes Beth says, "Are you sure you don't want to leave us, go back to your Dad?"

Dan knows there's no going back, only forward, only on into the waiting days. Because going back, you have to stick yourself back into that space that was too small for you, the one you had to get out of because it was making inroads on your brain. That was the point; not the cramped space with the three beds and Matt doing his bodybuilding and the telly on and the scummy bathwater coming out under the door and the smell of somebody's socks, but the space in your head. Because if you don't go on growing, you shrink, thinks Dan, and that's just the way it is.

"No," he says, "I'm not going back."

Because these people allow the space. Because they know. Because they've been through all this and out the other side. Because Matt's putting gel on his hair carefully like a hairdresser and will spend his own day in there with him at the social, even though he could be doing anything, changing wheels on BMW's, picking up girls.

There's a load of people waiting already, and little kids skidding about and escaping before they're scooped up, and the Security men on the door are saying nothing, and the ones behind the desks, you can't even speak to. God only knows how long it'll be. But if he doesn't get

his cash today, it'll be Monday, and a whole weekend with nothing to do or spend. It's the same with everybody. It's worse, Fridays. There's this tension, like the one in the room with Beth, there's this feeling something might explode.

They're in there for a couple of hours when this black guy does explode; he thumps the counter and yells about racial discrimination. It's because he's not getting his money today on account of not getting there early enough to begin with. The woman's telling him he might get a crisis payment. But he's not listening; he thumps the counter and yells some more and Dan sees that if he stops for a moment, if he listens, he will hear 'crisis payment' like some distant signal, but he cannot stop, he's let out his torch, his flamethrower, and it's burning up everything in sight.

"Fucking discrimination! Fucking racial discrimination!" is what he's yelling at them all, and while he's yelling and hurting himself on the counter and they're yelling back, 'Crisis payment!' Dan watches and thinks, this is what Beth keeps locked up in the bedroom, then, this is what we all keep locked up because if you let it out you hurt yourself so much, and you just can't hear anymore.

The woman behind the grille is shouting and the people all around are saying things but the man can't hear, he just whirls round and runs out, slamming doors shut, slamming them all into sudden silence, and goes without his money.

"Blinkin' idiot," says Matt.

A woman with a black baby on her knee clicks her teeth and shakes her head and the toddler beside her, who isn't black but pale and dark-eyed, runs to Dan and then stops stock still and stares at him.

"Bloody morons if you ask me," says Dan. For he knows what it feels like to carry that short fuse around with you and to have it lit and to explode with it, like pissing yourself in public.

The toddler has sticky grimy hands. The woman smiles at Dan as women do but looks exhausted. Dan knows about this exhaustion.

"Come here, Keiran."

"It's okay," says Dan.

The baby has round bright eyes and stares with its fist in its mouth as if it were plugged in. The toddler walks all around the wheelchair

and then rushes at Dan and thumps his knees. Dan lifts his hands.

"Okay, come on then!"

It's a way of making things happen, of making what is nothing into something.

It's like joining things up. Suddenly there's movement where there wasn't before.

It's one way of spending a day.

At three, they drop the heavy iron railings on the outside and lock them so that no one gets in. This is when you begin to feel it really, thinks Dan. They go for a breath of air, for a fag, he and Matt, not out of earshot in case his name is called, just as far as the bars and the gray strip of the street you can see through them and the patch of hot sky beyond. He's sticky, grimy in spite of the bath. Matt's got dark rings under his eyes today, the rotten wine they drank with Andy last night. Perhaps it's this day. Perhaps it's what happens: your brain shrinks to the size of a dried pea.

There's a young woman lounging on the outside, waiting for her man; she leans as if she can't stand up. "Got a light?"

He passes his matches through.

"Fucking degrading," she says, "if you ask me."

Dan says, "I always knew I'd end up behind bars one day."

You had to keep going, keep things light. It was like chucking a balloon about, for people to catch.

He thinks, so, a day behind bars?

It's four o'clock on a hot Friday afternoon.

"Fucking disgusting, really."

They both puff, he on the inside, she on the outside. The place closes at four, but she says they can keep you till five and then send you away and you still haven't a penny till Monday. And anyway the Post Office closes at five. She reckons they do it on purpose.

The young woman with her jacket collar up as if it were cold and her hands stuck deep in her pockets leans and chats, relenting. Dan thinks that it hardly matters if you are on the inside or the outside, the fucking iron grill is what's the matter, it shouldn't be there at all.

In his mind, he is talking to someone. Look, this is how it is. I've got there, I've discovered. I'm in it, in here, with them, with all of

166 / The Knowledge

them, we're at the bottom of it all, we've got to where it is. It's in this place with the iron grill that comes down. You're locked in or locked out. You pass a cigarette, a match, between the bars. Time goes on, an hour, a whole day, it hardly matters, because you're in it, it's all there is. It's what's been invented, and it's real.

But who is he talking to? And will they ever hear?

Then he sees a taxi draw up full of people. There's Euan and there's his mother and several men. Suddenly it's being visited where he thought he was anonymous. He isn't sure. The place changes as they come towards him. His mother grasps his hands through the bars. Yes, he's pleased to see her—why not? But confused. She mixes things up. It was fairly straightforward until now; now it's uncertain. Rose's American friend, whom Dan knows, is in a wheelchair too. They are unloading him from the taxi like precious cargo, down ramps. He has a style about him, Dan remembers, that can only be American. He fills up the narrow street. And the other men are dancing about him, adjusting him the way Matt and Euan adjust Dan. The street seems full of them all, like street theater. Everybody behind the bars in the DSS and the young woman with the cigarette outside the bars, is watching. It's a performance, one side watching the other.

"Hi, Howie!" shouts Dan, center stage. "Welcome to the real England!"

The other two men are pulling cameras from bags like people in a hurry to hoist sails and get going, and they begin taking photographs. There are long-lensed heavy things, black and gleaming like weapons, taking up the street.

His mother says, "We were passing through, we came to see you, I didn't expect to find you behind bars!"

So the bars are a joke? He begins to try to tell her that it isn't funny but fails. The other people behind bars are now watching as if the street theater were about to turn into film and be immortalized. They begin taking attitudes, in case.

His mother says, "Aren't you hungry?" She goes across the road to a café, to buy filled rolls to feed them through the bars. Yes, they are hungry. They all make jokes about the zoo, about feeding animals. Dan sees from her alert angriness and her jokes that she is close to tears. Sometimes he wonders if his mother is up to something, the

way she appears and disappears; but when he sees her close up like this, he knows that she is not, she's just trying to make sense of things too. He thinks, She doesn't realize, you have to be on this side to know. Or is that where she really wants to be anyway?

Howie, the American in the wheelchair, finds another man in a wheelchair who seems to have been coming down the street anyway. They are talking together like an arranged meeting. The other American is taking photographs. The old man in the wheelchair who was here anyway is laughing, surprised, he is like someone who has been told on television that he has won an enormous prize. The street is suddenly a wheelchair convention, on film, with prizes and applause. Dan sees that what Howie does, in his wheelchair, is rule. It's subtle; he's like a king, but benevolent. People make way, apologize, are polite, feel honored. The old man in the other, the NHS wheelchair, is a subject suddenly found to have royal blood. He goes on down the street in his crappy old chair with uneven steering, but radiant. Then there's the shout—"The Giros!"—and they all swarm back inside the where it's happening, and suddenly they've all got their pieces of paper. He's got his like a prize and he's waving it and yelling and Matt's whizzing him out into the street. You have to keep people in and make them wait this long, Dan thinks, for a shout like that to happen. You have to promise them something and then withhold it and then dangle it and then finally give it as if it were a favor, a prize. You have to do all this, to have that wild yell of shared release.

Then they're out, only the security guards are left on the inside, closing iron, locking it all up for the night, so that it can start up again on Monday.

The taxi driver says to him, "Get into the taxi, quick, I think I've found you somewhere to live."

It's all so fast, Dan wonders what made life speed up this suddenly. He sits on the back seat squashed up against Matt and his mother. His mother's joking with the American, and Matt has his eyes round and mouth slightly open, he's sitting up very straight and paying attention, learning all this as fast as he can. You can do this then, can you? is what Matt's thinking, you be picked up by a taxi by a laughing rich American and carried through the streets of London far from where you were only minutes ago, behind bars, and you can be

offered a place to live as if it were a can of Coke; you can see Matt thinking all this. He's catching the idea that's come at him like a fast ball out of the blue, that you can do anything, change things. He's breathless with joy, Matt is, and stern with paying attention, he's like a boy picked up by a conquering army and carried on way past victory.

Dan thinks, this is all a bit fast, perhaps?

The man who is driving, who may or may not be only a taxi driver, who may do other things, says, "I can't promise anything, mind. But there's an outside chance."

They're swooping over Waterloo Bridge next and the river is wide and sparkly; there are all those monuments you never see. Howie is doing a US-southern accent for Matt. Matt is in love with it all, with America. The driver, George, is talking plain matter-of-fact London. They're all going somewhere, at surprising speed. What is his mother doing in all this? Is it a rescue operation, a hijack?

George is saying, "It's just an outside chance." As if this were a race and they outsiders. "I may have found something for the two of you," he says, "but don't tell anyone else or they'll all be down here wanting it."

Dan thinks, who is George?

There's more power here than he's used to. He warms to it, it excites him, the sound of a man who knows where he's going and what's what. It puts him in mind of fathers, again. He thinks, there's something opening up here, something big? Something Joe couldn't quite lay hands on?

Howie is writing a paper on Dickensian London for his students in Washington to hear. Matt doesn't know what Dickensian means. Dan does. He thinks, are we just a bit of something then? Part of him wants to go with it all, the photographs, the accents, the speed, jokes about Dickensian London, going through traffic lights and over bridges as if they didn't count. Part of him wants to slow down, go back to the beginning. Freeze frames. This is where you have to go back to, to begin to understand. He doesn't know if he wants to be found somewhere to live, just like that. He thinks of Joe and Beth and Euan, back home, catching himself thinking, yes, back home, in the hotel. And of Andy who they were drinking with last night, who's

come out after seventeen years in Parkhurst and knows the Kray twins; of Mahmoud who fought the Russians in Afghanistan and who is still a virgin at twenty-six and won't touch booze; of Rosie and her bossy black hands, her laugh; of the smells, the closeness, the waiting, the tension, the sameness of the days. Perhaps that is what he wants, what he has chosen? Perhaps that was what he escaped to, when he made a hole in his old universe and went through it, out the other side?

Whoever it was who was going to meet them has locked up and gone home. The street is suddenly quiet and empty. It was that waiting about at the Social that did it, and then having to find a post office that was open and Matt going in like a robber for the money while Howie timed him on his stop watch and the taxi waited with its engine running outside.

George, the taxi driver, who might have been someone else too, says, "Shame. Still, I'll let them know you're interested and you can go along. Here's the phone number. Now don't lose it. And don't tell anybody, like I said."

He and Matt promise. It's like being part of a gang. They don't know, either of them, what's going on here, but they make solemn promises. Dan thinks, it's like a game, really. He knows that part of him is not really playing. Part of him knows already that it is all more complex than this, nothing lets up this easily. He thinks that his mother does not know this perhaps. She is going somewhere else again. He never knows quite where it is she goes. Howie the American is going back to the States tomorrow, it is all a run-through, like a rehearsal. He leans back on the wide taxi seat and listens to George. George, turning from the driver's seat, is telling them about something called The Knowledge. It is what taxi drivers have to know, it is everything about London, past, present, future, it is where everything is. Dan thinks, George does know this, but there are other things he knows as well. That is why he seems real, why there is more of him.

He thinks, here is another one like Joe. There are men like this, ones who maybe should be fathers. There is a world they can let you into, not quite like this, not this fast, not this sudden.

Howie the American is making jokes about people in wheelchairs

always getting in by the back door. He is talking about flying across the world.

Dan thinks, this is also The Knowledge. He listens. There are all these ways of being, of finding your way about. Howie's way is through all these back doors of airports, of embassies; pretending to be a cripple. It is a word Dan does not often even think, it is so terrible; but when he does think it, it is to mean invisible, not even human, something you can pretend to be sometimes in order to get through to where you are not. He thinks that Howie knows about this, that this is his knowledge.

Matt says, "Do you have to do an exam about it then?"

Matt has a horror of exams, they are what has excluded him. Dan is not sure whether or not Matt can read and write.

George says easily, "No, you just tell them everything you know. But you have to know it."

Dan thinks, he has it, like something he takes around with him, a constant store. He thinks, I want to go on being with this man.

But it is all breaking up, this show on the road, it is coming to an end. Everybody else has something else to do. His mother, Howie, the other American, even George. Only he and Matt have to go back to doing nothing, to waiting. Only he and Matt look as if they need to be rescued. They are crossing the Thames again, going the other way. The rest of the traffic is a broad stream coming towards them. The river is solid, like metal, sometimes. There are all these buildings that you know from postcards, that have nothing to do with ordinary life.

Matt says, "I wonder what's for tea?"

Dan thinks how Beth cooks tea in among the Indian women and the African women, all of them queuing crossly to use the burners. The Indian women don't want to cook if somebody is watching. They only want their own people there. Beth grumbles about this. Joe says everything smells of curry, there's no point cooking anything else. Joe likes steak and kidney pie, even in summer, it's his favorite. Thinking about this, Dan knows that Matt too has gone back home in his mind, to where the others are.

So there they are on the pavement again, outside the B and B.

Matt says to Dan, "So what was all that about?"

Dan says, "I think they were trying to rescue us or something." He lights up a cigarette, hangs it between his lips and talks around it.

Matt says, "What? Can't hear a damn thing."

"I said, they were trying to rescue us."

"What from?"

"Dunno. Life in the fast lane?"

"So do we have a place or what? In that place we went in the taxi?"

"No, I don't think so. But we don't want one!"

"Don't we? I thought we did. I thought that was exactly spot-on what we did want. A place. What you on about, Dan?"

"Not like that, we don't. I'd rather be back in this shit-hole than that. I mean, we got our pride."

"Right, yeah, see what you mean. We got our pride."

"We don't need handouts. We don't need hijacks. Wasn't bad though, was it, all that joyriding round in a free cab?"

"Dan?"

"Yeah?"

"You like it down here, don't you? With us."

"Sure do. Best family I ever had. And you're the best mate. Give us a hand up the steps, will you? Here we are again. Home sweet home. No, I'm never going to leave you lot, whatever happens, we'll hang together. Hey, you didn't want to go and live over there, did you, Matt? You didn't want to be bailed out?"

"Course not. I liked that cabbie though. He knew a thing or two. And I liked the Sherman tank. And I liked—"

But Dan has wheeled away from him with sudden energy and he stands wondering for a moment just what has passed him by.

# Instead of the Revolution

**T**HE TAXI driver swerves her car up out of the tunnel at the side of the Gare du Nord. They're doing renovations to prepare for the World Cup, she says. It's an old station, she says, wasn't built for this kind of thing, there's no access, not for the sort of traffic you get these days. *La Coupe du Monde, ça alors,* it's going to be hell. She wouldn't stay in town if she didn't need the money. There'll be terrorists, people behaving like idiots, you name it. Bombs and drunkenness, violence and mayhem, she's dreading it, and it's only three weeks away.

We're trying to head south, to the Left Bank. But the river of traffic flows and then stops, everybody's cutting in on everybody else, it's the rush hour and everybody's rushing home in their minds even if they're sitting cursing at their wheel or jumping forward in the solid traffic by a few feet. Boulevard Magenta, République, all the way south to the river. Belinda looks out of the window at the glass Pyramid of the Louvre, the gray-green Seine, the *quais* blocked with more traffic, the approaching golden dome of Les Invalides. The whole trip takes nearly an hour.

Yes, the taxi driver's saying, I'd be in the Massif Centrale if I had my way. Still, only a few more years, then *la retraite.* Quiet mountains, that's my dream. But you have to keep going. *Faut tenir le coup.*

She lives with her son. Yes he pays the rent, but these kids today, they don't do a thing, they don't realize. *Ils ne se rendent pas compte.* He's thirty already, *mon petit cadet, mon petit dernier.* In our genera-

tion, we at least tried to do something. Eh, Madame? We realized that if there were to be any changes, it was up to us. It was our future, after all. Now, young people don't give a damn. *Ils ont tout.* Parents, we don't know how to kick them out. *Les parents, ils restent en adoration devant. Adoration. C'est fou.* So they don't do anything. *Vous savez?*

I recognize her. She's my age exactly, she has dyed blonde hair twisted up in a chignon, the roots showing, she talks, she knows the score, she's a mother, she's a *soixante-huitard*, and her son is the same age as my daughter, who is sitting here looking out of the cab window at a Paris that has changed this much and yet not changed at all.

Thirty years ago, I was in a hospital giving birth. Thirty years, and the first thing someone said to me was, you have a daughter and there is a revolution in France. To the day. We're here to celebrate Belinda's birthday and all around us are the placards and newspapers going on about *mai soixante-huit* and what it all meant.

The taxi driver says, "Part of the trouble with this traffic is that there's a *manifestation des routiers* on the Periphérique today. No way to get through. They park three abreast and not even a cat could get past."

"What are they protesting about?"

"*Ouf,* I don't know, there are *manifs* every day at the moment. Somebody or other always protesting, students, *chomeurs,* the papers, the ones without papers. Doctors, nurses, teachers, everybody. Rue de Varenne, you said?"

"Rue de Bourgogne. It's a turning off Rue de Varenne. Next to the Musée Rodin."

"It's one way. We'll have to come at it from the other end. I'll find a way through. *Voilà un couloir.* Otherwise we have to go back, take a different tack. *Ouf, ça va aller. Voilà.* What number did you say?"

On the way we've dealt with the police, *manifs, les fils à papa,* kids who won't take responsibility for their future, who'll make rotten husbands because their *mamans* spoil them, because they *restent en adoration, terroristes, Islamistes,* people who have twenty-four children whom the state would have to provide for—*c'est nous, nous qui payons tout ça*—people who'll become twenty-four *chômeurs,* twenty-four bad husbands, twenty-four illiterate families, burners, producers of

twenty-four more children apiece, illiterate, car-burning, etcetera. The mathematics of this take us to our door in the rue de Bourgogne, we who have not produced twenty-four of ourselves; Belinda who has so far produced nobody else at all.

"You'll sleep well here," the driver tells us. "Here, you'll be able to sleep all night, *les yeux bien fermés*." Here in the *septième*, far from the car-burners and demonstrations, with three armed flics on every corner and almost as many national flags as in America. L'Assemblée Nationale at the end of the street and not an Islamic immigrant bomber in sight, unless you count the friendly Tunisian grocer across the road.

"What was all that about?" asks Belinda.

I'm here this time to do a poetry reading in an American bookstore, with my friend Lizzie. Lizzie is an English poet. I have been billed as an American poet; but maybe anyone who has come from the USA to Paris is counted as an American. I feel odd, seeing it on the posters. Lizzie, Belinda, and I are to meet tonight and celebrate Belinda's birthday, her *trente ans*. *Trente ans*, to the day, since huge demonstrations were taking place, all the way from République to Denfert Rochereau, and the students were occupying the Sorbonne. I don't go on about this to Belinda, just as I don't repeat the more or less gory and frightening aspects of her birth. She's bored by old history. The fact that Napoleon's tomb is under that shiny golden dome at Les Invalides interests her briefly. But my history, the history of my generation, no. I wonder briefly if I'd have remembered so much about *les evènements* if they hadn't coincided so exactly with the most earth-shaking event of my own life, the birth of my first child. I came down from too much pethidine and, *voilà*, the old order was tottering to its inevitable end. You can't put a baby back, so how could you put a revolution back? Everything from now on would be new. The world had been transformed in the night. Even the crusty old *New Statesman* was going on about bliss was it in that dawn to be alive, and there had I been, young and not in very heaven but in hospital, a mother myself, my child alive, child of the revolution, daughter of May '68.

We throw our bags down on our beds after we've rearranged as much of the hotel furniture as we can. We go to wait for Lizzie in the

nearest restaurant. We order a bottle of exceptionally good champagne. I've always wanted buckets on tables, I tell Belinda, and have been denied them for much of my life. She says she feels the same way about things that arrive at tables in flames. When Lizzie arrives, late from the Gatwick flight, she says that she's felt the same way about bottles in buckets and things arriving in flames, and that when she turned forty she realized you could just order them and put them on your credit card. She says that there are other things in life less simple than this, so you might just as well have the ones that are easy to arrange. Men and publishers with money for poetry are two of the things that are harder to arrange, she says. So we drink our champagne and clink our glasses together many times and eat tiny mouthfuls of Vietnamese food and have rice in bowls and vegetables in containers like small gardeners' trugs. We don't talk about the revolution, Lizzie and Belinda both being too young to remember it in the way I do. It will wait for tomorrow. It is out there in the streets of Paris, even here, in the septième, and it is asking me what I think.

I stay awake almost the whole night thinking about it. It was one of the most significant political events of my life, and I wasn't even here, I was in a hospital in England, nature not politics having its way with me as I was raced from the first twinges, the rumors of contractions, through the breaking of waters, the tearing up of the first cobble stones if you like, into the full-flown drama and demonstration of birth. The person I gave birth to is now asleep, a silent sleeper with only a turn and a mutter from time to time to let me know she's alive and there. I remember the way she used to stop breathing and drive me to panic. Now she's been doing it for thirty years. In, out, in, out, for thirty years. What I have set in train. In, out, peaceful breaths of a calm sleeper, a good sleeper, a baby who took lots of naps, a young woman who falls into deep dreamless sleeps, only sometimes speaks in her sleep in a sudden urgent voice and then is silent again. I go into the bathroom and lean on the window sill, looking out into a courtyard with a tree in it and a blank expanse of wall that goes up out of sight. One more Parisian hotel room, one more courtyard not big enough to swing a cat in, one more expanse of wall. One more expanse of wall, going up out of sight. One more sleepless night. One more occasion, God may it be the last, of blood on white tiles, blood

dripping onto white china, blood on the porous small square of toilet paper. I thought I was done with this, but no, Paris had it up its sleeve for me again, or was it thinking about birth that did it, or revolution, or all those other nights; is it the inner side of the question that waits for me out there still, the one about who we are now, and what has changed?

At least in 1998 I have a private bathroom to feel bad in, in the middle of the night. I can order what I like in restaurants. I don't have to worry about my baby dying in the night. I don't have to think about whether a particular man really loves me because I now live with one who does. Some things have changed. My body is different from the way it was thirty years ago but it still feels much the same inside. I watch the drip drip of my blood on porcelain. That will not change, it will only, presumably, stop. It had stopped, until now. I think about the taxi driver. Has she stopped? Why don't women of the same age, the same generation, who have children of thirty, who lived through the revolution, who were there on a certain day, throwing stones, or there in spirit throwing stones, who occupied universities either in fact or in their minds, who read the same news in them on the same day—why don't they just stop menstruating all at once, when a clock strikes—dong!—inside them and reverberates through their bodies, just once? I mop up the blood, write a few notes, eat a peach leaning over the sink, close the bathroom window, and go back to bed. Tomorrow I'm to read from my published book of poems and eat more wonderful food with the daughter who grew to be thirty. Isn't this enough change? What more do I want?

To know if we were right, I suppose. We, the people who believed in sex and socialism and thought these two things would change the world and save us. To a world that now has AIDS and global capitalism, this may sound absurd. But really, these were the twin beliefs we carried like banners, and there are photographs to prove it, reels and reels of film, graffiti on walls, theses written, songs, poems, newspaper articles, books, there are signs, marks, mementoes; I didn't invent it. It was useless to tell us that sex and socialism would not save us, for we knew better. Capitalism was dying of its internal contradictions, and sexual liberation, the orgasm, was ours. Ask somebody in their

fifties, if you don't believe me. Or look at all the photographs of the revolution, our revolution, the first day of the rest of our lives, in May 1968.

I keep on thinking about the taxi driver. I can see her face half-turned as she drives, checks the mirror, cuts across traffic in alarming sideways swerves. I see the blond hair with the dark roots, the back of her neck, her shoulders in a white blouse. My exact contemporary. There's something we don't need to explain to each other. We talk as if we've known each other for years. Then she disappears. As a cab driver, she can do this. As a tourist, so can I. We have this completely intimate and completely unrepeatable meeting. If I were to meet her again, I probably wouldn't recognize her, not unless she spoke the magic words, *mai soixante-huit*, and told me that her son was just thirty.

Just inside the glass-walled hall of the Maison des Sciences de l'Homme, Marie-Dominique and François are waiting for us. They are old friends of mine. Belinda has known them since she was a child in Aix. It's easy to recognize each other because when you meet old friends you don't notice their hair has turned gray, or they have a new line there, wrinkles here. You just see the essentials, that tell you who they are. We embrace, one, two, three, in the way that's become so obligatory that people in other countries do the one, two, and the French have to add on more kisses to make the embrace entirely theirs. It's also entirely formal, but we do it with warmth, taking our time with each others' cheekbones and skin.

Once in this same hall I saw Jacques Derrida standing waiting for the elevator, reading a letter. On another occasion, François murmured in my ear, "There goes Kundera, see?" It's like being in a zoo of French intellectuals; you never know who you'll see roaming across the controlled savannah of the vestibule or standing in line in the canteen with a tray. They're French intellectuals now, though many have come from somewhere else—the Brazilian sociologist, the Czech poet, the mathematician from Sarajevo. This is because intellectuals in France aren't an endangered species. Here, they have sanctuary, and are given rooms to think in, in this vast zoological space they have for them on the Boulevard Raspail.

There's also a great canteen, where you can collect a four-course lunch with wine. We make our way down to it. We take our trays and choose from *boeuf en daube*, pork, ratatouille, and omelet; with green beans and potatoes; then fromage, tartes, yogurt, crème caramel, you name it, as the Americans say. I mention the choices because this is what French intellectuals live off, and it's good. In the United States when I'm asked to make complex food choices in fast-food restaurants, it's hard because I don't want any of them. Here it's hard because I want them all.

When we're all installed at a table and halfway through our main courses, Marie-Dominique says something that will go on ringing in my mind for weeks, or even years, who knows.

She says, "I'm not the same person that I was in '68. That's why I don't want to talk about it. I was pretty militant, yes. But I'm no longer that person. I don't recognize the person I was. I think of her as someone else."

She takes a mouthful of wine and sets down the empty glass. It's like saying, look, nothing left.

I want to say, well, if that's true, who are we and why are we sitting here? But too much is going on.

François says, wiping his mouth, "I find all this digging up the past unhealthy. *C'est malsain.* The Papon trial, for example. We dragged this old man out to answer for things he did fifty years ago. It wasn't right."

"You mean, he's not the same person?"

"Exactly."

Then who is he? Do we change every seven years, every decade? Or does it go quicker than that, month by month, week by week, even daily? Am I the person I was yesterday? Is Belinda the child I had in 1968? When I get back to the States, will I be the person my husband married, and will he be the same person? Or do we just go on looking vaguely the same, enough the same for memory to be jogged, for us to know who our friends are, our spouses, our children?

"But if he's not the same person, then how do any of us take responsibility for our history? We don't have to be war criminals for that to matter?"

François looks as if he wants to go. "Shall we go and get a coffee?

All I'm saying is, that it's pointless to dig up the past. We should be focusing on what we do in the present."

We all go upstairs to the cafeteria where you can get tiny cups of delicious *café express*, and he goes to fetch some on a tray.

"Marie-Do, how can you not be the same person?"

"I'm just not. Yes, I was involved at that time, as you know, but I'm just not that woman anymore. That young woman I was." She smiles firmly, as if she thinks I'm demented.

"Well, I'm not the same as I was, I've changed in several ways too, of course, but underneath—"

"Are you saying you're still carrying your inner child around inside you all the time? How very American."

François comes back with the coffee. Belinda says, "I've been here before, I remember, in this exact place. I remember looking out through the glass, I remember this table. I'm remembering loads of things. It's weird. I remember being in Aix, I could find my way to the Piscine des Thermes, out of the house, turn left, go along beside the building site place, cross the road, there's a fountain, left again. Or go to the supermarket. Right out of the house, then left on the main road, there was a sort of roundabout and the supermarket was on the left. Then if you turned right at that crossroads there was the road that went to school. It's funny. Being here, I'm remembering all sorts of things. Those twins who used to wait for me outside the school. *Pain au chocolat* wrapped in a piece of thin paper at break."

She sits there pensive, in her world of memory, which may or may not now resemble the layout of the town of Aix, but certainly did then.

"I remember the house. Going up the stairs. Big pots of lavender. The front door, the cherry tree, the letter box next to the gate."

She's speaking English, as if speaking to someone who's not here, someone beyond me and François and Marie-Do.

I say, "Memory. Memory is what makes us the same person that we were." I look at François, and remember. His hands on the tiny coffee cups are the same. The bone remains the same, as the skin ages. There is something, the thumb-print, the soul, a gesture sketched in the air, that tells us who we are. Knowing somebody means recognizing this, in spite of anything that may have happened—age, sickness,

deliberate disguise—the way you recognize that a sycamore leaf is a sycamore and not an oak. You just know. You don't have to have been lovers to know this; I would know it of close friends. But to have been lovers, to be mother and child, to be siblings, you know, you know forever. What about Papon's wife, or mistress, did she think he had become someone else?

I'm thinking this when out on the balcony in the sunlight there's laughter from a little group of men and a woman.

"That's him," François says, "the Brazilian I was telling you about. A brilliant man. But people come and go so fast, here. You just have time to get to know them, and then they go home."

"Except the ones that can't, I suppose. I mean the ones who are refugees."

"Yes, this place has certainly benefited from all the oppression going on in the rest of the world. When I began working here, it was Chile, all the Chileans were coming. Now it's the former Yugoslavia. Indonesia will be next. China, perhaps."

"But if in time they all become someone else, they only look slightly like the person they were, then they could go back anywhere, and not be charged with anything, surely."

Marie-Dominique puts up her hands in mock surrender and cries out for me to stop, stop. But I can't, not in my head. The question preoccupies me. If I go to the toilet will I be the same person when I come back? When I read my poems later today, will I be the person who wrote them?

The image comes to me of a small girl sitting with her knees up and her arms wrapped round them, her chin on her knees and her hair fastened to one side in a ribbon. She's me. I know she is. And she's waiting for something. She's waiting for what she's going to become, because she knows who it is. She's Imogen, the person I call Imogen, whom others called Imogen first. She's not just my inner child, that suffering being beloved of so many American how-to books these days, she's a person who knows the future, knows she's a writer, knows one day she'll sit here in this cafeteria sipping black coffee and looking across at a mathematician from Sarajevo, a sociologist from Brazil. She just has to get from there to here, and then on, into old age.

\* \* \*

"How did you get here? Did you come on the Eurostar? Through the tunnel?" François asks us. "Yes? How was it? Marie-Do doesn't want to go on it; she doesn't like being underwater."

"It's not like being underwater. You're only down there for twenty minutes, then you pop up in France, as if by magic. No, it's more like being in the metro. That's underground, Marie-Do, you do that."

"But why is it worse than flying? You have all that air beneath you to fall through, when you fly."

She shudders slightly, "I don't know, it's just a feeling. If it began to leak, you know. Or there was a bomb."

François says to her, "It's not like snorkeling, you know, like water coming down your tube."

"I know, I know. I just can't do it."

"What do the English think of it?" he asks me.

"They used to think people like Hitler would come swarming through it. Then they thought all the rabid foxes in France would rush through it and give their dogs rabies. But now—well, the English are very good at accepting the status quo; we think anything's more or less okay when it's there. It's useful, for going shopping in France."

François says, "It's a very big historical change. You are no longer an island. It's like no longer being a virgin. It changes everything. Don't you agree?"

When we get back to the hotel, Lizzie is sitting in the courtyard at one of the little iron tables looking pink and secretive and pretending to read. At the other iron table there's a very well-dressed man of about forty with long gray hair and a young face. I say *bonjour* to him automatically and sit down next to Lizzie, who's staring at one of her own poems. She frowns at me. "Do you think I should read this? I don't know that it's relevant. Who d'you think's going to be there, mostly French or expats? Your poems are all so relevant. I don't think mine are."

"Oh, come on," I say, "of course they are. They asked you to read, didn't they? Everything's going to be relevant. They just want to hear you. It's going to be fine. Have you ordered tea? Let's have tea."

"How was your lunch?"

"Great," Belinda and I say simultaneously. She adds, "Why can't the British canteens do food like that?"

The man at the next table gets up and goes indoors, as if looking for something. Then he comes out again, gives the three of us a brief glance, and goes down the courtyard towards the street, where he looks up and down as if expecting someone. Then he disappears. Lizzie does a sort of collapsed sigh like a balloon letting out air. She sags in her chair.

"What about him, then?"

"What about him?"

"Well, isn't he gorgeous?"

"Mm-hmm." I've noticed, without paying much attention, and Belinda's too young to think anyone with gray hair is gorgeous.

"Must be French. His clothes. Wonder if he's alone." She's still pink and looks about ten years younger than her usual youthful-looking self.

"You didn't get to see the wedding ring?"

"No! Why? Did he have one?"

"I don't know, I don't look that carefully anymore. Oh, Lizzie, they're all married, aren't they?"

I can see she's off into the scenario, *le mari français*, the house in the country, wonderful clothes and food, the baby in frills in the little designer pram, the car, the ring. But above all, the man, the one who will adore her, who will *rester en adoration*, as the taxi driver so memorably said.

"Oh, Imo, don't say that. There has to be one, just one that isn't."

"True. There is. And you only need one. It's like publishers. However many say no, there's one somewhere who will say yes." I don't want her to give way to despair. It's a tricky age, forty. You feel your options shrinking even if they aren't, along with your ovaries. "All you have to decide is, you're going to find him. Then you will."

"You sound awfully American. I'm sure that isn't the British way. Aren't we supposed to pretend we don't want things, because if we say we want them we certainly won't get them? You know, I want doesn't get?"

"No, in America you put it out into the universe. Then it comes to you."

"How great. I wish I lived there."

"Seriously, it doesn't do any good to pretend you don't want things and hope they'll just go away."

"They go moldy, don't they? They wither and rot and start smelling bad, like old cheeses in the bottom of the fridge. So what should I do? Go and proposition him?"

I can feel Belinda beside me raising her eyebrows. She says, "Has anyone asked for tea yet? Because I'm going to. How do you ask for cold milk? And hot water?"

"*Lait frais* and *l'eau chaude*," Lizzie and I say simultaneously. The young Arab waiter passes and grins at us. "*Du lait frais et de l'eau chaude, Mesdames? Et du thé? Du thé à l'anglais.*"

"*Oui, s'il vous plaît.*"

"Like that," I say.

"Like ordering tea?"

"No, like making sure, however indirectly, that someone knows what you want."

"Well, in that case I'm going to have to find out if he's alone."

I don't tell her that by the time he comes back to the hotel, according to my friends, he will have turned into somebody else, that there is officially no continuity anyway, and that she is not the Lizzie I saw this morning, even to herself. I don't say that I'm trying to deal with this vision of life as a perpetual all-change. We've got a poetry reading coming up tonight at which the audience will expect us to be the people who wrote the poems in the books they're asked to buy. It doesn't seem like a very good moment to say that we're not. Unless they were deconstructionists of course, in which case it wouldn't matter, we could just drink our wine and be anybody, because all they'd be interested in would be the *texte*. Are deconstructionists still around, or have they changed into something else? I don't know. I drink my *thé à l'anglais* with relief, while Lizzie goes to try outfits and snoop after the man with gray hair who might be the man she has been looking for all along.

Just before we set off for the bookshop where the poetry reading will be, I pass by the gray-haired man on the stairs. He has two women behind him and they are all talking to each other in English with

American accents. I mouth "Hi" to him because we've met before, sort of, when he was sitting outside. Anyway, it's easy to say hi to strange men if you don't have any ulterior motives, so I've discovered. Since I've been married to Ed, all sorts of men say hi to me, and I say hi back.

"He's American," I tell Lizzie, who is sitting outside again, still looking nervously into her poetry book but wearing a tiny orange skirt and a jacket of Chinese silk.

"Oh. Oh, well, that's all right. I can just join you on your side of the Atlantic." I can see her changing the scenario, house on Long Island, or maybe Connecticut, boat, Cadillac, but same little baby in designer frills, same adoration, but American-style.

I don't say anything about the two women, as I don't want to depress her. But two women is probably all right. One would be a threat. Two could be sisters, cousins, aunts.

"Is this all right? I don't want to be too dressed up. Do you think it goes?"

"Yes, you look wonderful. Perfect."

Belinda appears, looking as effortlessly wonderful as only people of thirty can, when they put their hair up and wear earrings. Both Lizzie and I gaze at her.

"You look gorgeous," Lizzie says at last. "What a wonderful outfit."

"Thrift shop, Edinburgh," Belinda says. They stare at each other, mutually assessing, the way women have been taught to do for so long that it really seems impossible to stop. We don't dress for men, but for each other. We know that men don't really notice, but women do.

"Anyway," I remind Lizzie, "all we have to be tonight is poets. Our books are supposed to do it for us, aren't they? Isn't that why they have pretty covers? So we can grow old in peace?"

They both turn on me. "Imo, you don't look old! You look wonderful. You look just the same. You haven't changed at all."

"Mum," says Belinda, "really. You're the youngest person of your age I know. You don't even have any gray."

"Ha, that's the hairdresser, not me. But I didn't mean that. I mean, we can be ourselves, can't we? Probably half of them will be feminists. They won't care."

"But the other half will be extremely sophisticated Parisians wearing wonderful clothes," Lizzie says.

"But the point is not what we look like, that's all I mean. It's the poetry."

"Imo," says Lizzie, "that's a hopelessly out-of-date point of view."

Then I remember her in the late seventies, in the early eighties, when we were all wearing dungarees and boots and cropped hair in case anyone thought we were collaborators, except for Lizzie, who read at feminist gatherings and went to conferences wearing little black dresses and red high heels with lots of good jewelry and her hair down her back. I remember wishing I could do it too. Maybe the feminists in the Paris bookshop will all be into post-feminist chic, inspired by trail-blazing mascara-wearers like Lizzie, in killer heels and understated little frocks. Who knows what to expect anymore? I put my own book in my bag, with all the little bits of torn paper to mark the poems which I probably won't read when I get there, and ask the man at the desk to call a cab.

"But you look completely different," he says to me. "I do not recognize you. You have changed completely since this morning."

"I've been to the hairdresser," I say. Is this all that it takes? I've always wanted to do it, and now I do: go straight to the hairdresser when I arrive in Paris. Lizzie and Belinda and I all went this morning, immediately after breakfast, and sat in a row listening to the young women's comments on our non-French hair. *"Mais c'est une catastrophe. Mais c'est horrible.* You must tell your own hairdresser, cut it like this, do not cut here, but here. It must be layered, here and also here. *Comme ça ce n'est pas jolie."*

We all came out reassured of being *jolie* and set off into Paris. The man at the desk stares at us now as we file out, dressed in our best, free of our catastrophic foreign haircuts, going to take literary Paris by storm.

*"Vous avez changé, complètement,"* is all he can say.

What Belinda loves most about Paris is the arrangement of things. She stands rapt in the doorways of flower shops, gazing in at tight bouquets of creamy roses, giant silky poppies leaning over in cerulean blue tubs, little pots of herbs trimmed neat as a lawn. She photo-

graphs pyramids of oranges, symmetrical mounds of gleaming olives, cakes cut with mathematical precision, no flake of chocolate out of place. She gazes at laid tables, white linen, an arrangement of bathrobes, soaps, a shop full of hanging lamps. The breakfast tray in the morning pleases her: the white jug of hot chocolate, the smaller white jug of milk, the croissants erect in a nest of white napkins.

At a café table she exclaims, "But it's all about showing you how to live in a pretty way!"

We are as mystified as ever about how you cross, or go under, a narrow expanse of water and arrive in this country where everyone does things so beautifully. It isn't an illusion, or just good publicity. Our side of the channel, things are a mess: people's hair, clothes, shop windows, restaurant tables. In the U.S., as the French would say, *n'en parlons plus.* I can never quite decide whether or not I admire the way it's okay to go out in America wearing pink Bermudas over your varicose veins and that in England you can live year round in a gray anorak. Perhaps it's just very relaxed, perhaps it puts values where they ought to be, perhaps it's a logical extension of my own attitude about clothes at poetry readings; but if I'm truthful, I don't find it admirable, only sad. It's the same with flower shops, vegetable shops, butchers', and it's the same with restaurants. When will we learn? Never, I expect. I see my daughter looking about her with a satisfied artist's eye, here in Paris where for generations artists have come to look. She wants to live a pretty life, with beautiful objects, even ordinary objects, in the right connection with each other. She saw it when she was six, and now she's seeing it again, and I notice her noticing Paris, taking it in, making decisions of her own.

Lizzie is deciding to be once again the best-dressed writer in England. Or simply the best-dressed woman, period. I see her eye go off scouring the clothes shops we pass, Boulevard Raspail, Boulevard Saint-Germain. As we walk, I see her pause just slightly, assess in a second, and walk on. Her step becomes more confident, she struts the pavement as if she were already wearing those clothes, the ones she hasn't yet found but will find tomorrow. She holds her head high, tosses back her newly-coiffed hair so that the line of it lies smooth and exact across her back beneath her shoulder blades.

"The only way to be well-dressed," she says in a musing voice at

the same café table (we're sitting at a café just back from the Musée d'Orsay now, because one of us had to get to a loo), "is to spend a lot, I mean a lot, of money." She says it as if to an unseen person, who is perhaps the dea ex machina of her life. She murmurs it to herself, to us, to the world. She's making her decisions too. When I first knew Lizzie, she was always buying little black silk suits that all looked exactly the same to me; but they looked the same the way racehorses look the same to anyone who isn't a racehorse owner, or chairs the same to a noncollector of antiques. But she has the eye of the professional, the addict, she knows what she's looking for, and why. She turns her round surprised gaze to me over the *petits crèmes* we are drinking and says, "I can't think why I ever gave it up."

"Gave what up?"

"Looking wonderful all the time.…"

It's the gray-haired young-faced American who reminded her, I'm sure of it. Even if she never sees him again.

At the poetry reading, which takes place in a tiny space where the two young women organizing are incredibly nice to us and the audience sits almost on each other's knees, I meet an American woman who until recently has lived in Zurich. There, she once read a poem of mine in a magazine she subscribed to. It was about ten years ago. Am I, she wanted to know, the person who wrote that poem? She has seen my name on the posters and wondered, because it said American Poet and she knows I'm not American.

I breathe in and out, trying to remember the poem, and say, yes, that was me. It was, wasn't it? There's no way I am going to say that I was someone else when I wrote that poem, that the person who wrote it is no longer me. She liked it so much that she has come to this reading specially, to hear me. I am so amazed by this fact, I certainly don't want to ask her if she is sure she is the same person who read my poem in Zurich. Then I cotton on to something, I understand. You only say you were someone else then when you are ashamed of what you did. If it is something someone likes, you don't pretend you're someone different. War crimes, treachery, a bad poem, they're all the same. You dissociate from them as fast as you can go. Otherwise, you hang in there. You say, yes, that was me. Unless, that is, you can gen-

uinely take responsibility for that thing you did, said, perpetrated, wrote, and say yes, that was me, I did it and it was wrong.

All this goes round in my head fast as light as I listen to the American woman telling me how she came from Zurich to Paris and introducing me to her Swiss husband. We don't become someone else, we don't want to, unless we are ashamed. So why is it so uncool to admit in France today that you were involved in '68? Why are the French intellectuals so busy backing off from their stint on the barricades, or in the Sorbonne, or writing on walls or whatever they were doing at the time? I've always been slightly ashamed of not being there, when English friends of mine set off in their 2CV's via Ostend to be at the Revolution, the way English lefties like Mary Wollstonecraft did in 1789. I had the perfect alibi; you couldn't plan a child not to coincide with a revolution. But now I have this completely new thought to deal with, that those who were there are now ashamed of it; does it mean that I who was not there do not have to feel this anymore? I've always known that underneath I'm too scared to be on barricades and risk getting beaten up by cops. I've always been scared at demonstrations. At Greenham I was scared all the time, in Hyde Park I was scared, at Faslane I was scared. Actually, I hate and fear street violence. I was among those who didn't decide to go to jail, who didn't "go in" at Greenham, because I always had a good excuse, I had to get home, I was a single parent with waiting children, I couldn't take the risk. But the real reason, I want to say to somebody, perhaps this friendly smiling American in the bookshop, is that I was too scared. So maybe I didn't really want to be in on the Revolution, the only real one that came my way when I was young, the one in which it was bliss to be alive etc. I wouldn't even have been able to man an aerosol can, to write *"Plutôt la vie!"* or *"l'Imagination au pouvoir!"* on the nearest wall.

It is time to read, now, time to open a book and stand up and do what scares some people so much they'd rather do anything else, even throwing paving stones. I can do this, I think. This is one thing I can do and am never going to apologize for or lie about or give up. The words have come from somebody who isn't quite me, who stands beside me or is just ahead of me, the person of whom Robert Bly has

said, "I am not I." Paradoxically, that is why it is more safe than dangerous, however vulnerable you may feel.

Late, after socializing with the friendly crowd in the bookshop and a good dinner and a good bottle in the Rue Cherche-Midi, Lizzie and Belinda and I walk home. All along the Rue de Varenne, flics lounge against the high walls that protect various ministries and grand apartments from the mob. The mob is nowhere to be seen, just these young men, several of them black or Arab, who smoke cigarettes, tip their caps forward, and shift about in comfortable-looking boots into which their pants are tucked as if they are going bicycling. You can tell a lot about a country from its cops' footwear. Lizzie mutters to me that the young men look like people you could have a conversation with. They mostly say *"Bonsoir"* to us as we pass, edging between them and their trucks, called *"paniers à salade"* because of the wire inside. The flags all droop against the carved stone façades. The ministers are all in bed. Who are the flics waiting for? At Denfert Rochereau earlier, there were soldiers in khaki with machine guns cocked; Belinda and I saw them on one of our trips in the metro. We walked between them, keeping our eyes ahead. I noticed how my heart beat slightly faster, how there was an adrenaline rush of fear. It's just what happens when you go close to a man with a machine gun, we've all seen too many movies for it not to happen. Was this really all for the World Cup?

Guns and roses. *Pain au chocolat* and *paniers à salade.* Flags and *haute couture.* The *septième,* home of privilege. The homeless man asleep on his barrow outside the closed high doors of the *Ministère de l'Agriculture,* waiting for dawn.

When you're with two other women, I notice, you don't feel obligated by monuments. You know that Notre Dame, the Eiffel Tower, and Sacré Coeur, not to mention the endless corridors of the Louvre, will survive without you going to check up on them one more time. You pass them by with hardly a twinge of guilt. I know that when I get home Ed will ask me, did I? And I'll say, no. Even the exhibitions at the Grand Palais and the Pompidou will do without us, and we without them. It's just very relaxing, sometimes, to do things that you

wouldn't talk to men about, like spending hours trying on dresses or buying a lamp. You went to Paris to try on clothes? To spend two hours in a lamp shop, trying to decide on a kitchen lamp? Yes. We aren't necessarily going to tell you about it, but we did.

In about the fifth dress shop, the one with the hectares of close carpeting and the sofa to sink down in to rest tired feet, Lizzie comes pirouetting out of the changing room in her bare feet, turning and twirling before the mirrors that show her her changing, changed self. She's been trying on a series of little suits with close-fitted jackets and tiny skirts, her favorites. She's serious, in spite of the twirling. Or rather, it's serious paying attention as if we were at a movie. The saleswoman, who should have a grander title and probably does, folds her arms and watches. She knows by now which clients are serious. She has picked up something about Lizzie, who has the look of a hunting dog when she comes into shops; she knows that Lizzie is hooked. She also knows that she isn't going to buy just anything. That is why this may take a long time. Lizzie may pause, hesitate, leave the shop, say she'll come back tomorrow, that she has to think. She's tried the orange, the gray, the black. She still has her look, focused but undecided. The saleswoman ups the stakes. "We could alter it for you by tomorrow, Madame. For no extra charge."

Still Lizzie frowns. It isn't quite right across the shoulders, even if you altered the skirt. There's a wrinkle where a wrinkle should not be. She appeals to us. Belinda sighs. "How can anyone even think of spending that kind of money on clothes?" Belinda dresses from thrift shops on both sides of the Atlantic. When she's had enough of things she dyes them blue.

I hiss, "It's like you and lamps. Or garden things."

"I couldn't ever bear to spend real money on clothes. Anyway, they'd look awful on me. But I suppose we're here to be the audience, aren't we."

Suddenly I see Lizzie come out for her fifteenth appearance it seems, in a little jacket that swings above her own black trousers and transforms her into a star.

"Lizzie, that's it! It's you!"

"It is? You really think so? It's really me?"

"Yes!" we shout in unison.

The shop lady says humbly, *"Voilà, Madame, c'est vrai.* The others are classic. This one is unique."

Lizzie stops twirling and stands before the mirror like a ballet student, her bare feet slightly turned out. She studies herself in the jacket. She sees who she is, who she will be. There, it's done. We can all see it. Whatever else she does in life, Lizzie has to wear this jacket, until it is worn out, until she tires of it, until she is convinced that she is not the person she was when she bought it, this afternoon, in Paris, in May 1998. The price tag says—well, I won't tell you what it says, because she doesn't look at it, just asks to have the jacket wrapped up. It's a small price to pay, for the certainty of knowing, for however brief a time, who you are.